The Tree You Come Home To

Jane Olmsted

Legacy Book Press LLC
Camanche, Iowa

ACKNOWLEDGMENTS

"The Tree You Come Home To," was published in January 2012, on *TheScreamOnline*, a special poetry collection on the theme of heaven and hell.

"The Tree You Come Home To" and excerpts from "Memento Mori," "Minor Chord," "Ghazal by a Thread," "Blessed by the Dalai Lama," "Rogue Tongue," "Architecture of Loss," and "Someone Else's Offspring," were published in 2015 in *Seeking the Other Side* by Fleur-de-Lis Press.

DEDICATION

For Ken, Casey's dad

and for his daughter, Leah;
his brothers, Galen and Adrian;
his friend, Latoya; and niece, Omni.

CONTENTS

THE TREE YOU COME HOME TO

In the story I used to read to you
about the runaway bunny,
Mother Rabbit is always the very thing it takes
to bring her bunny home.

A page hangs in a poster frame on your wall—
"If you become a bird and fly away from me,
I'll be the tree you come home to."

Now that you have said, "I will die and
leave this earth and you behind,"
Mother Rabbit just wags her carrot,
and I don't know what shape
I can pour myself into
that can possibly bring you home—

Shall I become a wisp of light and scent
so you will recognize the angel who embraces you?

If I become the place where your shadow feet
can still leave an impression,
would you know me as the path you take
to find yourself at God's feet?

Beside the shivers of worm trails
and carcasses of insects,
I reach inside and grasp the place that weeps,
so you will know
in the way that spirits know
the weight is yours, is mine.

PREFACE: TWO MONTHS BEFORE

When I close my eyes at night and am ready to sleep, the imagery is all mountains and hills and up-reaching trees. I am in Wyoming, camping along Greys River—on administrative leave, a time to re-center after my spectacular failure, spectacular in that all-consuming way that egos demand. With time, I may come to see that the job (as dean) was not mine, better after all in the hands of the guy who got it, just as my path is better, realigned.

Four months ago, when I closed my eyes at night and readied to sleep, what imagery took me into the unawares? What ifs, a tired thing running endlessly. Not the life of this river flowing at my side, where every moment is a new wave, new drops of water. I wonder how different a person can be before she stops being who she was. How unhappy have I been and not realized it in my head—only in my body? I am too busy interpreting the past—lamenting it, romanticizing it—to recognize it swirling around my feet. And I have given over this internal landscape to planning the future—usually in terms of how it will serve me—rather than attending to what the river has to tell me right now.

In a passage in Herman Hesse's *Siddhartha,* Siddhartha describes what he has learned from the river: "Above all, it taught him how to listen—how to listen with a quiet heart, with a waiting, open soul, without passion, without desire, without judgment, without opinion" (90). He realizes that his life was "a river, and the boy Siddhartha was separated from the man Siddhartha and the graybeard Siddhartha only separated by shadows, not by real things" (90). I don't know how to live without judgment or to listen with a quiet heart, but I am trying to learn from the river—as metaphor, as analogue, as the other that is also me. How can I keep good imagery from slipping to the edges, replaced by repetitions that, like the wave that fails to see its rebirth, are dying?

When life is squandered to the point that we have no choice but to take note, our feet will take us to the river we have created. Will it swirl with death, its current too heavy to take that next bend, or will the waters lap the shore, surging forward in a song of life and love?

I faced another kind of river in a dream—one of those job-anxiety dreams. I couldn't find out when my classes were scheduled, and it was already the second day of the semester. Our online registration system looked completely different, and when I entered my ID, it came back invalid. So, I ran down the hall looking for the main English office, but it was being shared with the football office, and no one remembered where my department head's office was. I went outside and started running, dashing into buildings, looking for the registrar, but the campus had shrunk and swelled and shape-shifted into something unrecognizable. I overheard that volunteers in the student union were helping students find their way to classes, so I let a baffled international student follow me.

My heart racing, my palms sweaty, short distances stretched out to the horizon. We stood at the top of a small slope, where I could see that the bottom was a mud swamp (suspiciously like shit) about ankle deep, so I took a running start and then flew over it, landing on the other side.

"Sometimes you just have to fly," I told the bewildered student.

I ended up with a print copy of the schedule, sitting in the sun, and a tall colleague came over to watch quietly while I tried again to see when I had to be in class. He sat next to me. I leaned against him. He put his arm around me. My classes hadn't yet met.

It was the picture of harmony, the lamb and the lion in each other's tender care.

INTRODUCTION

It is November, six years later. I am looking for ways to get in touch with people who might talk to me about my youngest son, Casey. I am especially interested in members of the Burns family. I search for Patrick Burns, the son who was eighteen at the time, and Google offers me these choices: "Burns guilty in '09 killing," "Suspect's son, victim's father gave testimony," "Rockfield couple sentenced on weapons charges," "Opening arguments presented," and "Casey Olmsted – Discussion on Topix." I try Latasha Sampson, the girl, and the same headlines appear, along with a pdf of the appeal filed in April 2013. I realize with a shock that although the Court had indicated a likelihood of an appeal based on Judge Wilson's decision not to provide instruction on the imperfect defense of self-protection, I did not know that the appeal had been filed. Even today, I don't know what the result was, or even what's before me on the screen. Merely learning of the appeal does not explain this feeling of assault. It isn't that I don't know if he won his appeal or even if he is out of prison. It is reading the narrative in the appeal that brings it all up, the night Casey died, the months and years afterwards. It is hearing the story told in this methodical,

legalistic way, events traced in such a way that in the end, the threat of Casey loomed so large that any right-thinking adult might take the "castle defense," grab a handgun and begin unloading. After all, he'd seen drive-by shootings on TV. That this was an unarmed man—a boy really—seat-belted in his car and heading home, his anger already expended verbally—these are our facts, not those of Patrick's father, Leland "Stevie" Burns.

I had already collected my journal writing from the period of 2009-2014, gotten rid of the repetitions and as much of the self-pity as didn't escape me; obscured some of the identities. I had thought it might be enough to share that process of grieving and healing with others who might face a similar ordeal. But in those pages, though Casey features largely, and I remember him in the swirl of loss, his story is missing. I understood, sometime in the ensuing year, that his story is a powerful one of addiction, courage, grief, and recovery. Furthermore, he deserves that my story not be the only one. His father, Ken, and I began thinking through what had happened, year by year, and ruefully admitted how much we had forgotten or mixed up with other events. I scoured boxes of his papers—schoolwork, birthday cards, rap songs, his own journals—and began piecing together a chronology.

But since his was a terribly difficult childhood, leading to nine special placements or detentions—not including those institutions that he attended more than once—I needed more than the files I'd saved. Throughout the fall, I requested records from every facility where he'd stayed. School files had been destroyed, but several folders had been archived, offering a detailed, clinical account of his residencies. He'd been in an alternative middle school learning center; three times at the Children's Crisis Stabilization Unit, a facility housed in a beautiful Victorian home, where now his daughter attends Montessori Elementary School; Rivendell Behavioral Hospital; twice at a rehab program for adolescents called Care Academy in Willisburg, Kentucky; Day Treatment, another alternative school setting for adolescents who'd been expelled from

middle or high school; Lighthouse Academy, where he graduated from high school; and Park Place Recovery Center, another facility just down the road from us. Collectively, he'd spent several weeks in Juvenile Detention and the Warren County Regional Jail for adults; and he'd been court-ordered to participate in a highly structured and intrusive prevention program called Drug Court. At the time of his death, he'd been struggling with addiction for about eight years. He was determined to make it this time. The autopsy indicated his toxicology was negative, confirmation that he had.

Most children with these kinds of records come from families with very different backgrounds. We heard this over and over, from intake specialists, therapists, psychiatrists, teachers, and social workers alike, surprised that his parents both had doctorates, both taught in post-secondary settings, and were neither alcoholics nor child batterers. But as Mary Karr said, "A dysfunctional family is any family with more than one person in it," and ours was torn apart by the problems our three sons faced, the convoluted dynamics of drug abuse and trouble with the law, sibling fights, depression, a pervasive set of problems that we simply could not solve. Although we may not have been abusive per se, scars formed on all of us. The safest of families may crumble in the face of pressure and violence from without—and within.

Mental illness runs in my family. My second oldest brother, David, had schizophrenia—that it was drug-induced may just be part of the legend. My mother's first cousin, May, had severe bi-polar disorder. My uncle was an alcoholic, brilliant but abusive. Combined with trauma, a condition like bi-polar often becomes incendiary. During the period I was working on my Ph.D. in Minnesota, a teen-age boy who lived down the street began a secret assault on one of our sons; the reverberations would eventually shatter the family's bedrock, and if that's too strong, then they surely caused fractures that we continue to mend today. His family kept foster kids, and I feel sure that one of them, whom our son considered a best friend, was victimized as well. Our son kept this

secret from us for seven years, or that's a memory-fact I can't shake, revealing it to his therapist on the last day of his stay at Chad, a group home in Tennessee. On the ride home, I could see our son reaching for the van's sliding door, poised to throw himself into traffic.

There were times when our two younger sons were in facilities at the same time, and we took turns visiting one or the other. But usually, Ken and I both went every weekend, and when we visited his older brother at Chad, Casey usually went with us. Despite the boring drive, he enjoyed these visits, as he had a special affinity to his "bad boy" brother. But their relationship was troubled. Adrian, who would bang on Casey's bedroom door whenever he passed it, was rough. He broke his arm once—Casey said on purpose, but I suspect more that he flung him too hard, and Casey fell. I asked Adrian many years later if he recalled what happened, and he said, "I remember that. We were arguing about something. He was pissed about something and lunged at me. I pushed him away and he fell against something. I didn't think much of it at the time." We didn't realize for over a week that it was broken—Casey masking the pain. Both older brothers "picked on" their younger sibling, and the relationship between Galen and Adrian, only sixteen months apart, was strained at its best. Scuffling was frequent, full-blown fights were terrifying and deeply hurtful to the boys. There were two big physical fights between Casey and his oldest brother, Galen, when Casey was in high school, and once, our oldest called the police in fear that Adrian was going to hurt their dad. That incident arose when Adrian got angry at his father for yelling at him to stop peeing on the strawberry patch.

Galen said, "I just remember being afraid that Adrian was going to attack you, so I started screaming at him. My analogy is the T-rex scene in Jurassic Park; I was waving the flare at him to distract him from eating Dad."

For over 15 years, I danced between feeling frantic, depressed, angry, hurt, my patience drained, and enjoying my job

and rushing joyfully into the spikes that represented good family times. During that time, Ken and I finished our doctorates, got our current jobs in Kentucky, traveled to conferences, and went with the family on vacations. Every Christmas we journeyed to Florida to stay with Ken's parents, and often we went to St. Augustine, where Ken's mother had bought two condos, in part for rental income but also to provide a place for family members to vacation together. Our children moved from Kentucky to Minnesota and back again, graduated from high school, attended college, and the oldest graduated with an MFA in ceramics and started teaching. Our extended families were loving and generous. We had many good times—I want to emphasize that, even as I make the claim that the five of us were desperate and some of us traumatized. Our boys loved us, tried to love each other, and we loved them. Love was everywhere.

No matter how committed and fine the individuals we worked with at these various places were, the institutional power to heal was incredibly stunted. One of my fantasies, when one facility after another had failed one of our sons, was to find a place, a kind of retreat, removed from the seductive energy of drug-seeking teens. I could see the place and recognize the kind of leader. He was Native American, a kind of Nanapush from Louise Erdrich's *Tracks,* a teacher who empowered through wisdom and humor, someone who could touch Casey's spirit and bring it home, the way Nanapush brings Eli home. Casey would leave hunched over with the weight of the world on his shoulders and return a wise child, the child we lost with adolescence. Gone was the anger and hostility, returned was the spirit of joy that used to light up his face whenever he smiled. Sometimes I would go as well, but here the fantasy faltered, as there seemed no way around work. I know of the oppressive reality of reservations, the brutal poverty and alcoholism, the disgusting history of colonialism, so it was an homage to the possibility that fiction offered, this dream of a better place for Casey to heal.

19

Instead, the facilities were lockdowns, and what the public school system could do to nurture the life of the mind was paltry, and homework meant churning through hand-outs. Given how well I got to know some of his teachers, I don't fault them. Most of the time, Casey was uncooperative. The clinical notes from the Children's Crisis Stabilization Unit show this side. Those from Rivendell Behavioral Hospital show another side. In the former, he sneered and mocked the staff and threw clumps of grass at his father, raging impotently. In the latter, he became a peer role model. Such contradictions are systemic—in him, in us, in our actions, thoughts, choices. And yet, it was at Care Academy that Casey discovered a love of reading and realized a life-long spiritual longing that he expressed in poems and prayers.

I am stunned when I look back and read his reflections. I knew he was intelligent, deeply principled, and that he was wounded, but he was such a private young man that I had not realized the depth of his thinking. He careened between refusing to take responsibility and blaming himself—perhaps two sides of the same self-destructive coin. He would tell his therapists that he didn't feel loved, that we loved his brothers more than we loved him. He would say we didn't have time for him, too consumed with his older brother, Adrian, who was in trouble—legal, mental, drug-related—throughout his childhood and teen years.

Casey's is a story of anguish and struggle for love and self-worth, but it is also one of great personal courage and determination, a quest for spiritual wholeness. His story deserves a place next to the other narratives—what the facilities say, or the courts, therapists, lawyers, police officers, teachers, textbooks, psychiatrists, and what society says about boys like him. We face a world increasingly unable to raise our children safely. Casey's story, bound up with mine, is one of thousands of such stories, about a mighty love and all that transpired to tear it apart.

I tell Casey's story by weaving the evidence we have: memories—our own and family's and friends'—as well as written

records from schools and treatment facilities, letters and cards, and Casey's own writing. Among the many letters and cards we received after he died, two stood out to me. Both were from colleagues from Western Kentucky University whom I did not know very well; both had lost brothers.

Erika wrote:

You and your family—but especially you and Ken—are so much in my thoughts . . . but there is little more to add than helplessness. I know this perhaps better than most, because my brother died 26 years ago, shot under circumstances that remain mysterious and appalling. So, I know about the permanence of pain, but also that it does, with time—transmute—impossible as that is to believe.

And Lesa wrote:

When I was fifteen and lost my thirteen-year-old brother, Roy, within three weeks of diagnosis, I found out what it meant for the bottom to drop out of the universe. Your memorial to Casey online made me think Casey and my brother were alike in many ways. Some people have an innocence which remains intact even after the horrors of life bruise them black and blue. I've never understood why those gentle, pure ones could suffer so much in such brief lifetimes. Next Easter when I fast, I will do so in Casey's memory.

We are part of a community of people who know what it is to suffer great loss. They reached out to me, and now I do the same, even if I don't know who you are. In one of the poems I wrote in the months after, "Memento Mori," I reference the story of "Krsa":

Krsa the grieving mother went to the Buddha
for help. "Take away my pain," she said,
but instead he sent her on a quest for mustard seeds
and the admonition to accept them only if
the giver had never lost anyone.
She carried her dead baby in her arms.
They pitied her but she could not take their mustard seeds.
This one had lost a daughter, that one a father,
here an uncle, every step along the way
a son, mother, sister, friend.
Realizing the community of grief, her sorrow abated—
perhaps not much, perhaps enough to relinquish
the corpse in her arms.

Part I:
What Loss Dislodges
(2009-2011)

I—THE FIRST SIX MONTHS

November—looking with suspicion

It is the month following the month when Casey died.

Today Ken and I went for a walk to Shanty Hollow Lake. We hiked along the lake and then away, along some bluffs where we saw rock houses and laced rocks and mammoth boulders fallen from ceilings, and then to the big rock house where the path ends and a stream of water pours from above—after a rain, it's quite a waterfall, and in the winter, a paw of snow often reaches over the opening. I thought how much I'd like to walk there with Casey, how nice Ken's back looked as he walked ahead of me, straight and tall.

We came home looking out the windows at the passing fields and houses, and when I told Ken that I'd enjoyed the day with him (no one else around, not even the children), he said he had too but that "I don't know what's so enjoyable about me." I thought how words like squalor and degradation both capture a thing and fail. Now when I look at shacks along the country roads of Kentucky, my eyes see with suspicion, and my mind conjures scenes of brutality.

Here's another day:
low as dirt and bleak as dun
12 hours till bedtime.

It is a chaos of weeks.

Yesterday, after I'd organized a big stack of photographs and layered them in crisscross fashion, Diana picked through them and put them back into a single stack. I felt a crash of betrayal. How could someone *fail* to notice that they were a collection of little stacks crisscrossed. I said something about it, but being near tears, I left the room and sat down in front of the TV, where Ken was watching a game and grading. He got up and gave her a gentle lecture about not messing up someone else's hard work. It wasn't such hard work, but sorting (one stack for this family, another stack for that one) through pictures of people here for Casey's funeral, and of his plaque and the columbarium at the church, makes prickly what's otherwise numb and generalized. So, I played solitaire and sniffled and didn't say anything for a long time.

On the surface

Don't want to see anyone, am calm on the phone but that belies. I stop short, staring. Writing poems helps, if only to give me a reason to immerse myself in the missing. Ken said on Saturday that he keeps expecting Casey to come down the stairs. This habitual expectation of his presence keeps the tears starting to my eyes. When he was quiet and surly, I wished he'd just go somewhere, and now I despise myself. The quiet stewing had lessened. He was kinder, we chuckled together more.

Our hurt rides the surface, we knock around, sighing, tearing, writing poems in some urgent expression of finding a way back to him.

I'm sure it could be worse. I could descend into some prison of the mind, curl up in my bed, become fearful of the outdoors, dream demons into fact. I am not that bad—do everything normal people do, though a little too urgently at times. I have bad thoughts of police coming to the door to tell me another of my sons has died, or Ken, and then I have to distract myself before they blossom into full-fledged narratives of an impending disaster.

I printed out the pictures of those people and their horrible home—was there love and sunshine in that house?—stacked with guns, flak jackets, MREs, compound bows, sawed off shotguns, kits for machine guns, automatic weapons with serial numbers filed off. Sixty guns, 20 bows—what ring of hell did Casey drive into?

I am sick with the thought of him driving away, knowing or not knowing what hit him, aware or not aware as the car rolled into the ditch. Alone, my poor boy, alone.

> my hands grasp at air
> every day the tear widens—
> will I split apart?

December—dreams

Yesterday, a friend, noting that I was wearing Casey's cross, said that I am the last person one might imagine wearing a cross. I will never take it off.

Last night, Ken and I had nightmarish dreams and woke up at 3:30, together.

I was scheduled to be the second reader at a talk with some man, about grief—I was to read from my poems. The man went on and on, and during the break, most or many of the audience left, though one or two said that they'd come to hear me and regrettably had to go. When it was my turn to get up, I had a half dozen little slips of paper (about the size of the strips for a Christmas tree chain) written on both sides. I began shuffling them and waiting for a

27

couple of people to stop talking . . . one of them was writing in a workbook—he was an older man, a little fat, and somewhat slow—and he kept talking loudly to the person next to him, asking questions, and she was trying to help him. I waited until he got quiet, then started. My dean was there, and I remember talking "to" him. My talk now had shifted to environmental issues, and I tried to explain an innovative project that my students were working on, but it made no sense. There were three stages, but I couldn't even understand what they were, let alone explain them to the audience. I just kept searching through those tiny slips of paper for coherence.

I talked to Kathryn this morning and mentioned that Ken and I had both had bad dreams, and she told me that she'd had one the other day. Casey was knocking on their door and telling her son, Sam, to come on, and Adrian was saying, "Sam, you don't have to go with Casey."

> Nightmare or sweet dream?
> You wake me with a whisper.
> Stay and tell me more!

Christmas moments

This "holiday season" has been full of visits . . . Being with people distracts us from what looms. I get a jab in the midst of washing dishes or putting a puzzle piece into place, but it's only after everyone leaves, or sometimes when I remove myself, that what's been displaced comes rushing back. I keep thinking he's going to walk in the door or get up from a nap, and though it's a moment's illusion, the disappointment that follows is crushing.

Today I took Shelby to the vet because she's been getting skinnier despite our feeding her extra helpings of dog food and giving her the biggest bone or pieces of leftovers. The vet heard a murmur of about three on a scale of one to six. So, they did an EKG; we'll find the results tomorrow morning. The heart condition

explains her weight loss and probably her shivering as her heart tries to overcompensate for the murmur. Shelby is 12, or 76 in dog years, old for her size. She was Casey's dog, and I kept thinking about that as I tried to soothe her.

Tears come to the edge
The world goes blurry and strange—
Christmas lights look nice.

January—uncertainty

Today, Ken and I looked at the hospital report, which included a multi-page account of the EMT's actions when they went to Casey's accident site. We read about his color (cyan), his breathing (unresponsive), his pupils (fixed), his position (reclining, his head held through the window by a by-stander); the intubation tube, the 3+ epi & atropine they administered; the IO in his leg, the c-block with which they removed him from the car, the chest swelling and filling with fluid; the doctor's okaying their stopping recovery attempts on the road to the medical center; the sirens and lights. Their hard work was evident in the report and the clarity with which C. Houchins wrote it. Perhaps he was alive still in some corner of his body, but his last moments alive likely occurred before anyone arrived. The road would have been silent, and the trees.

We looked up the weather and found that at 11:53 it was 64 degrees with clear skies; the moon was waxing, half full, and became full on Nov. 2 (seven days later).

Last night, I had my most vivid dream of Casey yet. I was in a morgue. They brought him in and laid him on a table, then left. I noticed his color was pinker than it should have been, and then a single tear rolled down his cheek. I went over to him and helped him sit up next to me, and we began to talk. I had to lean in to hear him, but his voice was clear, though the words didn't make sense. It was as if he was trying to talk in another language. Then the word,

"Diana," came through clearly, and I had the sense that he was concerned about her. At one point I said, "I loved you, LOVED you," and he said, "Did you?" Then he said, "I know you did." I sobbed and held him close. We hugged for a long time. Then I woke up, flushed with a feeling of great love.

February—accident

Adrian went skiing on Horseshoe Mountain, hit a tree, broke his back (transverse progress 1-2-3-4) and is in a hospital in Morgantown, West Virginia. He will not be paralyzed, the doctor says—this being "the best" kind of back injury.

After some uncertainty about whether I would go get him or his friends would bring him back, there was a terrible conversation with one of the boys. He and two of his friends had already driven three hours toward home when their boss, after I'd talked to him about why they'd left Adrian behind, told them to turn around and get him. So, this boy called to say, "It was your job to get him," and that since I'd left that to them, I was "the worst mother ever."

April—you have to remember

"You have to remember these things in your mind." Advice from my older granddaughter, Omni, after I forgot to pick her up for ballet and was apologizing. Thence to a story about an incident at school: "Hudson the boy and Brianna got in an argument because she wasn't letting him play with other kids, but then we all held hands, so we were happy in our hearts."

I'm in the historic Catholic cemetery on Fairview. To my right is the furthermost western edge of the cemetery, bordered by its signature dark green chain link fence, and then a field, a row of trees, the river, the highway, and beyond. I'm sitting with my back against one stone and looking at another, a multi-colored marble, the Cullom family—Fannie, 1888-1972; Bee Lewis, 1883-1961; Lon,

1865-1938; Eliza, 1867-1958; and E. Cornwell, 1800-1925. Can that be right? 125 years? It must be 1900. But no, the birth year is clearly 1800.

For a time, I would miss Casey one day and then feel almost normal for two or three days, as if to say, "Hey, this isn't so bad." But lately, I've been crying a lot or carrying tears in my eyes. It feels right this way, though lonely, and I don't want to go back.

I am bothered by petty slights and bruises, a battery of stings. I miss Ken when he's not here. He wants to go to India this summer and see his friends there, but I am fearful. Something will happen to him. I will knock around the house in desolation.

Some stones don't have the birth date on them—at least these two, Wes and Maria Whitney, died 2 23, 1924 and 3 8, 1937. I look at the stones and do the math to determine how old they are. I imagine how they died. At birth, at two years, or at their peak, perhaps as new fathers or mothers. Perhaps old and utterly alone. Perhaps holding the hand of a husband or wife after a lifetime of bickering, or let's say, growing rich in the knowledge of each other.

My thoughts trouble me. I see my poems heaping with praise and then feel bad that some of them, perhaps my best poems, are about Casey, and it seems then that I'm turning loss into something obscene. I mean for them to honor Casey, but even as I stand on rooftops shouting his name, the Other crawls up my leg, my personal Gollum urging, "Shut up. Shut up."

Are you feeling blue?
Come then to this lonely place,
I will find you there.

Yesterday I got hit with a big sadness while I was watching the girls—there doesn't need to be a reason, and often it's an accumulation, like pressure building behind a levee. Sometimes being around people causes the rupture—all their needs pushing me

into a corner. Other times it's their absence, when silence careens around the house, pushing me into a corner.

I miss Ken and feel sorry for myself because no friends call, but nor is there anyone I want to talk to. I've regressed to my fifth-grade self. When I'm with people, I want to be alone. I keep thinking that Casey is trying to come back, then that it's *I* who wants him back, then that he *would* want to come back, to finish his journey.

On May 3, we go for another court hearing, supposedly when they'll set a trial date. It's also the day and approximate time when someone needs to be at the airport to pick up Galen and Tsering, Ken's Tibetan monk friend who is coming in from India. On Saturday, Tsering is going to perform a death ceremony. We've invited some friends and are having a potluck. I need to get some black material today for wearing tomorrow (the six-month anniversary) and some green, red, blue, yellow, and white cotton for the ceremony.

Elizabeth Gilbert writes in *Eat, Pray, Love* about taking steps to get better after her divorce and depression. She stops listening to sad music, something I don't want to do. I look forward to the plaintive, so I can go to that place of longing. I want to go into the emotions, not just *have* them. If I can't find the time for this miserable pleasure, the stress stabs the back of my neck until I think it will break and I'm weeping in desperation. This happens every few days, when I haven't been with Casey in the fullness of my heart.

II—THE NEXT SIX MONTHS

April

Yesterday was the six-month anniversary of Casey's death. I sat in my office, my black band around my arm, and waited for students to come by, was glad and mad when they didn't. Then I came home and had a second Woodford drink. Ate fast. Sat around. Then went to bed early and read Gilbert for a while. I would like to force myself out of this slump and do things that are more positive. Casey wrote in his journal about how hard it is to stay clean, and he was working very hard on changing his life. Honor that by doing the same.

Irrational fears:
Everyone I love will die.
Go away, bad thought.

On Sunday, when our spirit group met, Tsering did a "chod" ceremony, meaning to cut the ego. His talking about it and relating it to death brought tears to my eyes. Ken went and got me a napkin,

and I was weepy a while more. When Ken came up to my little upstairs office that night, he said he wasn't going to India this summer, that Brother Michael at Gethsemani Monastery had urged him to do something with me instead, and Ken said he'd already been leaning that way, and was that what I wanted?

Instant tears as I tried to say I didn't want him to stay because of me, and he said, "It's not like you're holding me back. I know you wouldn't ask me not to go, which is one of the things I love about you. But I want to be held and I want to be with you." I felt alright then, and it's true that I am relieved.

May—trouble in paradise

I have severe doubts about my abilities to do anything very well: poetry, administrating, teaching. I wish I were better so I could give Casey a good series of poems about what his loss means. I hear his laugh and see him coming in from the TV room to say something to me. Yesterday I could hear him say, "Happy Mother's Day." Maybe I can just leave a bunch of unfinished projects for my children when I die (scratch that, more self-pity).

I'm listening to the *Requiem* for the first time since the performance at the State Street Baptist Church on April 22. Ken is in Bloomington, Indiana, hearing the Dalai Lama. He texted me and said he has good seats and that his monk friend from Gethsemani Monastery is on the stage. That was this morning. He'll be back tomorrow. I've just had a margarita and am not too affected to be able to write here and to listen to Brahms.

I miss his laugh, the tone of his voice. His spirit—the way he struggled to overcome his problems. His focus and determination. A fellow writer—keeping a journal all through 2009.

Last night at the meeting with Glenda, which was a half-session since Ken and I split it so we could take turns watching Leah, I focused more on myself, specifically my confusion over who I'm supposed to be in the world, what to do with the contradictions I

feel—wanting to be both sought and left alone; wanting to be *asked* to lead this or that program, then to say no.

I was bothering Ken about this and that clean-up project around the house, while he was working at the computer—trim the front bushes, need to get the tomato plants in, look at this mess, someone needs to load the dishwasher, that sort of running patter— and he snapped at me, that he'd been waiting all semester to get started on his paper for the Vilnius conference. I held it together and said sorry, that's fine, and then went upstairs and shut the door. He came up a moment later, and of course I was teary, more as soon as he walked in and said he was sorry for yelling. I wanted him to go away, but he wouldn't until I looked at him, hugged, and so on.

Glenda drew an outline of a person with a ceramic vase in the center. This vase, she said, is a metaphor for our emotional life. Inevitably, cracks form, hairline fractures, caused by wounding. As we pour positive emotions in, they leak out unless the cracks are filled. Counseling helps. When positive emotions don't leak through the cracks, they remain inside the vase to give off a breath of emotional health, on which we live more wholly. Someone who had a very solid background and childhood has a vase with a strong base and thick sides.

Ken and I both went to yoga class, where there was talk of "opening up," "feeling the air," "find your breath," "this is your life force," and toward the end, "think of someone you hold very dear." Having already thought of Casey as I was "breathing" and "opening up," I imagined him and then immediately Ken. It was as if I needed both my missing one and my present one in my heart at the same time, neither one without the other. As I was bending and stretching, I found my eyeballs up close to my ankles, and it occurred to me that rather than looking at them with loathing, I might consider my legs to be my ceramic vases of endurance. And then the thought, formed as a sentence, spoke to me: "You've been in a lot of pain," as if someone else noticed what I myself had missed. I do not need

to store self-loathing in my body, do not need to grasp it as if someone were trying to deprive me of an old, tormented friend.

Voices

My former dean called to ask me to serve as interim director of the Commonwealth School. He started with compliments, referring to my "passion for adult learners and access" for the underprepared. That I'd be a "great, a calming influence." He went on to say that what's most needed is a steadying influence; he didn't deny that it would be "hard."

I was interested, composed a letter expressing my doubts, shared it with Ken—who thinks it's a bad idea. And then later when I went out with Libby and Mary Ellen, they both said it was a bad idea.

Libby said, "How important is it to you to control the destiny of your own life?" Grr. Why did she have to ask that?! Now I can't stop thinking about it.

Last night, I went to yoga again, this time led by Emma, who we'd heard was "gentle" compared to Maggie's being "harder." She closed with a poem about grass, about letting go. Every time these yoga teachers talk about life force and "opening up," the tears well up. Those words are weep triggers.

Have I been "closed"? Protecting myself? Should I imagine my metaphorical body closing on itself, shoulders rounding over, protecting the internal organs? And if so, how long before the real body mirrors the spirit body?

Summer and Fall

We're in St. Augustine: Ken, Leah, Galen, and me.

We've had a nice trip so far—relaxing and, well, just different. Ken and Leah saw two manatees. I saw the back of one, and the tail, and then the trail of halos rising to the surface as they

swam away. Later, Ken and Leah went to the pool, and Galen and I went to the beach.

On the way here, we drove midway to Atlanta the first night and stayed with Susan, Kathy, and Logan. My amazing sister-in-law, Susan, who does such brave and heart-breaking work fighting the death penalty in Georgia and trying to get convicts removed from death row, reported what her friend said about Casey's autopsy: 1) he would have been unconscious in 10-30 seconds; 2) there was not a lot of blood in the chest cavity, meaning his heart stopped beating almost immediately; and 3) it was not a survivable wound. To hear it verbalized brought the recurring questions: What was he thinking? How much time did he have? What suffering did he endure? What might he have said? Was it the obvious "Oh, no, I've been shot."? Or did he cry out for "Leah" or "Mom, Dad," or say, "I'm sorry," or "God"?

I'd ride to find you
(if love were a big strong horse)
and carry you home.

Ken and I talked about missing Casey last night. He asked if I think of him all the time, or several times hourly. I told him about the passage in Joan Didion's *Year of Magical Thinking,* where she talks about people "knowing" they're going to die: "Neither [Gawain's] doctor nor his friends nor the priests (the latter are absent and forgotten) know as much about it as he. Only the dying man can tell you how much time he has left . . . Grief, when it comes, is nothing we expect it to be" (26).

I am the engine of a train, whizzing past scenery, with my merry toot-toot and my dark exhaust dissipating in my wake. I know many cars follow me, but I can ignore them until I try to climb a large incline or until I have to slow down. It is then that the grief train catches up.

The Women & Kids Learning Together Summer Camp has concluded. Our graduate assistant, Shelly, and I did the story-on-a-necklace beading workshop, where the beads act as symbols in the illustration of each woman's story. I did a necklace for Casey, and later Trish, who is a poet and colleague, sent me this:

Jane, . . . I'm serious when I said that even the way you presented your necklace sounded like poetry. (Of course, it did; you're a poet.) I cannot shake out of my head the "many kinds of tears" one shares in grief. I branded that line into my journal. Other mothers/fathers need to hear those words, in just that way, because most don't have the ability to articulate their feelings—even though they may be in alignment with your emotions. Sharing those words with the voiceless is another way of healing.

Talk about a small world . . . I've been tutoring *the mother* of the young woman over whom this entire trauma began.

From her, I've gotten the "inside story," so to speak, because this mother is trying to help her daughter understand that she had absolutely NOTHING to do with the carnal rage and evil that precipitated and guided this horrific act against Casey. (She constantly asks about you.) Additionally, this woman . . . tells me how *she would feel* if this were her child—the murderous rage it would provoke in her. I remind her that you and Ken eternize peace and tranquility as guiding forces during this difficult time, even though anger and revulsion surface now and again (as is natural and intuitive).

Casey touched me (and many others) because he was not afraid to ask questions of "the soul" . . . I could not refrain from telling you that your necklace was the most provocative of all (and there were some really good ones). . . . Your story epitomizes the result of a culture that solves

violence with violence. How do we teach love and acceptance?

July

I'm listening to a new CD of Dustin Jones, whose two songs make up the music for Casey's Retrospective, which I've placed on YouTube. I have not cried since camp, and as we rush around taking care of the business of this life, I am reminded of what Mom wrote in a letter from 1944, to her brother, Bob:

Funny how all of a sudden a realization will come to one. For some weeks I have been going merrily on my way—with a scant letter a week, smug—not snug—in my own little sphere, feeling pretty much self-complacent. Perhaps it was Dr. Lowe's preface to prayer Thursday night at his review of Shalom Asch's great book, The Apostle. He referred to prayer as tolerant and inclusive. He mentioned the prevalence and predominance of faces and how one face calls up another. In a rather warm moment the next morning, I was contemplating my friends and remarking to myself how lucky I was to have such good ones. My thoughts turned to my family, and I realized of a sudden that they form the backbone of my whole happiness and feeling of well-being. If I didn't know they were always there sometimes in the foreground—as now—and again in the background—as they have been, there would not be much native optimism.

Given my earlier thoughts about yoga and the body storing pain, I am touched by her description of her family as "the backbone of my whole happiness and feeling of well-being." We will head up to Montana on Monday morning for my cousin, Niki's, wedding next weekend, and I am happy for Niki and so sorry that Casey can

never have a ceremony or find his true love and start a life with her. My backbone curves over my heart.

Reading the end of the story onto the beginning

Tears. Is it just the usual cycle of busy-sad-activity-sad? Ken asked if anything had triggered it, but I couldn't think of anything, or was just too low to say it. Is identifying what "caused" it something I do in retrospect, and can I pin it down? Does cause even matter? I am reading my Aunt Lois's love letters (from the 1940s) to her husband where she's admiring her new son's perfection and beauty, and I know it ends badly for them both. (Bobbie and his father, my uncle, had a violent relationship, and Bobbie died, having served in the Viet Nam War and gone on to become a pharmacist, probably by his own hand. My cousin has told me that love was not openly expressed in her family. Did you hug? "Never.")

Leah stayed over last night. Although she went to bed early, she woke up at 10:00, had some juice and watched television and brought Duplo blocks to me for a tower, and then Ken read her a couple of books and she came to bed and slept well. This morning, running around joyfully.

Leah's fingernail:
Skies hold other moons and stars,
but that moon is yours.

Saturday night we went to see (the awful) *Seven Brides for Seven Brothers,* with Diana, Latoya, Nick, and Omni. We were in front of the WS house, and Diana was parking. She was a little too far from the curb, so I suggested she drive up some. Ken thought it was fine, so he said, "You are really micro-managing." When it turned out that Diana had pulled into the yellow, I said, "You might want to move back a couple of feet," and Ken replied, "It was fine the way it was." I shot back with, "Why don't you kiss my ass?" He

wouldn't speak to me, turned his shoulder to me, and when I said I was sorry, he said, "You are."

I wept through the entire performance. Finally, he reached over and took my arm and whispered, "It'll be all right." And at home, he said, "I thought about all the sweet things you did today, and only one lapse." We made up in a very nice way.

Tiny Things

Last night, I dreamed three kittens appeared at our door, two normal and one the size of my pinkie nail. I kept it in a mint tin, and the next day, it was the size of a tree frog. Then it went missing and I worried about stepping on it, so we searched and searched and still couldn't find it. Why would anyone ever entrust me with a precious thing?

I am listening to the *Requiem* while Omni and Ken are at church. This morning, Ken sang the song he wrote for Casey. It is so beautiful—constructed well, lovely melody, heart-breaking words. I cried. Am still. The first stanza is about Ken lifting Casey to his shoulders, up "high above the unforgiving ground," and telling him to "smile." The second is about being proud that Casey is now a father, who lifts Leah to his shoulders, "high above the unforgiving ground," and tells her to smile. And the third, how a father should never have to bury his son, and Casey coming to him and lifting him to his shoulders, "high above the unforgiving ground," and telling him to smile. Ah, my heart.

Ken has started on a low dose of anti-depressant. I am waffling.

We are staying at the beautiful Bethany Springs, at the cottage overlooking the small lake, always alive with birds. On Sunday, I went with Ken to Gethsemani, where his lay Cistercian group meets monthly. We lingered in the places where Casey's picture was taken. In front of the God Alone sign. Reading on the porch. Smiling with one of the Brothers in the balcony. Crouched in

front of the cross on the hill. We saw Thomas Merton's grave, like all the others, a simple white cross. The service itself was lovely— the monks chant-singing the "Terce"—their service moves through all the psalms, and it takes about 16 Sundays, I think. The Abbott spoke slowly, with some humor, in a mesmerizing voice. At the picnic, Brother Frederick joked about the length of his homily—the norm is eight minutes and his was about 14— "it was very good but too long," Frederick said. Apparently, that's a running commentary, about length.

We leave in two days for Lithuania. I'm sitting on the deck watching the birds zoom around. In the big tree by the pond (big pond or little lake), three or four birds are having a disagreement. Someone zooms down into a leafy branch, and then there's a loud clack, like beaks striking, and he zooms away. Now things have quieted down, but I'm afraid.

It's 9 p.m. Vilnius time, 1 p.m. Bowling Green time. Ken and I are here because he's presenting at the Alisdair MacIntyre International Conference, last year in Dublin, this year here in Baltic Europe. It's still light out now but darkening, and the skies bode rain.

I helped Ken record his new song for Casey, "Up on My Shoulders," and we posted it on Facebook. It's such a great song. Both of us have been thinking about Casey non-stop—perhaps because of the song, or because his paper is about whether or not we die alone—or because here we are, gadding about in Europe. I keep seeing his face and hearing his voice, just a gesture, but so touching and beautiful. I had to cry on the plane, and I could tell Ken was seeing him too.

Ken and I spent a lovely morning revising his paper. We got it down from about 21 pages to 16 ½, about right for a 30-minute presentation. It was raining, so it was nice to hole-up in our room. Later, he noted his disappointment with his session. He only got to page eight when he was cued that he had five minutes left. They needed to be clearer about time frames, as we could have left

Heidegger out, so he could have gotten to Edith Stein and the conclusion about Casey.

We have entered a realm within the realm of the world where the losses of all time mingle. I imagine us as embodied emotions— bodies rendered as emotions—the grief and regret, outrage, sorrow, utter missing, and a space now opens where the person used to be. I keep thinking of Casey as a child or a teen, and that memory—how he sounded or how I felt—gets inflected by the fact of his death at a young age and at the hands of a man my age, ignorant, drunk. I am now the mother of two boys named Casey, one who was "just five" or "just twelve," growing up, and one who is "the five-year-old who will be killed" or the "twelve-year-old who will die young."

I want Casey to be today—not yesterday ruined by today.

September—planning for the memorial

We are planning the one-year Evening of Memory & Healing for October 22. Galen is flying up, Ken's parents are coming, Susan's and Kathy's families, as many as can. My cousin, Bette, and brother, Gordon, are coming, even Kathryn and maybe Linda, too. Ken and I are closing in on a program. I'm going to read the *Requiem* poem. I've been working on what to say that won't take too long, and yet just reading the poem with no context doesn't seem right. I don't want to seem precious about it, but some orientation about both the image of the bristlecone pine—and about Brahms' *Requiem*—seems right.

Ken's parents are bringing up Galen's beautiful black hole sculpture. They're kind to even consider it, as it will pretty much take up the whole back of the van. I look forward to hearing him talk about it. Ken will sing his song. Adrian will read from Casey's writing. I've ordered Tibetan prayer flags that people can write on— I need to get those cut, perhaps stitched around the border, and threaded before that night. Candle lighting to Part 7 of the *Requiem.*

Susan wants to say something, too. Ken wants a prayer. It will be lovely, I know.

And it was. I so appreciate that so many came—Casey's friend, DeCarlo, and his brother and mother, friends from here and from far away, Ken's parents and sisters, all our boys. In a bizarre moment that bubbled up unexpectedly, my Berea friends and I were standing in a circle and burst into "The Hokey Pokey." Later I wondered what had come over me.

III—ANOTHER SIX

Yesterday, they pleaded guilty to federal gun charges, and the federal prosecutors recommended the minimum sentences. Mary, his wife, was weeping. We learned that he has a third-grade education. He can read some but not write much. He understands what the judge is saying to him, why he is there. She has a GED. Patrick was there, his hair cut close, ears pierced, looking about like any other 18-year-old. How can someone have only a third-grade education? Flunk fourth grade, fifth grade, slip through, ignored? Whatever the answer, it isn't good.

I'm writing poems in long hand. I see places to add a line, a word. Maybe they don't belong, but the slowing down helps me hear what the poem is trying to say. I've sent some to Galen and Ken. I'd like to send more out, but I don't want anyone to think I expect anything in return, or to seem pretentious. Maybe I'm kidding myself; maybe I want attention.

Yesterday, Ken went to one of the pre-trial planning meetings and learned that while Burns' attorney Brad Kaufman wanted an extension, Burns did not. Either he's tired of waiting or thinks he can get a better deal with a jury. In any case, Chris Cohron

is "cautiously optimistic" that we'll see a trial February 22-25. The morning of the 22nd would be given to jury selection and the afternoon for his opening comments. He told Ken when they met privately that he expects that they'll try to get manslaughter 1 or 2 (the one that allows for the person to get angry but not to have intended any harm) and that Chris will hammer away at how there had to have been intent, given the evidence. Ken watched Burns' older son (not Patrick) request that the judge allow his sentences to be served concurrently—he's got 15 years for manufacturing meth.

The other hard news was that the medical examiner is going to be out of the state until the 28th of February, so there will be a deposition on the 9th—the day before Casey's birthday—in which the autopsy will be discussed. Chris recommended that we not be there. Ken and I have not missed anything and had been planning to attend, but that was before it sank in that there would be footage—photographs or video. Ken said he wanted to be there to study Burns' reaction. Ken says being there is a way of defending him. And that seems right.

I'm tired. Didn't sleep well last night. Bad dreams, creepy creatures. Some dead man in a cave with something like shrapnel embedded in his skin. He kept plucking the pieces out, and with every piece, color returned to his features, until by the end he had a pinkish hue. But it was scary. I was lost, didn't know why I was there in the cave. Or what those strange creatures with humanoid features were, bloated things that were not harmless.

They helped me with a line in the "Someone Else's Offspring" poem. The image was my fingers trying to pry open the wire covering the gable grille so the trapped starling could get out. But from the bird's perspective, they would have been scary, white things at the edge of darkness, so the line is "Like creatures that have crossed the line into abomination / they quiver at the edge of the starling's night." If I showed the magnitude of hurt, people would be overwhelmed, uncomfortable. I tell myself to stifle it and only let it out when I'm alone or with Ken.

Yesterday in talking with Adrian, I started to say something about trust. But he raised his voice a notch and said, "And I don't want to hear any of your mouth." I told him that I wouldn't talk to him if what I said was "mouth" to him.

But the rest of the evening, I kept thinking about how disrespectful—to me and to Ken over the years—the boys have been. Being yelled at by Casey, spat at, pushed. I know the other side—their regret, that they did and do love me—but the memories hurt. All those years, they struggled with self-loathing and self-doubt, putting up tough-guy facades to prove that they were not, in fact, vulnerable. Why could we never change that, despite all the therapists, interventions, hospitals, jail visits, special classes, and family group sessions? When other kids act stupid, I say, "It's not the parents' fault," except when the parents are obvious assholes. Maybe there was in us—or in me—something broken in the way I loved, maybe I put myself first.

February—threads are delicate

This morning all is quiet. Ken and Tsering have gone on to Hopkinsville, and I am playing the Gregorian chants album—beautiful.

Fifteen months later—how death stops cold the conversation between you and the one you love. You are left hanging your memories on the thread of love that reaches to him in the past and stretches into the future. It is a thread not because it is delicate but because it can go anywhere, winding, twisting, stitching, tightening, blowing in the wind. Tears cling to it. Will it reach him? Is there anything for the spirit to do but go into the unseen unknowable, merging into the great field beyond this one? Can he pierce it to see us missing him? Or is it all just gone, our memories vaporous and the thread an illusion, a longing only?

"Ghazal, by a Thread" is about these questions. I like its repetition of the word "life": "In utter stillness sometimes, I hear a

whispering, things not living, spirits / piercing the plane that separates us—though not you, silent from life . . . / So new to their world—are you seeking a way through, some breach? / I search the globe of every odd-shaped thing—scrap of life—"

Wells of sadness rise in me, which "I" then descend. I started crying at dinner the other night when everyone was talking about the Buddhist beliefs about death and ghosts. It just went on and on. The image of Casey as a ghost wandering somewhere took me down. I don't know—is some spirit form still out there? Is he looking, searching for a breach and a way to touch us?

It's snowing quarters, lightly falling through the branches outside my window, and on some of the bare limbs, drops of rain still hang, caught on the edges, not heavy enough to fall.

Spring

On Thursday, we (mostly I) defended the Social Responsibility & Sustainable Communities Master's before Graduate Council. Although they ended up approving it with no dissenting vote, there were a few nerve-wracking moments—why didn't we have a stats class and what is interdisciplinary studies "about," where's the *content*? My dander rising, I responded that the program is more (I corrected myself and said <u>as</u>) rigorous as traditional disciplines since students must be familiar with several disciplinary conversations and language; the way the program works is to make connections; that serious problems in today's world need perspectives. I'm not criticizing traditional disciplinary training, but surely the university has room for both.

I had a conversation with the lovely Laura R. afterwards, and she said, "I didn't realize it was Casey's birthday." I said, well, yes, and repeated my Facebook post about how we wondered if Casey would be born on my birthday, but he waited four more days "in that warm, safe place." She said something about my having "birthed another child," with the new master's degree. I said there'd been a

few miscarriages along the way, and we laughed. Another colleague, Tim E., caught up with me and said, "Thanks for the great defense of interdisciplinary studies. I almost clapped but thought that would be inappropriate."

Then last night, I couldn't sleep, despite a sleeping aid, recycling things people had said and thinking about Casey. I finally got up at 4:30 a.m. and finished *Galileo's Daughter,* a wonderful biography tracing the great man's life and challenges and integrating the daughter's letters (none of his to her survive). Then I went to bed, and this is the dream I had:

I am in a decrepit home, something like the Rockfield property. I've come for some reason, no idea why, but I see that a baby is being mistreated by the older kids in the house. One boy is kicking the baby, who is malformed. I pick him up and hold him away from the danger. His head is huge, larger than his body. I am distraught and don't know how to help him, other than to spin this way and that to protect him from the kicks and hits.

How do I interpret this? The child is my brainchild, who is being misunderstood by the disciplinarians. The location of the tragedy is obviously related to Casey, my real child, but the two have come together in the dream: my human child and my "brainchild." The fact that his head is so big in proportion to his body tells me that our new master's is "smart" and "worthy" despite the disparagement of people who recognize only the "disciplines" and everything else as "empty." I am protecting the brainchild, so much smarter than the kicking siblings recognize.

March—chugging along

It's a beautiful spring, and for the most part, I'm chugging along, if not merrily at least not in tears, though he is on my mind. Working on the poems brings the pain to the fore. Keeping busy at work and around the house, going to the gym, reading books for the fall course, AND getting psyched for the NEH Faculty Seminar in

Flagstaff! Yes, I got accepted. Ken's paper on Edith Stein got accepted for a conference on her in Ireland.

The oak tree outside my window is full of soft leaves again, with their dangling golden fronds—in today's rainy gray, looking brown.

Adrian called. He remembered a dream he'd had of Casey. They were walking and talking. He woke up crying. He cried again a little this morning, remembering it.

Ken and I had a deep cry on Wednesday last week. I had been thinking about how hard Casey was on me (us) sometimes and feeling guilty that sometimes the thought will form "at least I don't have to deal with his bullying. My house is quiet and peaceful. I'm not worrying over whether or not he's sneaking out of the house or needs another ride to an NA meeting or having trouble finding a job." And then the guilt, knowing I'd take any of it if he could be here again.

Ken said he wakes up thinking about Casey every morning and says a little prayer, "Thank you for the blessing of his life. Hold him in your sacred love." He said that the love he feels for Casey is a fire and any act of love is a stick to place on that fire.

I found this very beautiful. Why the recent onslaught of memories about how hard it was when he was so awful? The curses, the pushes, the stony silences, the times I went downstairs and cried and cried because I couldn't be upstairs with him and had no place else to go.

Ken said it's been important to us to romanticize Casey a little—which is not to say that the main story, memory, truth, realization about him isn't still true . . . and that includes how he was, by force of will and belief and longing, changing himself. The worst of the hard years was over, and he was moving toward healing, deepening his spirituality and his relationship with us. That shift in the arc is what would have determined the coming years. He was going to climb out of the hell of his teen years. He was going to be a wonderful father, son, person.

May

Leah has started saying, "I want my daddy." I'm not sure if she's picked it up from other kids, but she is getting to an age now where she knows something is not right.

I may have been in a much longer depression than I realized. How many years of struggle with the boys growing up, trying to keep them out of trouble? Fourteen since we moved to Kentucky. And then in Minnesota, all that strife and anxiety over what we couldn't see going on. I grieve so looking back at my beautiful family's difficult road. I wish we had had an easier time of it—the boys, Ken, and me. But wishing isn't going to change things. It was damn hard all those years. For Adrian and Casey, hospitalizations, institutions, visiting every weekend, one or the other. The third slogging on and just hanging on to the tip of a lashing tail.

Now when the girls are here and start whining and picking at each other, I just want them to be gone. I want quiet and peace, no discord; I can't bear it.

Today is the day after our 24th anniversary and we are in a cottage on a marshy pond, Bethany Spring, near Gethsemani. Yesterday, about 12 geese were paddling about, and this morning, there are two. A heron came to our end of the pond. A family or several families of red wing blackbirds live nearby. Last night, we lingered after dinner and listened to the birds. Ken knew which were the blackbirds and another four-note song we couldn't identify. This morning, a cardinal has been fluttering at the loft window. The blue of early morning has covered over, so we may get the promised rain after all.

3 p.m.: This morning we went for a walk through the monastery's pastures and woods—a wildflower lover's delight. Lush and beautiful. It's cool—I guess in the 50s, but that made walking nice, and the gray clouds made everything look full and vibrant. When we got back to our cottage, we were sitting and watching the pond when two white egrets lighted and began wading

in the shallow end, pausing, their necks stretched out or curved into an S, before darting at something in the water and coming up gobbling. And suddenly, two pairs of pure white pigeons flew in. They passed back and forth several times. We thought they were leaving, flying toward the tree line to our right, but then they circled back around, swooping and diving, never landing, always side by side. It was something, those four white birds, in pairs, against the dark green of the pond and the pale green of the grasses at the edges.

It touched me so. Later I put them into a poem:

Memory wavers like a shadow, as two
snowy egrets land near the far shore
and begin their long-necked
wading, so intent on subtle movement
they are not startled by the blaze of two
white pigeons that fly out of blue clarity
and stop my breathing, if not my heart—three times
circling the pond in breathless nips and tucks,
stitching up the terrible rending
that has pulled our lives apart.

A light rain is speckling the pond this morning. Ken got up early and went to mass at Gethsemani. I made coffee, then showered, and we've just had breakfast. Ken mentioned that we should make a journal entry about what we're doing on the occasion of our 24th, since we can't remember what we did last year, let alone previous years.

12:30 p.m.: Ken is up in the loft working on his Edith Stein paper, and I've been re-reading—just finished—Silko's *Ceremony*. Have now put Brahms on. Outside, the light rain rains on, cool, the distant knob that we can see through a break in the trees misty and gray.

Jumble of thoughts. About Silko's account of healing for Tayo, about being part of the story that includes the land and the

ancestors, that resists the destroyers, the witchery that is designed to kill the world. There's a passage in Part I of the *Requiem* that reads, "They that sow in tears shall reap in joy. He that goeth forth and weepeth, bearing precious seed, shall doubtless come again with rejoicing, bringing his sheaves with him." Did Casey and do we go forth weeping, and what is the precious seed? What do we plant from what has been taken?

Something in all this has to do with the cleaning out of my system, not just of what I've put into it, but what is doing "the putting." Thinking about addictions, how a part of me wanted to see how low I could go, to see if "a little more" gets me "there."

We were watching a documentary called *My Perfect Teacher* about the Tibetan who filmed *The Cup,* Khyentse Rinpoche, and the acolytes who were following him around and creating the documentary in the process. We didn't watch much of it because it was boring and self-indulgent. But one comment of the round-faced white guy who was Rinpoche's annoying assistant, did ring true— that "you go to the refrigerator not because you're hungry and want food, but because you're looking for love" (Patten). Food as metaphor.

And now that loneliness has become my constant companion, I have fed the metaphor, nights and mornings feeling rotten, waking up hating my self-indulgence, and beginning the process again of pushing it back and back, so that by 4 p.m., I practically race into the house for a special-made cocktail—the size of two or three. Bury myself in solitaire. Tumble into bed by 9:00.

But no more recriminations for now. The new food is good! Hurray for beans! Crispy sugar snap peas, hurray! Fruit, fruit, fruit, and collards!

It's Sunday morning. Ken and Adrian have gone to pick up Omni for the last Sunday School of the season and church, and then this afternoon, she's got her second and final ballet recital. Her group is representing the U.S. and dancing to "I'm a Yankee Doodle Dandy." She is so precious up there, tallest girl, her sweet puffball

up on her head and her long arms waving, fingers waving. She loves to salute and is the only dancer who sings along.

Casey should be here—to see his niece and to hold his daughter, to see Leah wave at Omni up on stage, to hear her say, "I'm going to get my costume," and watch her nod when I ask her if she would like to take ballet too. I can see him smiling and proud.

I don't know how to reconcile that with the gratitude I'm supposed to feel—and do feel—for having had Casey for as long as we did. But it's not enough! It's not what he was promised when he rolled out of my womb. There are no promises. But there are promises! And gifts! And trust and hope. Every blade of grass, every new tree, new child, every puff of wind, says "hope, love, trust."

Yesterday in the pool, Leah was whimpering that she wanted him; when we were sitting on the sofa, she looked up at the drawing Galen did of him and said, "That's my daddy."

Summer

NEH Faculty Institute, Week 1:

Julianne Lutz Warren is our first facilitator. On Tuesday night, she gave a public talk called "Music Beyond the Senses." It was a fine, fine talk about hope and the environment, with bird songs at intervals—the hermit thrush, starling, albatross, and then after she finished her talk, a chorus of the three, along with other birds, endangered and some extinct. My mother, who loved the out of doors almost as much as she loved music, was a devotee of birdsong. Her favorite may have been the thrush—almost from the start of Julianne's talk, I felt my mother coming closer, and finally she seemed to sit down and to listen with me.

I thought I would tell Julianne this in a matter-of-fact way, as in, "Thanks, your talk let my mother in, and she thanks you, too." But I was overcome with tears. Instead, I said something about how we daughters become our mothers. It's sometimes a shock when we, who thought ourselves such distinct beings, react in ways that tell us

how much a person's voice, her gestures—the way she positively lit up when a thrush's song interrupted a mundane moment and made it magnificent—are now internalized, through memory, and have altered who we are.

I didn't know when I sat down in front of that Audubon painting what invocations were about to happen, what spirits might be within earshot—whether my mother was biding her time, seeking her entry—or whether I was the one longing—or whether the "Music Beyond the Senses" was pulling all of us to a place where something extraordinary might happen.

I love her phrase, "If rain is the Earth's tears, then the Earth is inconsolable." It reminds me of what Terry Tempest Williams writes in *Refuge:* "If the desert is holy, it is because it is a forgotten place that allows us to remember the sacred. Perhaps that is why every pilgrimage to the desert is a pilgrimage to the self. There is no place to hide, and so we are found. In the severity of a salt desert, I am brought down to my knees by its beauty" (148).

I worry that my "Writing the River" essay—meditations and poems about the river as metaphor—is too much about myself, and therefore, inaccessible to others. Our circulatory systems are the blood rivers of our bodies. The veins in my hands rise to the surface—blue rivers crossing the bones that lead to my fingers. They weave visibly up my arms and then dive beneath the surface, always carrying air and blood to my heart, my lungs, my brain. An adult has up to 100,000 miles of blood vessels, a network of rivers down which our ten pints of blood travel many times a day. The 25 longest rivers in the world stretch approximately 67,000 miles.

Our bodies know other rivers—or canals, in the case of our birth, down which our delta follows us as after-birth. Birth attendants check to see that all the tributaries end before reaching the edge; they look for two arteries and one vein. We are reborn in rivers.

In one of my favorite passages of David Orr, he writes, "We have good reason to believe that human intelligence could not have

evolved on the moon—a landscape devoid of biological diversity. We also have good reason to believe that the sense of awe toward the creation had a great deal to do with the origin of language and why early humans wanted to talk, sing, and write poetry in the first place" (249).

It makes sense, then, that rivers and other life forms have entered our consciousness and shape our imaginations, even making wonder possible.

Thinking about breathing brings him to me.

Today in the afternoon session, a sociology professor guided us in some "insight meditation," which involved closing our eyes, focusing on our breathing. If our minds wandered, we could try counting our breaths, in—out. I knew I was in a vulnerable place after the morning session, which led to discussions about ethics, natural laws and procedural natural law, and the naturalistic fallacy (you can't start from an "is" statement and draw from that an "ought" statement). And thinking about the wall of dust—the haboob—that engulfed Phoenix two days ago, I was already feeling depressed. Apparently, the wall of brown dust is a regular event, moving from sky to ground toward the city, engulfing it, and then moving on or dissipating.

I was counting my breaths and Casey came sharply to me, the moment during which the bullet pierced his lungs, and there I sat, paying attention to my breaths, that most basic of acts.

In a section in her PowerPoint, "Awareness and the Mood of the Land," she talked about how "awareness begins in the body" (Schipper). We went through an exercise of looking at a series of different images/pictures of the same mountain and writing what we felt. I had trouble getting past what the mountain looked like, what it suggested/evoked, to what I felt in my body. I didn't feel anything. It was all intellectual: grand – muted – history (cold, distant) – lonely.

So, when she asked us to count our breaths and focus on our bodies, I was overwhelmed with the impossibility of acknowledging my own breath. My mind does not accept my body's breath as mine—as soon as I think about breath as mine my mind rushes in to say, "No, no," to flood me with pain, so I had to stop counting, get up, and leave the room.

I sobbed in the bathroom, and then I went outside, stood in the building's shelter, and watched the trees in the wind. I thought about cloudy skies without and within and let the cool breeze touch my face. I was in a state of emptiness. Why can't I make it through any life- or self-affirming ritual or practice—like yoga when the teacher starts talking about loving the self, or meditation, or talking about *Eat, Pray, Love* in our spirit group—without breaking down?

After much internal debate, I decided to present parts of my "Writing the River" essay, which included three poems, reflections on metaphor and memory, and what happened with Casey. I worried it was too personal, self-indulgent, or that my attempt to link my (our) loss with environmental loss was too far a stretch. But the response was overwhelming. People lined up to hug me after.

Dave was teary eyed and just said, "Thank you. We've been a bunch of egg heads, and this was what we needed." A lot of people said thank you, and Joan (one of our two organizers) said, "It was so beautiful, I was speechless." So, it really did feel good to have what I was trying to do validated that way. I enjoyed the brief debate about whether to integrate more theory or not (the "not" won). And today, the day after, Tony said again what he'd said yesterday, that "Simon Ortiz would have loved what you did with narrative." So, here I am, buttressed by what others say, validated in loss.

IV—RIDING IN DIFFERENT SPACESHIPS

Berea Years, 1986-1991

Birth to Preschool

Casey was born on February 10, 1989, at 11:59 p.m., in the Birthing Center at Mary Breckinridge Hospital in Hyden, Kentucky. Wendy Wagers, the midwife, delivered Casey at the end of thirty-six hours of labor. My first two boys had been born at home in Louisville in 1982 and 1984, with midwife Linda Cozzolino, and we wanted Casey's birth to have the same homey feel, rather than the institutionalized ambience of a hospital. However, by that time, the politics of midwifery had changed, and the nearest midwife worked out of the hospital in Hyden, a center named after the famous Appalachian midwife, Mary Breckinridge, about eighty-five miles from where we lived in Berea. There, I taught at the college while Ken taught up the road in Richmond at Eastern Kentucky University. In Berea, we were part of a close-knit circle of friends, and several of them joined us for Casey's birth. Ken and I headed down right away.

None of us was prepared for the long labor. My first son, Galen, also took thirty-six hours, his skin like peaches and cream when he finally arrived, but the second son, Adrian, just sixteen months later, arrived in only six hours, ruddy from the rapid descent, so I was sure Casey would come fast as well (having a head in the 95th percentile probably explains a great deal). We theorized that my body had had time to forget, since this was almost six years later.

He was a beautiful baby, and we took turns holding him and gazing at him, Galen and Adrian in the hero capes I'd made for them. Casey slept between Ken and me for several months. He was such a sweet, warm bundle between us, and I could sleep while he nursed.

We lived at the corner of Walnut and Boone Streets near a creek, where the boys would hunt for crawdads. A newspaper photographer snapped Galen lifting the corner of a slab of slate as both boys peered underneath, and they were excited to see themselves the next day in the paper. My mom came and watched Casey several days a week while Ken and I worked. This was the beginning of a strong bond between them that would last until she died in 2001.

Adrian began seeing a therapist while we were in Berea, primarily due to hyperactive behavior at the preschool he attended. Unable to nap like the rest of the children, he required one of the assistants to sit beside him and rub his back, but still he craned his head trying to see what was going on and rolled back and forth until naptime was over. Later, he went through a period of biting, and when the children would sit in a large circle for story or sharing, he made noises until someone came and led him away. Other than these early relatively minor challenges, we appeared like any other normal, happy family.

That summer, the five of us drove to Canada, where we rented a small house on a lake north of Toronto, and later Casey and Mom accompanied me to a conference on leadership in Wisconsin. Soon after I learned I was hypothyroid, which would explain my weight gain, puffiness, and stumbling gait. In Canada, the two older

boys played in the yard, and then in the evening, danced to the Beatles while Casey lay on his back batting at a mobile made of carved pegs of wood that his dad had made for him (and which later Casey's daughter would play with). He was only about four months old, so we sat him in his portable recliner-shaped car seat so he could watch his family singing, dancing, and making dinner. He liked for us to rub an index finger up and down against his lips as he made blub-blub noises. One day we snuggled him into the middle of a rope hammock so he could sleep close by while we went about our play. Ken looked over to check on him; he'd fallen through the ropes and was still asleep on the ground. He remained a sound sleeper his whole life.

During the days, we fished or explored a nearby island. We had gotten some gold coins from the bank, and Ken hid these and then drew an ancient treasure map (he even burned the edges) and placed it where the boys were sure to find it. They remember the adventure of it—following that map and finding that hidden treasure—to this day. We learned, too, that Adrian was a fisherman at heart. We had gotten our first video camera—a big, shoulder-held thing—and we have him on tape peacefully casting and waiting for the fish to bite.

At one point, he turned to the camera, and in a perfect Kentucky accent said, "Whatcha doin', taking a video or somep'n?" In the evening, Ken tied a black garbage bag into knots, strung it from a rope over a bucket of water and then lit it while we watched the flaming bits of plastic "zing" as they fell with an explosion into the water.

Ken's favorite time with Casey was walking him in a stroller around Berea; Casey showed his excitement at things like Christmas lights by vigorously waving his hand. The gutters of our two-story house on Boone Street often filled during a rain, creating a powerful cascade at the corners of our back porch. Vibrating with delight, Casey raced from one edge of the porch to the other, grinning and gasping as the cold water splashed off his head. One of our prized

photos captures that moment. Because our house was at the bottom of a steep hill, a torrential river flowed down the street gutter on the far side of the street. The two older boys sat sandwiched in each other's legs as the water shot over their shoulders.

Minnesota Years, 1991-1997

Preschool through Second Grade

In 1991, after I'd been offered a graduate assistantship in the English Department at the University of Minnesota, we moved to Champlin, a suburb about a half hour north of "the U." Mom moved with us, which made it possible for us to buy a four-bedroom house with a nice-sized privacy-fenced back yard. Fairly soon after we found a preschool sitter, Deb Soden, so Mom wouldn't have to watch Casey all the time. Deb had a gift for entertaining children. At first, Ken struggled to find meaningful work and even mucked stalls and then drove a school bus, joking that he was still working "in education," before he found adjunct teaching work in the city and eventually a full-time temporary position at St. Olaf College, about an hour south. One scary day, Casey wandered off, wearing only his diaper, which came off somewhere along the way. A neighbor saw him and called a police officer, who noticed us looking for him. When he was four years old, Casey attended preschool. He did not understand how to smile for the school pictures, but he spread his lips in a facsimile of his usual smile. The next year shows him with a beaming, closed grin, eyebrows raised, still getting the hang of posing.

During the Minnesota years, all the boys wore footie pajamas. In the evenings, we'd sit in the lower level of our split-level house and watch *The Simpsons, Home Improvement,* or *The Cosby Show*. Every night, Casey crawled into my lap where he fell asleep, and then Ken picked him up and carried him to his bed, the sweaty impression of his body still on my chest. For a couple of

years, Casey slept on a small mattress at the foot of ours, within easy reach either way. Adrian had a bedroom to himself upstairs next to my mom's room, and Galen had a bed in the corner of the huge family room, and later, for the sake of privacy, in an area in the downstairs utility room. This sounds odd, but it was a large room, with the furnace and hot water heater at one end—his nook was at the other end, like a secret hideaway.

It is difficult to characterize our five years there. Six people lived through the same thing very differently. All of us tried to do the right thing, please others, and nurture our relationships, while at the same time protecting our sense of self, whether that self was at the early stages of crystalizing or evolving from what had been a stable core to a highly uncertain one. My mother and Casey are gone, and although everyone has agreed to let me share their story fully, I move forward with trepidation.

Every school year, our second son had trouble behaving— and in fifth grade he was referred to a psychiatrist who recommended a brief stay in the hospital for evaluation. Unable to sleep the night, she requested this. I'd sit bolt upright and say, "This can't be happening," and then lie back down only to spring up a moment later to say, "She must be crazy." Eventually I settled down to what would be a new reality: psychiatric and behavioral programs and institutions. We visited our son one day and stood in the doorway as he paced the perimeter of his small room. When the bed blocked his path, he climbed over it, never slowing down, pacing the circumference of that room as if he was trying to unwind something.

Because he felt different—certainly he was beginning to be treated that way, by his teachers, by administrators, probably by us—he was jealous of what he perceived to be his older brother's normalcy. Torn apart by what was happening to him, he launched what seemed like a campaign of mockery against Galen, teasing him for his name, capitalizing on the homophobia of school culture. His nicknames for his brother became "Gaywad" and "Gaylord." When

boys came over to play Magic the Gathering, the insult of choice was, "You're gay" or "That was gay." Every time I heard this, I emerged from the other room and told them that gay bashing was not permitted in this house. They could call each other asshole or stupid but not gay. It was endemic in "Minnesota Nice," this use of "gay" among boys to control and intimidate.

The impact on Galen was devastating—we'd learn later that he was also bullied at school. I remember him burrowing into a cave of covers and looking up at me with despair in his eyes. He had a yellow blanket throughout his early childhood and a big yellow cat named Twiggy. He had developed the habit of folding his bottom lip into his mouth and sucking on it. I continually reached over and gave a light tug at his chin; he'd release it, stroke his blanket, and the next time I'd look, the lip would be back in its warm, dark home. That blanket and Twiggy anchored him, but nonetheless, in 1995 when he was twelve, he changed his name (informally) to Chris and began taking Prozac. We put him in a Catholic school in Anoka, the only alternative to Jackson Middle School and a brief car ride across the Mississippi, but though he tried his best, it wasn't to be. I received a call from the principal while I was at work at the U, and she told me that Galen could not stay. The reason was vaguely about "fit" and because I had left off the application form that he was taking an anti-depressant. They were angry about that omission and remained unconvinced that it was unintentional. I hung up and burst into big, ugly sobs as my two coworkers rushed over to pat me on the back, squeeze my shoulders, offer me a box of tissues. What was going to happen to my oldest son now?

Minnesota Nice was anything but. I learned many years later that the policy for the K-12 school system was "neutrality" about matters of sexuality. Long after we'd gone, within a two-year period, eight students committed suicide in the Anoka-Hennepin School system. I am certain that the roots of that record reached right back to Oxbow Elementary, 1991-1996. When he returned to Jackson Middle School, it was as "Galen" again, and he began

repressing his hurt, developed a temper. As a young adult, he wrote about the bullying he endured at the hands of one boy in particular at school and about the teasing he endured about his name and face:

I was an awkward young boy, and my bullying started early: third grade. It is easy for me to remember many things when I was bullied, because acts like name calling and taunting or worse stick with a person for their entire lives. I remember third grade because it was the beginning of shame put on me about my name. It has, of course, "gay" in the first syllable. At this age, children were beginning to understand a pecking order, and I was at the bottom. Other kids in school would make fun of me for things I couldn't help, such as my name, what I looked like, and what I wore. From third grade until 11th grade, I felt constantly at odds with bigger, more powerful boys who would make the easy choice to put someone else down instead of sticking up for those who are less fortunate.

I can recall one bully who was especially bad. Once while I was in the lunch cafeteria minding my own business, this boy who was older and stronger than me decided to come over to my table after glaring at me for most of the lunch period. He snuck up behind me while I was sitting and slammed my head into the table. I was in shock, upset and scared. This bully sat down next to me and ogled with his friends. All the boys were older and stronger than me, and they outnumbered me five to one. When I asked him why he attacked me, he said, "You're ugly as a monkey," as his friends laughed. When I started to cry, they just laughed harder. He even spat in my face. He would push me in the halls, and he only got more violent if I tried to fight back. Acts like those I have just described have stuck with me for my entire life. I deal with self-esteem issues every day, and although I have learned

to accept myself by and large, there are times when I still hate my face and my name—the name my mother gave me out of love.

I don't forgive the public school system, though I liked most of the boys' teachers. The vice-principal tried to be reassuring: "I tell the kids if they can hang on until high school, it will get better." What kind of system have we surrendered to that our best solution to misery is to endure for just a couple of years for a "better" future that may or not actually come (ask the parents of those eight kids who killed themselves)?

The individual ordeals the older boys endured had an impact on Casey. Thanks to the protective workings of memory, I have mossed over a lot of what our home life entailed. I know we had many happy and tender moments, but there had to have been fights—arguments, tantrums, pleadings—during the five years we were in Minnesota as we tried to address seemingly inexplicable behaviors and the horrific effects of depression and bullying. There were weekly therapy sessions, frequent calls from the school. Meanwhile, the adults were trying not to hurt each other's feelings. I saw a therapist for a few months, and she helped me gain perspective. I was feeling inadequate to the demands of my doctoral program, brought to a head when I took a course about poetry, and one of the students was so superior and disapproving of anything I said (and probably others) that when the therapist asked what help I wanted from her, I said, "I want you to help me accept the fact that I'm a mediocre person." She asked me to go home and draw a pie, slicing it into as many "pieces" that would encompass all of who I am: mother, daughter, wife, teacher, student, writer, dreamer, and so on. It was exactly what I needed to help me see that I was not, in fact, being devoured by life, despite a recurring dream of a hunk of meat on a counter next to a bloody butcher knife, blood dripping onto the floor.

We had good times, for sure. We traveled to the Boundary Waters for short stays up in the northern reaches of Minnesota, spitting distance from Canada (where we had once threatened to move when Reagan got elected). On the drive back home, we bought smoked salmon, saying, "This will be good to eat this coming week." Then bit by bit, we devoured it all, the boys in the back saying, "Can I have a little more?" and Ken and I looking at each other with a little shrug. Every Christmas, we made our way to Florida to stay at Ken's parents' home in Gainesville, trekking over to St. Augustine with Ken's sisters and their families. For a while, all the cousins made a perfect staircase by age, but then the boys shot up, each of them 6'1" at least. Casey got tired of being the youngest, and later, when his niece, Omni, was born, he exclaimed, "I'm not the youngest anymore!" That might partly explain why he was always such a kid magnet. These were nice, family times but not without incident. I remember one time, maybe even before Casey was born, when we were seated at Ken's grandparents' dining room table, and Adrian could not sit still, kicking the child sitting across from him, no matter how many times we whispered, "Stop," or put a restraining hand on his thigh. Finally, I grabbed his arm and walked him across the street, where I spanked him with a flimsy slipper, and then I felt so bad I just held and rocked him as we cried together. He looked up with those earnest blue eyes through a tangle of brown hair, "I'm sorry, I'm sorry."

Minnesota Interim, 1996-1997

In 1996, Ken and I, both "Drs" now, went on the market, eager to embrace the careers we'd worked so hard to prepare for. Ken got a year's full-time appointment at St. Olaf College in Northfield, Minnesota, and I got my dream job at Western Kentucky University in Bowling Green—a joint appointment in English and women's studies. Mom moved back to Louisville, and Galen, Adrian, and I moved to Bowling Green, where Adrian and Galen

started at Henry Moss Middle School. Ken and Casey moved to Northfield, where Casey started second grade with Mrs. Peterson. It was a difficult decision to split the family in this way, but the job at St. Olaf seemed too good to pass up. Casey missed me a lot. Ken wrote at one point, "He was inconsolable," so I drove up with the boys for a visit. We drove straight through, a sixteen-hour trip. Casey and I snuggled, and he followed me around like a lonely little pup.

Casey was baptized in the Russian Orthodox Church and *Skete of the Resurrection of Christ* in Fridley. He had gone to church with Ken on Sundays for about a year and liked Fr. John and Fr. Juvenal. He took his baptism very seriously—we have a picture of him in a tie looking proud. As time went on, he also took fasting very seriously. His Aunt Susan remembers sitting down to dinner with him once and his telling her when she passed him a dish, "I am trying to stay away from meat and dairy," which the orthodox church advises during Lent.

Our written record of the 1996-1997 academic year consists primarily of emails, which refer often to finances—credit card bills, car troubles—as well as to work-related challenges. We also shared our joys and woes with being "single" parents. These two emails from fall 1996 suggest some of the routine struggles Ken had with Casey:

> 10/30: Casey has been fussy. Thankfully, he alternates the fits with periods of cooperation. I think he needs more neighborhood friends. We have come to a kind of standstill. After finding several early on, I need to be a little more aggressive in meeting some neighborhood kids. He is very creative on his own and is doing some neat things.

> 11/18: Casey hated *Christmas Carol*. He raged about going to church, then had a good time once we were there. We went to the party at John's. Casey didn't hit it off

swimmingly with John's son, Carlin, and after about two hours, he started asking me every five minutes when it was time to go home . . . I'm surprised that Casey said he wanted to stay in Northfield. I never know how much weight to give some of his statements. During a recent rage, he let me know in quite clear terms that he hated me, that you were nice.

Casey has made some real breakthroughs in reading. He's moved to the next level and what he calls "chapter books." He read a few chapters in *Lion Witch and the Wardrobe* (some of the words are a little too hard for him). But he's had a smashing success with *The Boxcar Children*. He's read 50 pages on his own and really is excited about reading. He reads in the car and at home.

The excitement of Northfield is starting to wear off, and we are setting in on the hard task of making it through the winter. The car has frozen shut several times. Still, it hasn't failed to start and is reliable. Building a fire has been nice.

We have a card he made for his dad: "I [heart] Ken" and another construction paper fish that says, "I love you Dad." Another art project shows a folded page. On the cover, there's a drawing of four people waving. A teacher has written, "What will satisfy you?" Inside is a drawing of two adults and three kids, along with his handwriting: "I am more satisfied to be with my whole family."

That spring, I had a shock when I discovered Adrian had been cutting himself. Reading Caroline Kettlewell's *Skin Game* helped educate me, but at the time I felt overwhelmed with what I didn't understand, that cutting can serve as a kind of safety valve, a distraction from overwhelming emotional pain.

4/18: Last night Adrian carved "A+J" in his forearm, definitely broke the surface but not deep cuts, no dripping

blood. Just red and angry looking, with the skin welted up. He says he did it with a paper clip and knife because he was bored. I talked to him, but my first reaction was to say, loudly and freaked-outedly, "What have you done to yourself?" His reaction to my "yelling at him" was to duck his head as though dodging a blow and then to immediately start calling names and muttering angrily. He went up to his room and locked the door. Later, I went up and apologized for yelling and put some antibiotic on his arm. I asked him why, when he wasn't really deeply in love with her, and he couldn't really say, just bored. Doesn't care if it hurts, said it didn't hurt. He asked if I had called the therapist, so he knows it's not right, though he tried to say, "Lots of kids do it."

"Are you going to send me to the psychiatric ward?" I said I didn't want to but that it was very upsetting to see him hurt himself. He's staying after school this afternoon for a dance. But I am not inclined to want to leave him here while I go to Berea, though he says he doesn't want to go.

They were nearing the end of their time in Northfield when Ken wrote:

I'm having problems with Casey. He is refusing to obey and is setting himself up in the "You're not the boss, I don't have to do what you say" mode. It's mostly little things, but it is such an irritant. I asked him to put up his drawings, get ready for bed, go to school. All with little to no response. He was so slow at getting ready today that I refused to take him even though he was already late. He had to ride his bike, and I think with him getting there late he will have to get a tardy slip—I think maybe if he has a taste of the consequences of his choices he may shape up— but I'm not exactly hopeful.

He is constantly comparing me to you. He keeps saying how mean I am and how nice you are. In light of all that I do for him, I really find it hard to take. I threatened a strike, and I may go through with it. I'm not letting him play with friends today. He has been so helpful and co-operative up until now. But he's tired of school and anything else he doesn't want to do.

Elementary Years, 1997-2000

It was a beautiful summer day when Ken and Casey arrived. We danced with excitement. Ken stopped the U-Haul truck at the corner and let Casey stand on the passenger side running board as they finished the journey. Casey grinned ear-to-ear and waved his hand like a flag.

Our home came with a swimming pool, something we hadn't anticipated, and which has been the source of much fun (and expense). I took pictures of the boys that day, trying to snap the photo the moment they hit the water so that it would look as if they were all just standing on the water. We still have the photo of Casey, standing ramrod straight, his toes tapping the surface. It was a grand summer, with a sense of renewal and togetherness.

The early part of this period is a blur, but beginning in 1998, we have records showing the troubles of our middle son, who entered three different residential programs from mid-1998 to fall 1999—Chad, a now defunct residential treatment facility for adolescents, where he worked with a therapist he liked a lot, Janice Moore; then to Rivendell, the Behavioral Hospital in Bowling Green, where he stayed a few weeks (he'd stayed there earlier as well); and then from August to October in 1999 at Ten Broeck in Louisville. He was dealing with deep-seated pain and anger, which led to our surrendering custody to the state so that he could be cared for at these long-term facilities. We would see him on weekends, when we would travel several hours to visit. Letters written through

most of 1998 from the family to him show how we missed him and detail growing troubles with the two boys still at home. We went to lots of counseling sessions—mostly with Glenda, the counselor who had worked with Adrian when he was in middle school and who continued with us, individually or in family groups.

Glenda had us each draw a picture of our family. Galen's showed a big spaceship where we were looking out of the windows and a smaller spaceship off in the lower left corner, where Galen had placed himself. He recalls, "From what I remember about those therapy sessions, they were often times fun once we got started, but I always dreaded going. I remember few details, but I have always felt like a bit of an outsider, and I think that was what led me to draw my own ship. But this may not have been solely from my experience in the family, perhaps it had very little to do with the home sector of my life. I was always more of an outsider in social situations that had nothing to do with the family. I do remember being quite jealous of both Adrian's and Casey's problems, because it garnered them a lot of attention from you and Dad. I wanted to be more fucked up so you and Dad would invest more time in me."

Even though his brothers were frequently sent away to this institution or that, Galen himself was often hard to get along with. He had begun to dig in his heels, and if he didn't want to do something, he was rude and angry. He began smoking pot and drinking as he neared high school graduation. He and Casey bickered.

The letters we exchanged when Adrian was at Chad, especially those from Ken, illustrate the ways we tried to confront our problems in positive ways. For a while, Casey did well in school. He had a very nice third and fourth grade teacher, Ms. Hume, but I remember one morning he refused to get out of the car. He was in fourth grade, and even Ms. Hume, who came out and squatted on the sidewalk next to his door and urged him to go with her, got frustrated, her lips pursed as she stood up and looked toward the

other kids streaming in. He sat, arms crossed, tears in his eyes, and then finally rolled out of the car and followed her in.

May 22: Dear Adrian. Hi sweetie! I am missing you a lot and wondering what you're doing. I hope you slept okay your first night at Chad. Is the food as good as they said it was?

It was very hard to drive away and leave you there. We were all quiet for a long time thinking about you. Then we saw an ostrich! Really, there's an ostrich farm along the way. It looked strange there in the middle of a Tennessee field. I guess anything is possible!

Did you like the photo album I put together for you? I really enjoyed looking through the photos for ones I thought you'd like. I tried to get one of everyone in the family, including a couple of cute and funny ones from when you boys were younger. I love that one of you in your wooden Robocop contraption—remember how much fun you used to have with get-ups like that? I was going to put one in there of you in your cape and underwear, but decided you'd probably rather pass on that one.

Well, we're going to get this in the mail. I love you, my sweet son! Mom

May 23 [from Ken]: Dear Adrian. Well, I can't begin to say how much we miss you and how hard it was to drive down that driveway and leave you behind. It is hard on us, and I'm sure it is hard on you as well. We will be coming down on the weekend and will visit then. In the meantime, do try to stay in touch. I will write letters. I am going to try to write three letters each week. (That's a promise you can hold me to.) I hope you'll be able to write to us as well.

I had a really good time with you on Friday. It was fun to dash in for donuts, to go shopping, and to go out to eat.

I hope you like your new shoes and clothes. Casey was talking about how much he misses you when I was tucking him in last night—it was hard for him to be in the car so long (he's not a patient car rider). He was really good about praying for you in Rivendell, and I'm sure he will keep it up while you are in Chad. His prayer last night was that you find good friends there and that you would be happier there than at Rivendell.

I hope you're really working hard there at Chad—as hard as you would for Eric (but it's a different kind of hard) . . . It will be hard, and I'm sure you'll get pressed to be angry. Here's a Bible verse that may be helpful to you: "We rejoice in our sufferings, knowing that suffering produces endurance, and endurance produces character, and character produces hope, and it does not disappoint us, because God's love has been poured into our hearts through the Holy Spirit which has been given to us." (Romans 5:2-5). I hope that your character will grow strong there. We love you a lot and think and pray for you every day. Love, Dad

May 28 [from Ken]: Dear Adrian. I took Rocky, Shelby, and Babe on a walk yesterday in the cow pasture. Shelby stayed with me nicely, so did Rocky, but he ran off several times out of sight. One time when he came back, he was covered with some white foamy stuff and a bunch of grass seeds. I don't know what he was rolling in, but it smelled like raw sewage or some dead animal that had turned to jelly. It was terrible. I got some of it on me and couldn't get rid of the smell. When I got home, I hosed him off, and later, Mom gave him a bath, but we could still smell him. Galen put some of your cologne on him and that helped a lot. We didn't know Galen had put it on him. Rocky came in where we were watching TV. Mom said,

"What's that smell? It smells like Adrian in here." We get reminded of you in little ways like that. Love, Dad

June 18 [Ken wrote]: Dear Adrian. Well, I've let several days slip by without a letter and lots has happened since our last visit. I've been trying to make you the cross that you asked for (without sharp points). The cypress wood I've been using keeps breaking. So, I just bought some poplar wood to make a real fancy one. It will take some time, and I'm going to try and chisel it out with some designs in it. I may make a quick one to bring up on Friday but the other one may take a week or so.

It was good to see Grandma Casey for a visit. After we visited with you, we went and saw the Shaker Museum as well as shopping at a Mennonite craft store and bakery. Even though it was a good visit, it was really hard in some ways because of Galen and Casey. Both of them were acting up since you have gone. Glenda has said we need to shape them up so that when you come back, they won't be a bad influence on you. We want the house to be calm for you when you get back, so we are working on therapy. Right now, we are working on teaching both kids to be cooperative and respectful.

Things got out of hand with him a few days ago— worst of all when Grandma was here. It even got to the point where I had to restrain Galen. Here's what happened: I asked Galen to make up his bed at bedtime (he and John were up in the room and Galen had been asked to make it up several times during the day). He did a crappy job. I asked him to do it right, showed him how I wanted it done, and then asked him to do it. He did a crappy job again, and when I told him it wasn't right, he started yelling. He tried to walk out of the room, but I was standing by the door. He pushed me. I grabbed him by the shoulders and then got

him in a side head lock, and we both went down on the mattress that we had out for John. It was very bad—I didn't sleep well the whole night and felt bad.

But that's not all, when we got back home, we went out to eat (at Galen's request). When we got to the restaurant, it was crowded. Galen said, "Do we have to eat here?" very loudly and with a whining voice. I told him he was acting rude, and he walked out. When we came back to the car to say we would try another restaurant (because by that time we found out there was a 25-minute wait), he was gone. We drove around and went in to eat finally and decided we would go home and call the police to help us find him. Luckily, we found him out wandering around on our way home.

I know you don't like it when I call our family dysfunctional—but truth to tell—we are. Violence, running away, yelling, and cursing at the top of our lungs are all signs of dysfunction. This violence and the attitude that leads to it has got to stop—it's not just you, it's our whole family. Please remember us in your prayers as we try to change and make a good family for you to come back to. I have strong hopes in you. I think you are going to be the one who really helps turn our family around.

I hope everything is going well for you at Chad and that you continue to work on your behavior and attitude. Mom was really impressed with the way you talked with her at your last visit, and she said that you sounded very thoughtful and mature. She said that sometimes I should visit you when it's just two people. I'd like that and maybe that will work out sometime.

August 8 [from Ken]: Dear Adrian. As usual it was so good to see you. Cracker Barrel, the movie, all of it was fun. It had been a hard day for me, and I was still on edge

about getting Galen to come to therapy. The fact that I would have to go to a judge and get a court order is so embarrassing and seems to show such a lack of respect on Galen's part that I couldn't always be calm.

I probably yelled too much in the car at him for hurting Casey—but I still think I did the right thing in making him take responsibility for what he was doing—I should have been able to do it more calmly, but I didn't. I'm sorry if my grousing put a wet blanket on an enjoyable evening. I thought your idea of a walk when we got home was an excellent gesture in realizing that we needed to calm down and also to recognize Galen's hurt feelings. You have good and generous instincts.

After all my apologies, I have no right to be a teacher about anger and enemies, but since the subject of enemies came up, and I didn't get to say what I wanted at the time, I hope you will give thought to what will follow. If you want to know what Jesus teaches about treating enemies and about anger, probably the best place to look is Matthew Chapter 5. His teachings are clear, but of all Jesus' teachings, I think these sayings are hardest of all to follow. Also, Jesus teaches that it is better to be persecuted in a just cause than to persecute. He says, "Blessed are those who are persecuted for righteousness' sake, for theirs is the kingdom of Heaven."

These are HARD teachings. I don't think that Jesus wants you to let other people beat you up. Turning the other cheek doesn't mean (I think) making yourself into a punching bag. It does mean, though, that it is wrong to try and hurt someone back. I think it is OK to fight defensively, if you need to. But fighting to hurt someone else and to destroy them is not good. If you can't do good for your enemies (like Jesus can and like God does), at least do them no harm. Our thinking so often here is the very reverse of

77

God's thinking, especially when we think it is better to hurt someone else than to be hurt by them. Hatred is deadly to our souls—it will eat us up from the inside, and the anger that can feed hatred is really like a fire in our bodies. If we get hurt in our bodies, that's bad, but if we get hurt in our souls, that is terrible. Hatred hurts the people who hate in their own soul. They will not be happy; they can't be because love is true happiness, and hatred and love can't live in one soul together. We should pity those who hate because they hurt themselves most of all. If it is possible, you should nurture feelings of pity for your enemies and do good for them if you can. If you can't, just stay out of their way.

Well, I hope this is somewhat helpful. Keep working on getting home. We really want to see you soon and have you come home for a few days. Love, Dad

September 21 [I wrote]: Dear Adrian—Hi there #3P [code for the behavioral level he was on]! I hope you've been able to maintain your level. Verbal kickback seems like something you can overcome, and so does antagonizing others. You can do it, okay?! We want you to keep making progress so you can come home.

Which reminds me—I was so out of it when you left that I think I said have a good trip home. Of course, I didn't mean *Home* with a capital "H" but the place you're living a while longer, your temporary home, lower case "h." I also want to tell you not to take what Galen says when he's sounding harsh or cold or hostile to heart.

He's going through some teen phase these days where he's that way to all of us. I'm not excusing his rudeness, just saying it's not about you. We're working with him to be aware of how he is with others—you'll remember I had a talk with him at Walmart.

I <u>loved</u> having you at home, even though I was sick on Saturday and couldn't deal with anybody. You're a very special person with a sparkling personality, and I just love you to no end. Take care, sweetie. xx Mom

September 22 From Casey: Dear Adrian. I am going to take the academic team try-outs on Wednesday. By the time you read this I will have already taken it because it is Tuesday 7:32 at night. I hope I pass. How is your school going? Today I got grounded because I forgot to bring my spelling home, but no one wanted to play anyway. Last night I watched wrestling. DDP is going to fight Goldberg at Halloween Havoc. It is going to be a blast. I hope DDP wins because Goldberg has never lost in his entire career, and he is too good. It was good to see you on Friday. I liked being with you at the party and playing Play Station with you. See you soon. Love, Casey

[Typed in different fonts] From Galen: Adrian, How's it going? I had fun during the party. I liked it when you stayed last weekend. I am sorry if you felt bad when I didn't come to drop you off. I have not been doing anything fun or great since you were here. Did you have fun during the party? Dad wants me and Casey to come with you next time we go to drop you off. Galen

October 14 [I wrote]: Dear Adrian—Hi there! I'm sorry to hear about your recent trouble. I understand there was a fight. I hope you aren't feeling too discouraged—it sounds as if some medicine needs to be adjusted and that Ms. Moore is seeing to it that the psychiatrist knows to up the dose. It's hard when the balancing act—getting the medications just right—gets off kilter. But it also means that if you keep us all informed about your thoughts and concerns, we can help you get back on your feet. Thanks

for trusting us and being honest with us about things. We are thinking of you all the time.

I loved having you home this weekend and look forward to seeing you. I love you very much and am so proud of all you do and all you are. Hang in there, my sweet . . . xxooxx All my love, Mom

[Casey's note]: Dear Adrian. Hey yo! What up beside the sun? Homey. It was FUN! It's not good for me to say "fred" but I wrote it. Are you still watching Flintstones? One of the *fun things* is hanging out on the porch and the gifts we shared on the back porch after dinner!!! I also had fun wrestling with you because I said Fred [Casey and his friend, Josh, thought it was hilarious to call each other Fred, a kind of anonymous self that everyone has]. I think you should come home and visit some other time!!!!! Sincerely with love, your brother, Casey Olmsted P.S. See ya

October 20 [From Galen]: Adrian, What's up? Those RC people sound pretty crazy. Hey, I don't want to go through what you're going through, but you should just hang in there and try your best. My letters are always short. I'm not very good at it (writing). This is very hard for me to write, and even harder for me to say, almost impossible, but I do love you. Please don't show this letter to anybody. Love, Galen

[A second note, printed with large letters]: Adrian, you need to come home. Get all your work done at Chad so you can come home. People are asking about you on the bus. I think your friends on the bus and in the neighborhood are getting anxious. Everybody misses you at home. Galen

November 10 [Ken wrote]: Dear Adrian. Hi. I've been thinking about you lately. We just got your letter from Thursday—it was a really perky letter. Casey got your

letter with the picture of Sting. Your letter was very encouraging for Casey—you are a really good brother. I'm trying to get Casey on a basketball team this year. Both Mom and I think the exercise would do him good. So far, he's still saying he's not interested. I hope he'll change his mind.

I hope you are working hard on your behavior and keeping your attitude really good. I sometimes get pretty down and sad about not having you around. When I try to look at the good side of things and think about how soon you'll be home, how far you've come, how good your drawings are and how much they mean to me. It's really cool to sit by the mantle and look at the picture and think, this is a picture that tells me what it looks like to be Adrian. It's so colorful and full of twists and turns. It perks me right up.

Got to go. Lots of love, hugs and kisses, Dad

No date [Galen wrote]: Hello Adrian. How's it going? I'm okay, we miss you so you're going to have to hurry up and get this thing with Chad over with. Envision yourself climbing a giant mountain. Then envision yourself, while you climb, already done. If you do this, you will always accomplish what you want to do. I do this a lot with everyday activities, like when I'm painting an eye on one of my figures. I see myself doing the best job ever and tell myself: "I am the BEST!"

I think the best thing you can do is use this method, because it works to boost self-esteem, really make you feel better about yourself and what you do. Just remember to always tell yourself you can accomplish anything, and envision a picture of you, Adrian, standing at the top of the mountain already done, and in record time. Love, Galen

Adrian came home from Chad, having disclosed the secret he'd kept for so many years. I contacted the police in Champlin, and a detective investigated but didn't get far since we could not remember the family's last name. Many years later, I drove through Champlin and saw the house, shrouded by two huge pine trees complicit in hiding what had gone on there. I left with a sense of urgency, sick to my stomach.

Soon after Adrian got home from Chad, we had to take him to Rivendell Behavioral Hospital for Children, and by August, he was in Ten Broeck Hospital in Louisville. I can still see him glowering at us the time we went to visit him, and his counselor abruptly ended the family session. He had been warned twice for foul language, and on the third instance, the counselor closed the folder he held in his lap, a sign the session was over. We stood up and told him we loved him. I remember walking away down the hall and looking back at him, to see his eyes burning as he sat immobile in the folding chair.

Casey was ten years old. His anger was simmering, about to erupt.

Part II:
What their Writing Tells
(2011-2012)

I—THE TRIAL

A month has gone by. Ken and I returned from our travels—he to India, me to the NEH institute in Arizona. And we got through the trial, July 26-27, which was in the news for three days. It was grueling, and the sentence is not what we'd hoped for (manslaughter 2 rather than wanton murder). Even though he wasn't trespassing and never got out of his car, the jury kept going back to the fact that Casey had driven over to their house.

Some facts are indisputable: Casey texted with Natasha—a girl he'd dated once or twice but who was staying with the Burns family—and with Patrick, the son, and at 11:00 or so the evening of October 26, Casey drove our car to their house. Parked on the county road in front of their house, he exchanged insults with Patrick. He remained seat-belted and did not enter their driveway. Leland "Stevie" Burns, a few beers in his belly, saw his son grab a handgun, asked what was going on, took the gun from him, stepped outside, and fired four shots. The car rolled up the road a hundred feet or so and then stopped. Later, a good Samaritan saw the car and knocked at the Burns' residence to seek help. Mr. and Mrs. Burns and Natasha and Patrick followed her to the car, and one or all expressed

surprise at seeing that the driver was someone they knew. They expressed varying degrees of dismay and upset (mostly Latasha).

Some facts are not indisputable, and it's been gutting to watch Burns' attorney interpret them, always with an eye to shifting blame to Casey.

Ken's parents were here for the whole week, as was Ken's sister, Susan, who is an attorney; she said later that when they finally left, she cried all the way to Nashville. His other sister, Kathy, came down on Thursday and was there for the closing. Friends came as well. I appreciate their loyalty. Adrian was here for the whole thing; though on the first day, he kept glowering at the defense, so Chris Cohron, the Commonwealth's attorney, subpoenaed him as a possible witness, supposedly because of his email exchanges with Natasha right after it happened, but mostly to keep him out of the trial room. This made him angry, but he dealt with it pretty well and understood why in the end. Our brother-in-law, Bob, made two trips down from Louisville and sat with Adrian "in the shrinking room all day."

Some parts rushed past us, others galvanized us in some way—these, for instance: the 40-minute recording of Officer Skaggs interviewing Burns at the scene—distraught. "I'm going to hell." "Let me shoot myself or you shoot me." "I thought he was coming to whup my son." "I didn't know how many were in the car. I've seen drive-by shootings on TV." "The bullet must have ricocheted off a branch."

1. The coroner's flagrantly inappropriate presentation of the wounds and path of the bullet—she was having a lark, performing on stage.
2. Natasha's testimony, Patrick's testimony—he saying that she'd told him that Casey had raped her. She saying she never said that.
3. The slides of the text messages. Ugly, macho, racist, and homophobic insults. Natasha and Patrick saying, "You'll

get shot if you come here." Casey responding, "Shoot me." Sex being a joke for Natasha. Insults about me, Casey's response, "If you say anything else about my mom, it's over."

4. Chris Cohron's moving closing statements, in contrast with Coffman's insulting and misleading, mercenary comments.

5. Ken's statement at the close of the trial, mine at sentencing.

~~~

Ken's statement:

I want to thank the court and the jury for the chance to say a few words about how Casey's death has impacted our family. I have two notebooks full of writing trying to get a hold of the ways in which we have been grieved. I obviously can't share them today, but since his death, there is hardly anything else I want to talk about. I heard Mr. Coffman use the word, "tragedy," to speak of Casey's death, and I was struck by how insufficient that word is and how hollow it sounded in his mouth. What is a better word? A father and mother burying a son is so far beyond tragic— the best word that I have found is to say that this is the most Godawful thing that has befallen me and our family. I have found the words of the psalmist come closest, when he says, "You have given me the bread of tears to eat, bowls of tears to drink." I have had to stomach what does not nourish or satisfy—day in and day out with a new reason for grief—it is like eating bullets or swallowing your own teeth.

When I first was told Casey had been killed, I was driving alone in my car. I just screamed out again and again, "I can't do anything, I can't do anything." As a

parent, Jane had sat with Casey through fevers—trying to cool his brow, or I had stayed through the night when he was in the hospital after his wrist had been reconstructed—there was always something I could do, and as parents, we always tried to move Heaven and Earth to do what we could for our kids. But now, no; Jane and I feel the helplessness to oppose a Godawful death. Further, to raise the pain threshold, Casey's body was being taken for autopsy and we had to wait while our son was out of our hands. At the first viewing, I realized how beautiful and lively his body had been, and now it was lifeless—something that was sacred had departed. I held his ashes at the funeral service—ashes that had been at one time my hopes and dream for the future. Those brilliant hopes I had for him now murdered. How can a father and a family mourn their murdered hopes and dreams? I suggest it is beyond tragedy.

Our sense of time stretches and collapses around trauma and periods of emptiness. I am haunted by what Casey endured until the moment he lost consciousness. I weep for the ribbon of time that Casey must have felt unfurl as he wondered what had just hit him, that flap of crystalline clarity when he must have realized, the subsequent rush of regret and loneliness unlike any he had ever known. I imagine him reaching out to his baby daughter, his mother, his father, his brothers, his future. Part of our grief is well expressed by Jane, a sensitive, poetic soul as she lay awake at night to rise and give voice to her anxiety and ask, what were his last moments like? Here is an excerpt from some writing, including a part of a poem ["Rogue Tongue"]:

I breathe into the cathedral of my hands
with their arches of bone and flesh,

ivory walls clatter shut around roof and palate
and the rogue tongue spins out its soft lament:

Spirit child, will you speak to me?
Are you truly free of pain,
or does the blueness linger there as well
like the clothing of a sacred memory?

If your answer's yes,
or if it's no . . . or if you have no answer,
go then to the lonely place—
I will meet you there.

We have had to listen in silence while his name is defamed with no small number of remarks that my family and I have found mercenary, disrespectful, and insensitive. But I don't want to go on in a minor key. I want to sing a note of joy for a moment to talk about Casey's grace and beauty. He is not the death-inviting person that the defense wants to paint—he's complicated. After the funeral, we had a service of sharing—over 200 people were there and consistently shared Casey's love and kindness. We saw a video produced by Jane and his Uncle Bob of pictures of Casey's life. Among them were pictures of Casey's volunteer work at a camp for underprivileged children. In almost every one of those pictures, Casey has some little kid on his shoulder. He had a kind side that you wouldn't believe. We also found his journal writing and discovered a depth of thought that I had missed while he was alive. . . A friend who happens to be a monk, Fr. James Connor, said, "I rejoice with you today on Casey's birthday. It expresses something which far surpasses the ordinary wisdom of a young man his age at that time. It portrays one who is very close to God." He was a young man with a love

of God with a penetrating depth of gaze and a love of children who was cut down in his prime.

But I still haven't gotten to his real life and joy yet. His daughter Leah, and his niece, Omni. Being the youngest, Casey always wanted to care for someone younger, and when Omni came over, he was always doting on her, picking her up, taking her to the swing outside, throwing her up in the air and catching her, even changing her diaper without being asked. For a 16-year-old, he was amazingly loving and caring and responsible. The real joy of his life, though, was his daughter, Leah. It is a terrible burden that she will grow up not know the continuing love that I know he would pour out for her. Casey was an imperfect person, but he loved her perfectly. We have set up one of these pictures at Leah's eye level. She often goes to it and kisses it. She is too young to understand his death—but from time to time, she will cry out, "I want my daddy," inconsolably. How to comfort her? How to comfort ourselves? This is the grief we live with, the bread of tears that we eat each day. I want you on the jury to know this side of him, but I know I cannot fully get it across in this brief time. If he were alive, you could see it in his smile.

I ask you to think of me as an expert on Casey's life. Some have looked at few moments here and there and have made a cartoon caricature of him. And I invoke his name on behalf of his family and loved ones. I say Casey Lee Stewart Olmsted, you are beloved, you are our most precious son, brother, nephew, grandson, and Father, loving and beloved. We say no to those who would tar and feather you. You are our beloved and we stand shoulder to shoulder with you this day. You have been bequeathed a legacy of violence and death, but we your living family and friends today remember, cherish, and preserve the legacy

of your love. You loved life—you did not have some crazy death wish that you brought upon yourself. No. No. No.

I am not without pity for Mr. Burns and his heart trouble and his breathing difficulty—but I ask the jury to measure out breath for breath—a breath which he held in wanton disregard. Mr. Burns pointed a gun at him and broke what he could not fix and failed to keep in mind the value of his complicated, precious, heartbeat which he could have let drive off into the night. We are chewing on the bullets, which he oddly kept in the refrigerator, and which have become for us the bread of tears.

I am also somewhat moved for Mr. Burns' fear that he has hell to face. We heard him testify that he believed that he was surely going to hell for this. It will be my prayer that he be forgiven and received into Heaven at his death. However, I think it is also right that he should spend the rest of his time on Earth paying the price for this Godawful deed that has brought immense pain and suffering for Casey and his family. I respectfully ask that you jury members give him the maximum sentence of ten years.

~~~

Ken's statement was moving and brave—especially since the defense attorney, Brad Coffman, kept him on the witness stand after the reading to cross-examine him. The judge even had forgotten to ask if Coffman wanted to, so profound was the impact of Ken's statement. We all sat in silence. Then Coffman flattered Ken and contrasted his "eloquence" with that of his poor clients who can't articulate their loss, and finally said, "Would it have been better if Casey had stayed home that night?" Ken struggled with what to say, looking down into his lap for what seemed like a long time, and finally said, "I think you know the answer," and when Coffman pressed him, Ken said it again, "I think you know the answer." Chris Cohron was furious and said, "State stipulates that the answer is, 'yes,'" and the judge told Coffman to move on.

Sentencing—September 19, 2011

Since Ken read his statement at the end of the trial, we decided I'd read at sentencing.

~~~

I would like to thank you for the opportunity to speak at today's hearing. As I walked into the Justice Center this morning, I paid special attention to the figure who looks out over Bowling Green from the second floor: she is Lady Justice, a symbol of truth and fairness, and in her hand, she holds a scale to show that in Bowling Green, at least in the Justice Center, we care about the balance of these two ideals.

But in our family, things are out of balance. I am here today to invoke Lady Justice and to request that the sentence in some small measure seek balance, between action and consequence, between the horrible wrong that was done to us and the consequences for the person who pointed his gun into a car that was driving away on a county road, thereby killing our son.

Judge Wilson, I urge you to rule that the federal and state charges not be served concurrently but rather sequentially: ten years for the crime of manslaughter 2 and two years for the federal charges of possession of illegal weapons, for a total of 12 years. Given rules of good behavior and the possibility of early parole, time served will almost certainly end up much less than that. Given the likelihood of reduced time that Mr. Burns actually serves, I ask that you help to ensure that justice is served.

The first reason for this request is that Casey's parents and brothers have been grievously wronged. I will never get to hug Casey again, nor laugh with him, nor help him with his homework, nor praise him or scold him. Casey's

father and I will never know the joy of seeing him become a man. It feels to us as if our hopes and dreams have been trampled and now lie at our feet where we are left sorting through the remnants of his life. We miss him so deeply that our home sometimes cries out loud. If someone shares a memory of him—no matter how slight, no matter how removed they were from the intimate details of his life—I want to grab the person and say, "Tell me, tell me. What do you remember?!" Because each shared memory is as if he has entered the room, if only for a moment.

Second, Casey's daughter has been grievously wronged. She is three years old now and has learned to say, "My daddy's dead" and "I'll get a new daddy someday." I hope she will have a wonderful stepfather someday, but even if she is so lucky, she will never look into the man's face that resembles her own and know the unconditional love and protection he would have offered her. We collect things for her that will help her to know who her father was, but what will this early loss mean to her over time? Will she suffer from uncertainty and anxieties about separation? On behalf of my granddaughter, I ask that you make these sentences consecutive.

The third reason is that Casey has been grievously wronged. He will never smell the rain after a drought, nor become the person he was on the road to becoming. I can imagine that anyone in this room could look at themselves at 20 and be thankful that they had another chance—many chances—to learn life's lessons, to fulfill the promise of their birth. Whatever else the defense wants to say about Casey driving out there that night, he was innocent about the sort of person who stood on that porch as he, seat-belted in and radio playing, pointed the car toward home. When he drove up and honked his horn, he didn't know that a would-be soldier of fortune was sitting on a mountain of

weapons and caches of MREs and was about to play out his paranoid delusions against a boy he couldn't see and whom he had never met.

I would like to share a snippet of something Casey wrote when he was about 18. As you can see, he was a seeker of truth and fairness. He left us with many of his thoughts, written in journals, notebooks, scraps of paper, even on napkins. He deserves to be heard:

## Mysticnary

Written by: Casey Olmsted

Take a moment and think about everyone you know.
Now think about everyone you don't know.
What if you knew everything about everyone you know,
everything and everyone you don't know
Not only that but all of nature and the universe,
even the cure to cancer?
That is impossible, because that is God.
Does that discourage you? Do you
think you could handle all this knowledge?

Look at God's love and knowledge as
a life-time goal to get your best
understanding of it, because the
more you can understand God the more
you can understand your place in this world.
Our time on this Earth is nothing to eternity.

What is eternity? What is our life here
on Earth? These questions take time,
and you must search
for the answers!

Even as a teenager, he was taking a long view of life, searching for his purpose, asking the big questions, and reflecting more deeply than many people ever do.

I think about those scales, balancing truth and fairness.

Imagine Casey's heart on one side of the scale, as the coroner lifted it from his chest. It weighed 330 grams. Add to that the weight of my heart and that of all the other broken hearts that proliferate as a result of this one act. But most especially, let us think of Casey's own broken heart—for I am convinced in the seconds before he died, he knew he was dying, and he cried out in his loneliness and his grief.

We have endured two years of postponements and delays. We have attended every hearing, every discussion. We have respected the system by holding our heads up and maintaining silence in public. Casey's family has been at our side. When Mrs. Burns stopped me in the parking lot to say, "I'm sorry about your son," I didn't look at her with hatred, but only said, "Thank you." I have pity for more people than I would have thought possible when I first laid eyes on the person who did this. And even though the trial was excruciating, and every day seemed to bring out new heartbreaks and indignities, I have sympathy for almost everyone involved.

But it doesn't matter how much sympathy and pity we feel.

In terms of truth and fairness, it doesn't matter that Mr. Burns has health problems.

It doesn't matter that his family misses him.

It doesn't matter that he regrets what he did.

As Casey's mother, I ask that Mr. Burns receive a sentence that shows the Court has weighed our heart-breaking losses and recognizes the magnitude of Mr.

Burns' wanton act. He could have let Casey drive away. But he didn't.

~~~

My comment about paranoid delusions sent the defense attorney, Coffman, off. He began listing things Casey had done wrong. We could hear a couple of women a few rows behind us, whom we didn't know, saying "So?" and "That doesn't matter." I thank them now!

The Judge finally snapped, "Assassinating that kid is not helping your case . . . at all. I want it to stop now." He also said about the Man-2 conviction, "No one thinks that sentence was adequate," partly due to the 20% served parole opportunity.

The jury came back with ten years, the maximum, which we'd hoped for.

Galen came up on Thursday, July 28, after the sentencing. The four of us went out for sushi in Nashville after we picked him up from the airport. Adrian was devastated and at first did not want to go, but then we persuaded him, and he ended up having a good time and feeling better. He'd left the courtroom after Ken's statement, he was so upset with the verdict, and disappeared; later we found out he'd gone straight to a bar on the square. Ken and Kathy ended up going to get him before anything bad happened, and he came back in time for the conference with Chris Cohron; lead detective, Tim Adams; and Cohron's assistants.

And now something dreaded is behind us, though we'll have to go up for parole hearings. But this part is over, and we did well by Casey. For the last month, Ken and I have been walking in a dark cloud. I've been angry at Casey, too—why did he have to prove something?!

At 8:00 p.m., Brad Coffman called us. Ken put it on speakerphone, and I took notes:

I wanted to apologize. I think I was out of line today and didn't want to say hurtful things about Casey . . . I'm

fiercely defensive of my clients, you know that's part of my job . . . I have defended hundreds of young men like Casey who messed up and then started getting their lives together again. I've been to the website and read his writing and what others said about him many times, and I'm impressed with him.

What Ms. Olmsted said today about him knowing he was dying really touched me, and I think she's probably right. [Then he began telling his own story, loss of parents early on, his wonderful stepfather.] I hope someday that you'll understand that perhaps I know how you feel more even than the judge of the Commonwealth.

I just wanted to get some things off my chest. I'm very mindful of your loss. And Mr. Casey, when you testified, I lost my temper and asked you some stupid questions and probably cost my client a couple of more years. And today I didn't need to go into that [litany of things Casey had done wrong—times arrested, being in Drug Court, giving up his license, taking the car].

I'll probably see you in Court again, and I promise you this: I'll try not to say anything more about Casey.

At that point, Ken agreed that perhaps Mr. Coffman did have problems with anger and that he'd said things that could have been said better, such as "people die every day," but that he appreciated the call. Then I said something to the effect, "It took a lot for you to call us tonight, and I appreciate that." He then said he appreciated my saying that.

It was another strange thing to absorb, appreciation flying every which way. Perhaps we've made a villain out of him, and he's got his side, too. On the other hand, Susan thinks the call was, in the end, self-serving.

II—DEFINING PASSIONS

Family Project: Letters in Boxes

As someone experienced with family tragedy, I have discovered a new urgency in understanding who my family is, and "why." I began work on the family project in the fall of 2009, when I went out west on sabbatical, just before Casey died. I had already talked to my cousin, Bette, about collecting letters and journals from her father, Robert W. Hiatt (Uncle Bob), in order to write a biography of him. I took home five bins and began organizing by decade. Then I found a box of letters to and from my mother that I didn't know existed, under my oldest son's bed where I'd stored her things after she died in 2001.

I feel sure that in reading about someone else's life I will understand my own—and I know already that they were superb letter writers.

The bulk of the archives contains letters written from 1938-1948 (and one from my mother's father, known as LR, to his two-year-old daughter, when he was in Siberia, in 1921). My grandmother, Isabel, died in 1942. My mother, Betty, and my uncle,

Bob, both went to college and graduated—she from Eastman School of Music and then University of Minnesota, he from Optometry School in Chicago. Life looked good, and the loss of a beloved mother and wife had pulled them closer.

There's a kind of reaching back that speaks to me, even as I move through the various shapes and colors of the last three years. And increasingly it seems that in order to know Casey and me, you have to know my mom.

How many of us have a defining passion, so crucial to our being that without it, we would seem emptied, a photograph rather than a real self, the spark missing that ignites all our other loves and hates? I wonder if I have one, or if I would agree with what others might say it is if I were to ask. My mother had no such doubt: she was a musician. She played the piano with such love that I always knew two concerts were going on. One was for whatever audience she might have: me, friends, a congregation. Compliments were met with "aw, pshaw," a chuckle, and an undertone of "pitiful, pitiful." It was as though praise were legitimate only for the Rudolf Serkins of the piano world. The other "concert," which marked so many of the days of my growing up, was in reality no more a concert than a private conversation between intimate friends, is a public speech. Her attention was absolute, and her body a testimony to her sacred communion with the only religion that never let her down.

I see myself back then, her only child, curled up on the sofa, reading. Periodically I look up, perhaps to reflect for an instant on what I'm reading, perhaps just to see something outside the frame of the page. From where I sit, I can't even see her face, only the top of her head. What looms is the piano itself: stiff, stocky, a black casket on three short legs, a contradiction in terms, a baby grand. In earlier days, I found the piano cave a wonderful place to play and tucked small treasures into its hidden corners and boxy spaces.

"Play louder," I said, and then kneeled inside that booming space, eyes scrunched shut, hands over my ears.

I don't know when she got it or if there was ever a time, after it was just the two of us, when it didn't hold a central spot our home. Did she get it in Columbus, Ohio, where we moved after her divorce? Or carry it with her from Minneapolis, along with her 18-month-old daughter? I can only rely on my certainty that *it was always there*. And so, I wonder how my mother's love of music affected who I, a marginally musical person, would become.

As a kid, I accompanied my mother to concerts. It must have begun when I was old enough to be told to sit still, but again, I remember it as something we *always* did. Until I started seventh grade and we moved to the country, across the road from a blueberry farm, we went regularly to Carnegie Hall in Oberlin, where she was head music librarian. I sat next to her, drawing in the program's margins, nudging her now and then so she would look. Sometimes she'd give me an encouraging nod, other times a brief shake of the head, which let me know that it was time to listen—or to let her listen.

Sometimes with my head bowed to whatever work in progress I had in my lap, I would sense a change in her and look up. Her cheeks might be wet with tears, her eyes closed. Other times I looked up just in time to see her chuckle, and only after would I notice some light-hearted shift in the music. Even though I didn't always listen, I must have absorbed the story that music invites its listeners to tell—or see, since listening to good music is also a visual experience, especially in that strange state between sleep and wakeful attention. Only then might I see that leaping trout caught glinting in the morning light, the grab of that fat grizzly paw, then crash, boom, bang, and the fish was out of the paw and its tail slapping that furry face, which would turn in a moment and look right at me. Colors took shape behind my eyes, guided by the strains that rose and fell, poignant or exultant. Later, I would read E.M. Forster's *Howard's End*, with its scene where the music snob interprets a Beethoven passage as evoking goblins, and then later, Zadie Smith's retelling, in *On Beauty*, where the music has shifted

to Mozart's *Requiem*; listening, her character sees a yawning pit and hears a heavenly choir that is also the devil's army. I knew exactly where they were coming from.

"Bravo!" she'd cry out, her shout affirmed around the great hall by other "bravos," letting me know that my mother—and I, leaping up beside her—knew greatness when we heard it. Then it was that I saw the conductor or pianist or violinist—the person responsible for our delight, small as one of my black stick figures—take a bow or many bows before retiring with dignity to the hidden area behind the orchestra.

At an age when I resented being told to sit like a lady, I liked the way the women cellists spread their black-skirted legs for their cellos. And I loved the kettle drum, the timpani, and the serious, bald-headed man who came alive just in time to bring the movement to its crashing close. But most of all, I loved the way the piano, the strings and woodwinds, and all the different sounds became lines of color and sensation behind my closed eyes—that half asleep I was creating something with the music, orchestrating an exchange so that it seemed as if the music stepped aside for my story in images, and just as smoothly, my story made a place for the music. What are the physics of sound that transform a feeling that I had no words for and yet knew was shared? If my eyes were dry, I nonetheless knew what my mother's tears meant.

There was always the risk that she would embarrass me by scowling at people who persisted in talking during the opening measures or clapping between movements. I wanted to crawl under the seat. I came to understand her impatience with others as the regrettable price I had to pay for having a mother who loved music beyond what was reasonable.

A few years ago, during one of several interviews with family members, I reminded her how Aunt Beth used to brag about her piano playing, claiming that her clever niece never played a wrong note. "I've changed since then," she chuckled. Whether she played wrong notes or not, she used to tell about performance

anxiety, particularly the time when she was in a high school performance and for some reason inhaled some teeth-cleaning powder and began sneezing on stage. What horrified her was disappointing her parents, who were up in the balcony watching. In 1940, when she was twenty-one, she graduated from Eastman School of Music with a major in music theory and a minor in performance. For a time, she thought of performing but changed her mind when one of her arms gave out. She had to sit under an ultraviolet light for weeks afterward. At least this is how I remember it. I thought her heroic for over-extending her arms, something I knew would never happen to me.

Within artistic families, which art is more often passed down from generation to generation? I can think of more great musicians with musician parents (the Schumanns and the Serkins, Woody and Arlo, Hank and Hank) than parent-child writers or painters. Maybe it's that music is the most communal art. Or maybe hearing is the finest sense. Maybe it's the immersion of senses: we see the hands play along the keyboard, we hear the emotion in chord, melody, motif, we imagine the lines and passages part for us, closing behind us, creating a shelf for us to watch from, a path for us to follow. It's the way music and thinking push and pull each other along—did the music conjure the image, or did the idea pause and turn for the approaching arpeggio? Despite moments of rapture and years of piano and flute lessons, musical talent is not what Mom passed on to me. Perhaps more important than the specific talent or passion our talented parents pass on is what comes with it.

Mom was intuitive, though I used to think her reading of others' feelings and motives exaggerated. She seemed to look for hurt feelings, slights, snubs. If I got ahead of her walking from a concert to the car, she sulked and refused to look at me, slowed down even, ambled. I used to mutter, "big baby," under my breath, and then wait, let her catch up, begin walking again, leave her behind. Maybe she read people the way she read music, sensitive to the

slightest shifts of meaning. It was a perspective that kept her inadequacies at the center of her attention.

One episode from her childhood haunted her. She was at her ninth birthday party, and in the midst of her friends, she looked up, saw her father approach, and called out, "Hello there, Lyman." He strode across the remaining distance, turned her over his knee, and spanked her, right in front of her friends. It set the standard for every mortification she ever felt. What did it mean that she was a girl and he a big man who, she told me, took pleasure in upsetting her finer sensibilities, farting, for instance, at the dinner table, mortifying?

Another story. She had just divorced my father and was leaving with her eighteen-month-old daughter for Ohio. She called Lyman for help. "You're the one who divorced him. You're on your own now." There is a picture of her from those years that shows sadness etched into the lines around her 35-year-old eyes.

At the memorial service we held for her, a number of people spoke about her generosity and her love of music. In the letter she left for me, detailing what she wanted me to do upon her death, she asked only that Brahms's *Requiem* be played at her funeral. If people were not willing to listen, they should arrive *after* the playing of the *Requiem*. If anyone spoke during it, she wrote, "I'd probably rise from the dead to scold them." Since she had willed her body to the University of Louisville's medical school, we had no casket, no graveside service. Instead, we had two "artifacts" tables with pictures or things that had been important to her—a Scrabble game, some crossword puzzles, musical scores, a picture of her hands gnarled and poised over a keyboard. In the two weeks between when she died and the memorial service, I was flooded with memories, which eventually coalesced into "things my mother taught me."

It's a sentimental list. How to be a good Democrat and to rage against religious demagogues and to sass political idiots on TV. To be quiet during concerts and not to clap between movements. And so on. Rising above the flood of memories was an incident that happened when I was in high school, and Aunt Beth had moved in

with us. I was washing dishes while Mom and I argued. I said horrible things to her. Aunt Beth decided that such a disrespectful child should be dealt with more firmly than Mom was willing to do. She walked—marched—into the kitchen and said, "Don't talk to your mother that way." Feeling cornered, I whirled around and snapped at her to stay out of it. At under five feet and 89 years old, she has to be admired for facing up to a strapping teen-ager with a big mouth. She started to slap me. When I lifted my arm to block hers, she slipped on the wet floor and fell, spraining her wrist. I looked down in horror, drenched in guilt and shame. I had to be the most despicable person alive. But it's here that my mother's voice comes back to me as clear as if it was only yesterday. She could have pointed a finger, "Now look what you've done," but all she said was, "Well, Auntie Beth," and in the unspoken I heard, "What did you expect, coming in here and hitting my child?"

And so, Mom gave me her very best gift. She showed me that loyalty is a force so powerful that it can transform guilt into forgiveness and shame into a sense of justice. Whatever range of emotions we feel in the wake of the talents and passions that define our parents, what we're really grateful for is the sort of thing any parent can manage, at least theoretically: to be alchemists of the heart for us, turning the base metals of our lives into gold.

Loyalty doesn't necessarily follow a musical gift. Plenty of performers have deserted their children—many would never have made it with kids in tow. Poor, sad Schumann children, their father lost to madness and their mother torn between them and the concert circuit. No, for Mom, it was loyalty first, music second. That's why it's hard to admit we had a rocky mother-daughter relationship, that some hurts cut so deeply I still catch myself nursing the wounds. She used to say to me, her voice full of longing, "I'm so ashamed at the way I deprived you of your childhood, the way I burdened you with my problems at work, when you were too young to understand. It was as if you were the parent, and I was the child." Such avowals were embarrassing. I knew I hadn't been deprived. I was like the

children Stephanie Coontz writes about, "Resilient enough to survive many of our [parents'] mistakes, and even to benefit from them" (225). Even in the midst of contradictions, I knew I was lucky.

Probably what was most fraught had to do with being female. I was an adventure-loving, tree-climbing girl. When I started my period, I could not muster the words to tell her. I lay in bed, and every few minutes called out, "Mom?" six or seven times throughout the night, and every time her response was, "Yes, what is it?" She never came to find out for herself. This has been a failing of mine all my life, to put out tentative word-callings in hopes that others will understand and save me from having to say exactly what I need.

In the morning, I got up as usual and made my way down the hall that separated our two rooms, too sleepy to remember what had happened the night before. My mother paused in her doorway, her hand to her mouth, and gasped. I looked down at the circle of blood covering the front of my nightie. "So that's what you were trying to tell me last night." I remember standing awkwardly in our small bathroom as she got out a sanitary napkin and belt and hooked up a bulky thong with metal clips that would throughout the day carve initials into my tailbone. I couldn't bear to wear it, so instead I wrapped toilet paper around the crotch of my underwear and changed it every time I went to the bathroom, flushing it down the toilet, leaving no evidence of what was going on. One time I hastily tucked a wad of folded tissues in my underwear and ran outside to play with some friends. As we skipped through a neighbor's yard, the tissues fell out and landed in the grass at my feet. Ever the quick thinker, I snatched it up and held it to my nose. "Oh, no, my nose is bleeding again," I said, and ran home to develop a more sophisticated method of protecting myself.

Obedient to the girl version of the Oedipal script, I was overcome with shame. Throughout high school I remained unable to leave the evidence of my period anywhere, even in the wastebasket in my own home. At school and other public places, I

waited to leave the stall until the restroom was empty, so I could tuck the sanitary napkin beneath the paper towels piled up in the trashcan. At home, I smuggled the wrapped product outside, where I would bury it in a shallow grave in the crumbling leaves.

"You're a woman, now," Aunt Beth said. I couldn't have put it into words then, but I knew that I'd been handed a raw deal. What self-respecting girl would willingly enter terrain that denied the freedoms that had, until then, defined her? Besides, everyone else said *you're a woman now* when a man put his thing in you. It was too stupid.

Somehow my mother's grown woman's body was to blame—after all, who else had given me a body in her likeness— thighs, breasts, and butt like hers? She didn't shelter me from nudity, and I'd seen her getting dressed many times. However, about this time I saw more than my blundering self could handle. I went into the bathroom to brush my teeth and saw her lounging in the bathtub, her breasts flopping to the side, her thighs mountainous, and her pubic hair waving in the water, something pink beneath. The her-ness and me-ness of our separate bodies blurred, and I looked away quickly, my own eyes glancing away in the mirror. More implicated than ever before in my deepening sense of loss, she *became* the terrain I needed to avoid. The first time I decided I wanted to carry a purse—a little red and white zippered thing, about four by eight inches—I wondered how I could introduce this purse into my mother's presence without her noticing? I worried that in adopting this girlish symbol I would indicate my acquiescence to an inferior status. My mother was the mercury in the thermometer—the more she saw (and praised) my girlishness, the hotter it got. I wanted that mercury pooling at the bottom where no one could read it.

As it turns out, she made no comment (or I remember none), and so I went from purseless to pursed, and then from make-upless to blue eye-shadowed, then to girdled and stockinged and shoes too small—I was convinced that if my shoe size went over a seven, my classmates would line the hallways pointing and sneering—but by

high school it didn't matter how much she noticed. I had made the transition; it was the boys' barometers I was reading.

Throwing myself into culture meant smothering my anger. As long as my society was innocent, I could live up to its demands. Although I was not a fat girl, I was never thin, and my hair was hopelessly curly. My model was Patty Duke, and during seventh grade, my braces glinting, I stopped washing my hair, imagining that the oiliness made it seem straighter, more like Patty's. I could fill my fingernails with the dried sweat of my armpits. How did Mom fail to notice my atrocious hygiene? Maybe burying the evidence of my coming of age, slyly edging a purse onto the piano so that one day it was just *there* and wearing loafers whose seams had split— maybe these were attempts to get her attention, while claiming not to want it. By eighth grade, I was bathing again and sleeping on soup can curlers because the larger the curler, the straighter my hair would be—unfortunately, all it took for my hair to spring into curls was for someone to sneeze. By high school, I had moved on to Dippety-do, Girl from U.n.c.u.r.l, and the iron. My senior picture shows me with straight, shoulder-length hair, curled slightly at the ends. I had gone from geeky, oily, and shunned, to almost sleek and popular. Ironically, despite the implicit self-hatred of those high school years, I was happier than I had been in junior high.

Another tricky psychological maneuver that allowed me to be female without being my mother, was to transfer my love for her to my grandmother, Isabel. Although my grandmother died well before I was born, I had heard enough about her to know that she would have soothed all my hurts. My mother had told me so many times how she wished I could have known my grandmother, whose first name is my middle name, that I felt I did know her—or more precisely, that she knew me and looked after me from Heaven. Always the peacemaker, who my cousin says, "Must have been a saint" to live with my grandfather, Isabel was the epitome of redeeming love, as Mom's comments show:

When my mother was sick in 1936, she had to spend about three months in bed. I remember being especially close to her at that time. I think I've mentioned that I would lie with her in her bed sometimes, and just feel a lot of strength from her. Just in quiet talk probably, not amounting to—it wasn't profound or philosophical necessarily, but the communion was rich and deep.

My grandmother had had rheumatic fever as a child and was told when her only daughter must have been about fifteen that she could either stay in bed half of every year and live a reasonably long life or live a normal life and expect to die much sooner. She chose the latter. Mom measured herself as a mother against Isabel and found herself wanting. This was a kind of ammunition I could have used but didn't. Isabel was mine. I wouldn't use her against my mother. I could not bear the thought of my angel being disappointed in me.

Mom's first family of four sang and played music together (Mom on the piano, her brother, Bob, on the trombone), and if certain betrayals made her too sensitive, even sulky at times, something much greater was permitted to grow there. Love of music made Mom bigger than she would have been without it. Isabel's talent was peace-making. Isabel gave Mom her first piano. Music was Mom's key to life outside herself, an invitation to dine at a banquet so spiritually fulfilling that the smallness of others couldn't diminish it.

Music was my mother's sacred answer to pain. A few months before she died, a music-loving friend from Lexington, Kentucky, gave her a CD of Richard Stoltzman. The last time I saw her alive, I went to visit her in the hospital where she was listening to Stoltzman and fading in and out of consciousness. I sat down beside her bed and watched her listen—a muscle twitch now and then around her mouth, a small moan, more like punctuation than an expression of pain. When the sound of the clarinet rose suddenly, she struggled to free her arm from under the tubes and waved her fingers in the air, tracing something. Then in her clear soprano voice:

"Ah, there he goes." Was she following the clarinet or was Stoltzman responding to her, following the path she'd drawn through the landscape of her mind? She opened her eyes and saw me, smiled and raised her eyebrows, a gesture I am familiar with, her nonverbal way of checking to see if I have gotten it. "Nice music, Mom," I said, and she shrugged.

"Nothing like it," she said.

September—9/11/11

Mom lived long enough to see the Twin Towers fall. Ten years after 9/11 and all the United States is honoring those who died, waving the flag, overdoing it. Naturally, no self-reflection in sight.

My long-time friend, Linda L, spent the night Saturday on her brief stay in Kentucky, where she was a guest at Murray University. We had many good talks, and on Sunday morning, we spent an hour going over my letters project. We finally determined that I have about 1,200,000 words from about 1938-1946 with a few more up to 1952. That's about the length of *The Lord of the Rings* trilogy. I'll need to edit by theme, focusing on a young woman coming of age. Maybe later, a second collection around the WWII years for Bob and Lois' letters.

Several months ago, Ken sent me something Thomas Merton had written. If you write for God, you will reach many people and bring them joy. If you write for people, you may make some money and you may give someone a little joy and you may make noise in the world, for a little while. If you write only for yourself, you can read what you yourself have written and after ten minutes you will be so disgusted, you will wish that you were dead.

I don't write for God, or even know what that would mean. I don't make any money writing for "people," and my noise in the world is very small. I don't write for myself really, though perhaps in part, since I do like the transformation of idea and image into written word. And I know the disgust Merton refers to! For him, the

best entity to write for is God, and I suppose he has brought people joy in doing so. Certainly, he has reached many people.

Later, I was sitting with Ken in his basement apartment in Hopkinsville—he was grading, we were listening for some reason to Joni Mitchell's *Blue*—and it occurred to me that feeling sad about Casey has gone on so long that I can't even share it with Ken anymore. I remember when I felt uncomfortable being around other people—what can they say?—why put them in the position of trying to soothe or sympathize? It was easier just to hold it in until later when it was safe to be sad together. But tonight, it just seemed too much to try to articulate—then he said, "Ever since the trial I've been missing Casey a lot." So, we shared that for a few moments and talked about how to mark the second year, coming up in about a month. Same day as Ken's birthday. How would we celebrate one and honor the other? And then it occurred to me that perhaps we need to separate the anniversary of Casey's death from the celebration of Ken's birthday . . . lest we forget to be happy, always sad on his birthday . . . So, we would set aside one to allow the other to "be fun." This is a normal conversation.

October—memory of eyes

I've been thinking about Casey's eyes—for instance, Adrian's dream about reaching down to pull him up when he was lying on the couch and seeing Casey look up at him. In *Dark Green Religion* by Bron Taylor, there's a section about what he calls eye-to-eye epiphanies. Jane Goodall talks about such powerful inter-species communication in *Reason for Hope*. I think Casey has become a bridge species, and we see him in our dreams, arising, one foot in each world, the point when he shifts over completely hazy and backlit.

We are at the Grace's House of the Merton Institute, at Bethany Spring near Gethsemani, in the middle of a large field—about a mile from the road, down a rocky driveway. We have just

finished dinner and are listening to the chirping of the crickets and frogs while the moon, at about three-fourths, shines overhead. A dog barks in the distance, and ahead of me and a little to the right, I see the distant headlights of a car driving down a nearby road.

I stare at the bright white moon with its telltale gray shadows—no face tonight, or even part of a face. Instead, the shape is like a spill in an open book, duplicated on either side. I don't know where our three days will lead, and deciding what to do with yourself is different when you're away from home. There's a ringing in my ears—I guess because the silence is different.

I was about to close my computer and then I didn't, looking for a while at the desktop picture of Casey catching Omni after tossing her up in the air. It's a beautiful glimpse into their relationship. She's completely relaxed, her blue shirt billowing in the breeze of falling, her little fuzzy bun touching the green edging of the roof of the lighthouse building. Her brown arms are reaching slightly down. You can see her underwear peeking out from her capris. Casey is reaching up, his eyes on hers, his mouth open across his teeth, not exactly a smile, more like an expression of strain. I remember how he worked up a sweat, tossing her up. "One more time." His hands are apart, ready for her to land between them. You can see his left hand clearly and part of the right—four fingers, part of a palm, the inner line of his right arm. He is slim. The T-shirt he's wearing gathers around his reaching shoulders, leaving the front loose and draping. Behind them are the telltale black and white stripes of the base of the St. Augustine lighthouse.

9:25 p.m. We have returned from a walk along the pond and into the woods and then the pasture. We didn't take any light with us so had to rely on the moon and stars and reflection of the sky in the water. When we emerged from the woods into the meadow, the light was so bright my eyes had to adjust, and then again, reentering the woods, though the streaks and spots of light coming

through the trees were enough to lead me safely downhill and along the lake. Ken is trying to discern if he can walk to the abbey at 6:00 in the morning for early mass, using only his night vision. Of course, it will all be different then—the moon will surely be gone, and the stars? I don't know. And perhaps the earliest signs of morning will be on the horizon.

Good morning, Day. You are lovely in your crisp air and long shadows fronting the porch and sweeping across the meadows. Your sun is now in the upper branches of the trees to my left, and to the west the trees are showing what is in store for their cousins across the meadow: direct light drying the evening's moisture leaf by leaf, mostly white trunks drawn out of the darkness. Birds soar in the branches of the sunlit trees, those still-shadowed trees less fine for perching—all are leaning toward the sun.

As usual, in the distance the motoring enterprises of humans, as least those not already at work on a Friday morning: the hums and guffaws—and occasional rifle shot!—are literally on the horizon, below consciousness unless you are listening for them, and certainly not a distraction from my lovely meadow.

The sun has just hopped up a branch and is now warming the side of my face. Early this morning, Ken slipped out for mass—I don't know yet if he drove or walked, but my guess is walked, as his shoes and socks are laid out to dry. He is still in bed after his early-morning jaunt. Another shot! What is someone doing? Hunting? Target practice? Killing someone?

I think we should become regulars here, twice a year. Even if it is a little over $100 a night, it's a lot less than buying our own land and having a "shack" like Aldo Leopold's family. I find the idea appealing, though I romanticize it. Still, when I read accounts of his family's

going there and working together to plant trees and mark birds, I am struck by a wave of envy. It comes unbeckoned, the longing for what we didn't have.

I'm envious of families that lived and worked together in harmony. Though there would have been quarrels and annoyances, they didn't suffer as we did. Even though it's over, is it really? The two oldest boys are grown up now and the youngest is dead. One of my last memories is when Casey and I stopped to pick up the molly malone pizza at Greener Groundz before going to an NA meeting; we had to grab it in a to-go box and rush to the car in order not to be late. I am driving and he is wolfing, grunting in pleasure, "Oh, that's good," with every piece. But mostly I think how it amused me then, and does now, those grunts of pleasure.

I'm pretty sure it's a groundhog who's been hanging out at the far end of the pasture. Earlier I watched a squirrel cross the meadow near him (or her), and it wasted no time, but flew across the distance, its tail flipping over its back in the squirrel way. But this groundhog is not without awareness of the surroundings. He ambles along, then stops, stands on his hind legs and peers around. I assume he is making sure the coast is clear because it lasts a few seconds, and then he is down on all fours again, foraging. Maybe we should stop every so often to take stock. What's going on around us? Is there danger on the horizon? Beauty we should contemplate?

2:40 am. Can't sleep, thinking about the book, and aroused from reading both my own and Ken's journals over the past two years. Read until 11:00 or so, then lay in bed until now, heard the monastery bells ring at 3:00 a.m. and again for the beginning of the 3:30 service. Ken says seven to eight times a day they go to worship services, sometimes for only 15 minutes.

7:30am: Ken has gone to Complin. I took a dusk walk and looked at the moon in the tree branches. Am back now, listening to Izzy's "Over the Rainbow," preparing to read until Ken gets back. Casey used to play it over and over, and we sang it in the car at the top of our lungs. He needed hope and the beautiful. They were part of his vision, counterbalance to the darkness, the "emptiness." Where will we find you, my love? Above the chim-en-y tops.

October 9—Happy Birthday, Mom. Ten years ago today was your last birthday on Earth. You were eighty-two. I wonder what you knew in those moments before. I don't think I've ever wondered that, assuming that the aneurism in the lungs or heart caused sudden failure, no time for gripping your heart or chest even, just the slump. They said you were sitting on the portable toilet that they had next to your bed, where they found you in that crouching position, curled around yourself, your hospital gown open at the back, your arms loose at your sides.

Did some memory, unbidden, leap across the screen—some childhood moment, or later perhaps, what you wrote about as defining: lying beside your dying mother and gathering strength from her ability to soothe others around her, even when she herself knew what was coming, what was gone. Did you in those final moments finally understand what it means to live in the present-ness of time?

Or perhaps your last thought was of you and your father, sitting in a rowboat somewhere, quietly waiting for the fish to bite while all around the mist lifted. I don't think that as a child I got the right perspective of Lyman, wanting to hear about how he humiliated you, his roughness, his favoritism for Bob. But in reading your letters, and his, I

gain a much fuller picture of him, his humor, love of the outdoors, love of family.

Perhaps in your last moments, you thought of your grandchildren, or me, a flood of light and warmth filling you, knowledge that your love was returned, no matter how selfish we could be, or in my case, impatient. I'd like to think that. I prefer it to your being struck at the end with how alone you were, there in the hospital, in this town where we moved you, where you knew so few people, or in that apartment playing solitaire in the gloom of late afternoon.

Do we die alone, Ken asks? Did you?

Reflecting on death, my mother wrote home (March 26, 1944):

Funny how some mornings one has undercurrents of feelings which require a few hours for maturation . . . Dr. Lowe spoke on the Strategy of Jesus for those who must meet suffering and Death. About suffering he said, "Take yoke upon you for it is easy"—meaning accept hardship but make the most of it—the Greek connotation of the word "easy" being "useful." Of death he said, "It is the incident, life the eternity. Life goes on before and after—death is but a moment. A door, many mansions, and all eternity."

Along the same vein, she wrote:

In looking over (and perhaps overlooking) my life, I have come to the conclusion that while to an outsider it may seem a mite too serious, even grim, to me it is a very happy one. With a family very dear to me, though not all present on Earth, I have perhaps the richest of blessings. With a job that is engrossing and productive of the wherewithal for

satisfaction of my scholastic inclinations, I have a means of subsistence with a voice teacher who is at once artistic, intellectual, and sympathetic. I have a fine inspiration. With a church to minister to my spiritual needs and a choir that has the potential of doing likewise (certainly the director has the power now), I receive strength—a source of happiness. With good health, a comfortable place in which to live, a friendly atmosphere, good friends, a fairly idealist and practical philosophy, I have much for which to give thanks. Yet have I much to learn in the way of tolerance and charity.

Some 65 years later or so, her youngest grandson was trying to write his way out of drug addiction and depression. In sorting through the pages of writing he left, a few pages in this spiral-bound notebook, a few pages there, drafts of poems, even a napkin where he drafted his "Mysticnary" poem—we discovered a depth of introspection that I had not expected. I knew he pondered "deep" questions, and sometimes he would say something that let us know his line of thinking, but more often it was, "Stop getting in my business." He talked with Ken about some of his spiritual questions, so we know he was searching for what his work might be.

I know, too, that he was tormented; he told me once that he'd seen a demon snarling at him in the mirror. I found a drawing just last week in a big boot box full of papers of a sharp-toothed demon with the words, "I'm waiting for you," written over his head.

In a journal entry, Casey wrote, "My mom will be gone for a couple weeks, and I miss her." To which I reply: "I miss you, too. Every day, every week, every year, my lifetime and the life we should have had together." I see so much similarity between Casey and his grandmother, though she was a passionate scholar with a good education and he, handicapped by a weak education and a string of "special" schools and programs as he struggled with addiction and moved in and out of trouble. They were both seekers.

His grandmother revealed her feelings openly, in letters to family, he in fits and starts, writing privately of his trials and tribulations. He was "going over the mountain" and probably would have always done so—perhaps nearing the summit, glimpsing "the other side." It's that honest struggle that they shared.

III—THREE YEARS

Three years after, to the day, I have come up here to read some of his writing. He was searching, intelligent, but so often discouraged about his life. He was reverent and wrote a lot about God and the greatness of his life or any life with God, but it is overwhelmingly sad.

Tomorrow I go to Hopkinsville to celebrate Ken's birthday—going out to dinner with Taylor and Julia. Then we've got some candle balloons or whatever they're called that we'll light and send into the night. For Casey.

I am reduced to (uplifted by?) symbolic acts. Ritual actions that open a space for us to be with him in some real sense. I don't know what I hope for—mostly I want Casey to know that we miss him and love him. I think of him as a consciousness somewhere that still holds onto his connection to us. I want him to know that we're doing everything we can to honor him. That he is not alone . . . out there. The lifeline is still intact. Maybe it's I who needs all that—I am not alone here. This awful absence is not complete. He's loving me, us. I have not cried too much for several months, but I did yesterday when I watched the retrospective again, and I am now.

November: Today is Tuesday and I'm working at home. I've just put on the *Requiem* since I've not listened to it for a while and am feeling unmoored. I posted something on Blackboard for my course, the minimum I felt I could get away with. I submitted two batches of poems to two journals. I read a little. Ate some banana-almond butter-lettuce roll-ups, drank coffee. Watched the birds. Chased a couple of squirrels from the yard.

The leaves in the oak are green and brown mottled, heading toward the brown that precedes the fall to Earth. Another cycle, telling me how permanent loss is. I said to Ken that I keep looking for meaning. I look down paths that lead to walls and dense thickets where there's no finding my way out. I stop, turn, look again. Some people say that death's purpose is for the living—some lesson from the aching heart. What conceivable learning can we gain that we couldn't have gotten a better way, with our son at our side? I see no lessons for me here. Appreciate what you have, use time wisely, be kind to others, let go of old bitterness or grudges. I want to call out, now what? Where is the peace of mind? When can I see my boy and hold him?

Promises, promises. What future after death can alleviate the suffering in the now? I don't see it. How busy does a life need to get before the hurt doesn't crowd the eyes?

There is a period after every incremental step in this process of living without Casey—the trial, the second-year anniversary, the discovery of another piece of his life—when we descend, sliding, into a place where the grief is heightened, where the pain takes hold of our bodies and then enters our minds intrusively. We are more sensitive, maybe even paranoid—about what people say. What do they mean? Are they suggesting -----? Instead of making me more other-oriented, I feel the magnitude of self.

I want to embrace him. Touch him. Hear him. That longing has stretched and gaped inside me. There is no point in speaking of it. The only people who understand are those who are where we are, and even then, there's nothing to say.

On the way home from Hopkinsville this morning, I was thinking about the way the mind wraps around feeling to make it into an image or a story, making sense of it, placing it in a context. I catch myself feeling something, and then shaping it like folds of a shawl, gathering the feeling in and writing it out as a part of a poem. Then it is the poem that has my attention, and with it, all that goes along with being a poet—finding meaning, wondering if the image achieves that, if others will get it. The feeling becomes a thing I use to stroke myself. Thus, I turn everything into something that will feed the self, which is starving. I don't like that.

But this morning I was thinking about something Ken is planning to write about—the underlinings and marginalia that Casey wrote in *The Warriors*, which Ken teaches and had given to Casey his last Christmas. The marks tell a story: words he didn't know, ideas he liked, passages that spoke to him. The same with his underlinings in the Bible . . . Ken's dad used to do that when he was a med student. I think of my uncle, memorizing words and meanings, an expert at crossword puzzles. Words as solace. I had an idea for a poem, too, which now escapes me. Did it have to do with the underlining?

Thursday was so sad it wanted to run away. Molly's mom died that morning. I played hooky, and at the end of the afternoon headed to Hopkinsville the second night in the row. I found myself narrating, like looking through the wrong end of the binoculars—in fact, there was a sense of everything rushing away from me. "She's got a lump in her throat . . . she's playing a game now . . . she's thinking about how to promote herself . . . don't dare look at a picture . . ." until the floodgates opened, and I snapped back into myself in one long howl.

I don't know if there's anything more to be said, here ten years and a day after my mom died and starting the third year since Casey died. Do the same word configurations work? Are they the same but we are different? Or are we the same people, just layered by what happened: parents wounded and longing for the boy?

Some weeks ago, Ken and I were talking . . . I'd re-read some of Casey's journal entries and was saying that he was sad so much of the time. I started to say, "Even his writing about God," and Ken finished my thought, "It was tortured."

Maybe it's working on Mom's letters, editing the time when Isabel died. We live day to day never thinking about how little time we have. It's hard not to wonder what the point is. I mean, I know— it's to love and be loved by—each other, the Earth, to grow, to step back, and let others grow. As Casey says in "Mysticnary," "Don't look too far down the road . . . life shouldn't be taken advantage of . . . rules are not set so that we will be miserable . . . Figure out the meaning of life by living it." I think I'm doing that, my son, but something feels mislaid, and I can't get my hands on it.

Adrienne Rich wrote, "The moment of change is the only poem." Reading my mother's letters in the context of Casey's is a long poem, entwined voices from until.

Dream

I dreamed I was in a lake at waist level. I was with Casey, who was a little boy, and then he was missing. People began searching for him, feeling under the water with their feet and arms. I was looking, too, and then I had to go inside, perhaps to look for him, but I felt bad leaving, and when I came back out, I had no top on, so I was covering my breasts with my arm and looking for him with my other arm. I am eaten up with guilt, a bad mother—what once filled with what nourished him now exposed. What is the water? Place of death? Life? Whenever I dream of this beach scene, there is threat, from tidal waves or something else.

I was watching the birds at the feeder the other day and thought about Casey, in particular the time when he had gained so much weight. I knew even then that he was eating out of pain. He would spend long hours in his room, and I remember at the time thinking, *Well at least I can get this work done.* The boys were

having so much trouble and Casey was beginning to fight us. I didn't know what to do. I failed them. I left my missing baby and let others search for him in the ocean while I ran inside to take care of my own needs.

December

Last night, Ken had a dream that he and Casey (and others) were made to stand on a ledge. Ken had his arms around Casey and Casey was angry that they were going to be killed, then was crying that they wouldn't be able to hold on. Ken kept telling him that he wouldn't let him fall. Even while he dreamed, he knew that he was dreaming and was grateful for the opportunity to be close to him. I'm glad Ken has that sort of dream where he touches Casey and Casey talks to him. I want him to come to me as well, and it doesn't matter if it's "real" or not. What is real—this place where I straddle my daily work, the living world, and this world of grief and longing, the expression of what's beyond understanding?

Last week on Tuesday, when I didn't go in to work, I stood at the front window looking into the gray sky and pled for him to be in touch. For a moment, all the details of the landscape faded and there was just this gray reaching out for Casey. It seemed that by force of my own longing, I had in fact contacted the *place* where he is. It was as though I was knocking on the door of a vast structure and did not know if I could be heard, and if so, by whom.

Today is Tuesday again, and I am weeping again and staring at the tree outside my window where the gray has caught on the branches and wrapped it up in sorrow. I don't know what makes me a mother—my female parts, the caring I have done for my three boys, the failure to protect them, or this longing for my boy to give me a sign. I think a lot about being dead myself, when that will happen, Ken first or me. Whether I will finish anything I've started and what it means if it ends up not mattering to anyone. What "good

energy" have I put into the world, and what possible healing have I offered to this broken place, this world we have broken?

Not my mother's child

Omni singing in the car: "There's a lot of weather that's raining / with only a little bit sun / We don't know where it's coming from / but pro'bly from the sky . . . Oh-oh-oh, Wah-ah-ah . . . I just can't take it anymore /. Oh-oh-oh, Wah-ah-ah . . ."

I've been thinking a lot about my mom these days, marveling at the maturity her letters show, for a 19-year-old determining what her life will be as an adult. I look at my boys and remember how, years ago, she tried so hard to interest them in "higher culture": music, reading, history. And I look at how three sons struggled to be literate, let alone "cultured." What happened in the transmission? I was steeped in it. She may have been brilliant as a pianist, but I was a clumsy, stumbling player, not much better with flute. Impatient with museums. I did love reading, and do, but so far, the boys don't. In his last English class with Paul B, Casey complained that he couldn't write a book report, no matter how well he did at identifying key passages. "This is too hard for me." And yet his teacher sent us a message, saying, "He would come to my office to get help with deciphering a short story when he was struggling— something none of his classmates made the effort to do. I respected him for that. He was always polite." Despite this, he withdrew from classes. Maybe their literacy is "elsewhere"—Galen's with his hands in clay, Adrian's with his sales, and Casey's in his music, his soul-searching.

I'm making space for grieving for what appears to have stopped with her daughter, this relishing of musical performance, how she used to be swept away by the emotion of a piece. Right now, listening to Christmas Adagios, I remember how she loved choral music. One time, back in the 1990s in Louisville, my brother, sister, and she sang madrigals while she played the piano. I sat there

rolling my eyes (inside). But now, reading her writing about her madrigal performances, others' "radiant" voices, I am chagrined. Here, in 1938 at 19, she writes home that Madame Flagsdstad has a "radiant personality and a radiantly warm voice," and transitions to her brother, saying, "How about it, Bob? Are you going to let them write you up as radiant, vibrant, etc.? Come on, show'em." Countless passages about musical performances, her own and others'—it was the air she breathed.

At 19, I was getting stoned and experimenting with downers, thinking about boys, and listening to rock'n'roll (still do)! In over a year of letters, still no talk of boys—just music, classes, family, and girlfriends, more music (food, snow, the cost of things).

What geometric pattern represents YOUR family?

Isabel, who my uncle called a "saint" and a "peacemaker" and whom my mother adored, suffered from heart disease. One family story tells of the doctor advising her to either stay in bed half the year and live a reasonably long life or live fully now and die within a year or two. She chose the latter. Uncle Bob told his daughter, Bette, about a trip he took with his parents and seeing Isabel's calves swollen "this big" (8"-9" diameter). Mom used to tell me how she'd lie down beside her, and peace would come. These stories filled my imagination when I was young and living alone with Mom, and I came to believe that she was my guardian angel, looking over me across the edges of the picture frame.

Bob wrote to his dad, a letter in which he described their family's shape as a parallelogram, which changed to a triangle when Isabel died. For many months afterwards, LR, Betty, and Bob all signed or began their letters with a triangle, often with each corner darkened. Eventually the practice fell off, but I love Bob's imagining a symbol for the family and how the parallelogram had to be revised after Isabel died, but it was still strong, a triangle.

What happened to my family's shape when we lost Casey, the youngest son/brother? I don't know, but it's darkened. I was talking to Bette a couple days ago about how I have to "go to" Casey periodically, or the pace and business of life simply overwhelms. When that happens, I can't bear to look at another person until I've had a chance to go down there where it's dark, sometimes quiet, other times stormy, and embrace him.

The "shape" is that of a large and jagged rock tossed into the river of my heart. The ripples jar the edges of consciousness until I dive into the opening it's left.

About Motherlove

Two 1943 letters appeared in an envelope from Betty to LR. The first, from Bob, talks about how he remembers their mother, on Mother's Day. The second excerpt, from Betty, gives her dad the "go-ahead" to remarry:

My dearest sister, . . . Needless to say, this Mother's Day has brought to mind many recollections of Mom. My white carnation is big, very fragrant and as white as can be, so symbolic of her purity and loveliness. So many times, I could kick myself in the pants when I think of the lack of due devotion to her I manifested. Isn't it too bad that we cannot recognize virtue, or anything good, until we are deprived of it?

I have found nothing, and probably never will, that can compare in value to the example set to us by Mom. In fact, it's hard to realize how such a perfect woman could exist. We'll never know all the unselfish devotion for us and sacrifice made in our behalf which she possessed or underwent. Without hesitation, I attribute all my little successes to traits inherited or learned from both Dad and Mom. And there's no question about it. So fixed as Mother in my mind that yours will never fog my memory of her. My prayers aren't finished without a plea to God that more sons and daughters be blessed by such a Christian mother as he so afforded us.

It sets a person thinking, doesn't it? I've enjoyed this day of meditation extremely. It's been a rare treat.

---and from Betty, on her birthday---

Dear Dad, Curiously awake at the rather potential hour of five-thirty, I am suddenly astounded to recall that an anniversary is at hand. In former years I fear I have been very childish in the recognition of what such a day really means. Like the material-minded child on a Christmas morning, I have secretly asked, "What will it bring me?" This question is not present in my contemplations today. Rather I am filled with a sense of obligation and gratitude for what has come to me since the day of my birth twenty-four years ago. What Mother went through then, with you away, is difficult for me to comprehend, but I realized it was a great crisis for her. What, too, you both haven't had to go through in those twenty or twenty-two years of "bringing me up" fills me with not very much esteem for what I have done with those opportunities—not in the sense of worldly accomplishment but in the vastly more important sphere of humanity in general and our family life in particular. . . .

So, what am I thankful for? That my mother was emotionally open (even if at times, as is perhaps always the case with a strength, it is also, if inverted, a weakness) and that she left me these letters, so that I could discover, in my fifties how amazing she was at 25? That both these siblings are the root and bone of our families today? Okay, yes.

IV—THE MOMENT OF CHANGE

6th Grade and Middle School, 2000-2001

While Casey started middle school, his older brothers were graduating from high school (2001 and 2002). Galen headed to Western Kentucky University as an eighteen-year-old, and the following year, Adrian left Kentucky to attend Installer Institute (car sound systems) in Daytona. There he met Latoya, who would become the mother of his daughter, Omni, born in 2004, and our dear friend. I went up for tenure and promotion in the fall of 2001, and Ken started teaching at Hopkinsville Community College. My mother moved to Bowling Green and surrendered her car after a minor accident. I visited her every week and brought her home for visits, but it was hard for her, though she did make friends with a neighbor. I see her playing solitaire or her piano, cataloging family pictures, browsing recipes in *Gourmet* magazine.

In May 2000, when he was 11, we took Casey to the Children's Crisis Stabilization Unit (CCSU) for the first time, located in a beautiful, old Victorian home. Casey had been referred to local child psychologist, Cathy Reeves, and to Dr. Scott Littleton,

for medication. When I began researching Casey's records, I called Dr. Littleton, and although he didn't remember a lot, he did recall one incident. "I think it was Casey being disrespectful, and I asked him to write an apology, which he did, but in BBQ sauce, which struck me as a passive/aggressive response. I never felt like I connected with him. Junior high age is either the best or most frustrating. Kids have to admit problems, and boys have to have hair on fire to get them to recognize there's a problem." Ken remembers another incident when Casey refused to participate, so Dr. Littleton made a deal: "Let's arm wrestle, and if I win, you participate, and if you win, you don't have to." Casey lost. And I remember a time when Dr. Littleton and I were trying to get him to talk. He slid down in his chair and then rolled over, hugging the seat so that his butt wagged at us, a clear indication of what he thought of us.

This period is a blur for us, so our primary source of information is the file I obtained from Life Skills, which ran the CCSU. In the entries below, I have removed the repetitious entries, such as for medications and other routine entries, but kept in the abbreviations and minor mistakes. This first stay lasted 11 days.

May 8: Admitted to Underwood Jones House (CCSU). Cathy Reeves, therapist. Dr. Littleton psychiatrist. Prescribed Seroquel ½ tab, 25mg bedtime. . . . Parents' description of problem: out of control, angry, non-compliant, uncooperative. . . . Client's perception: "same thing." Psychosocial stressors: "was mugged" [we do not recall this] . . . Lethality Assessment form: Comments: "Makes idle threats, says things but says would not do it if he had the chance." . . . Psychosocial form says: presenting problem: "beyond control—hitting mother, threatened to kill father. Client refused to say other things he had done." Under Family Constellation: "usually picked on by brothers. Make fun of him." Assaulting others: "yes"; Sexually abused: "no." . . . Strengths: "average/

above functioning, family support, mobile by self, good physical health, good selfcare."

May 9: Goal: Learn house rules and staff/peer norms. Shift Note: 0700: Ct was oriented to the unit as 2330. Ct went immediately to bed. Ct noted to be resting with eyes closed. 1300: Ct very quiet. Keeps to self most of the time. Ct following house rules and staff direction. Ct does at times feed into peer negative behavior (telling secrets, inappropriate comments). . . . Ct has been quiet and withdrawn.

May 10: Global assessment of functioning: No significant behavioral acting out noted, however defiant like behavioral interaction very prominent. Stated "I'm violent" when asked what problems he was having.
Goal: Why do I abuse my parents? Beh [stands for "desired behavior"]: Take responsibility for my actions. Shift Note: 1200: Ct has complied with chores, goal group with redirection to stop making noises and antagonizing younger peer. Ct complied with school. Ct left with father for appt with Cathy Reeves (therapist) at 0915 till 11:00. Father reports ct did not participate in therapy session. When asked why placed here ct reports "I don't know" then states "violence and out of control." Ct is very superficial when asked about anger management. 2154: Ct has been compliant with chores and both groups. Ct required numerous redirections after phone visitations. Ct was placed in time out for not following directions, singing inappropriate songs, and being sneaky. While in time out ct began mocking staff. Ct continued to be non-compliant throughout the rest of the night. Ct became very superficial and refused to talk to staff.

May 14: 0915: Ct was seen grabbing ct Tyler in an aggressive way. Ct stated that Tyler provoked him. Both cts were separated. 1350: Ct has complied with chores and group activities. Ct is quiet and reserved. Has not talked with staff. Ct had visit with family. Ct is on green level. 1500: Ct became upset at end of visitation. He wanted to go home. He was not respecting parents. MHS intervened. Ct threw grass at dad and was verbally aggressive with parents. Ct will say or do anything to go home. Ct has appt with his therapist on Monday. Ct didn't want to go in but later complied. Ct is calm and doing better. 2100: Ct participated in recreational activities and group projects. Ct has maintained flat affect throughout most of shift; occasionally becoming bright and cheerful when playing games with peers.

May 16, 1500: Ct has complied with school, chores, goal group, and outdoor activity. Ct has needed redirection to stop telling secrets and being sneaky at times. Overall good shift. 2030: Ct had visit from parents. Visit didn't go smoothly. Father went out on porch while mother finished visit. Ct came into goal group with an attitude. Ct becomes hyper toward evening and with music. Ct is on green level.

CCSU Progress Note: Behavioral: defiant. Affect: anxious. Client was not very cooperative. At first, he did not remember why he hit his mother. Then later said he knew but did not want to tell me. We discussed the outing to see his therapist on 5/15/00. At first, he did not want to tell me what happened then later told me he had been yelling about something, refusing to say what, when some boys in another car started making fun of him. He in turn made a rude comment and called them a name. His father then apologized for his behavior.

May 17: 1100 Ct has had a rough start this a.m. Ct refused repeatedly to get out of bed. Once out of bed ct refused to change out of dirty shirts and needed verbal prompting to make bed and complete chores. Ct responded to interventions with sarcasm and obstinate behavior. Ct finally did respond when program manager spoke to ct. 1500: Ct has made a vast improvement from earlier in shift.

May 18: Shift Note: 0600 Client slept restlessly all night. 1500 Ct has complied with chores, goal group, and outdoor activities. 2100: Ct had a visitation from family, and it went very well. Afterwards, during goal review group, when asked how he was feeling, ct stated, "Happy because I got to see my parents." Ct was appropriate with interactions with staff and peers.

May 19: CCSU Progress Note: Completed psychosocial on client. Client did not want to answer questions. Continued to look out the window most of the time giving as little information as possible. Client showed little emotion throughout the session. Work toward discharge by 5/22.
Shift Note: 1100 Ct needed much encouragement to change clothing slept in. Ct has very poor hygiene practices. Ct has complied with chores goal group and group activities. 1500: Ct affect dropped following lunch. Ct b/c angry. Ct participating in family session with Cathy Reeves.

The CCSU typically allowed stays of up to a week with preference for shorter stays. This was the first of three stays, always at the point when we had exhausted ourselves trying to solve the growing problems on our own. His violent outbursts would escalate, and he would refuse to do what we asked. We had learned about

restraining, something that Glenda (the therapist who worked first with Adrian and the family and then with Casey) taught us to use in extreme circumstances as a way to deescalate out-of-control behavior that could lead to someone getting hurt. One time during family therapy, he was being disrespectful to us, refusing to cooperate. She walked over calmly, sat him down on the floor, and then wrapped her legs around his middle. When I interviewed her, Glenda recalled him calming down quickly, though he was not happy with her. We attempted restraining him once, holding him down on the floor of our bedroom, where he was screaming at us and threatening to kill us. Red-faced, he struggled fiercely, spitting up at us. Time blurs the sharp edges, as we careened from one stressful, hurtful incident to another. Helpless much of the time, pushed to the limits of my abilities to act positively, I cried, yelled, apologized, begged, accepted apologies, and then watched the same snarling attacks, walked on eggshells, fearful when the phone rang.

In July, we all headed to Switzerland, the five of us and Mom, who paid for the trip. It was a wonderful time, full of adventures and good relations. Galen met his first girlfriend, and they'd sit on the back of the bus kissing, to everyone's amusement. The trip, sponsored by my mother's alma mater, the University of Rochester, was designed for families, with both adult and kids' activities every day. The biggest challenge was a climbing trip the three boys and Ken took up a glacier and down into a crevice. We have a picture of them afterwards, red-faced and jubilant. Casey is flipping the bird (with both hands). I helped Mom create a travel book for the experience, and the hikers wrote the following accounts:

Casey: Ice climbing was fun, but really hard. You have to have a lot of equipment. When you're climbing up you have to have a jacket because it's cold, but you also get hot from the hard work. Hahno was cool and very funny. He reminds me of Mr. Johnson, a teacher at my school. I don't

think I'd do it again because I got big old bruises and scabs on my ankles. Maybe I had the crampons on the wrong feet.

Adrian: It was exhausting. It was fun. The hardest part was climbing up, keeping your endurance up. My chest hurt a lot. It was still one of the best parts (but I also liked the fact that the legal drinking age is 16, so I could have wine with dinner).

Galen: I am simply the greatest climber ever. I know some people who think that a sport can only be a sport if there is competition, so they say that climbing isn't that. Well, I found more than enough competition pitting myself against the wall of ice. Ice climbing was my favorite experience from the trip, because it took me to the limit of my strength and will. That's why we do anything, right? To test ourselves, and to see how much we can accomplish. Switzerland is the most amazing, different place I've ever been. Note my strong protest to one of the following pictures.

Ken: Though I tried to put a brave face on things at the time, I can now safely confess that I approached the ice climb venture with fear and trepidation. As it turns out I had good cause because it was an excursion that really pushed me. Surprisingly, the biggest push was not in the descent into the crevice but the ascent up the glacier. The ascent was about an hour and a half hike up a steep incline, with heavy gear.

Casey turned beet red with heat exhaustion, and we had to make a stop to divide up his carrying load and also to take off several layers of clothing. Our guide, Hahno, was a great encourager, and Casey was perhaps the unsung hero of the group being the youngest on a very athletic hike. Tested to somewhere near the edge of my limits, I was rewarded near the end with a special vision--I started to see rainbows everywhere! We were all relieved when we

finally made it to the crevice and took a rest while our guide made preparations for rappelling down into the crevice.

On our way back down the glacier, with our climbs behind us, everything seemed to be downhill. The glacier also spoke to us as we left. I have heard ice crack on lakes and ponds before, but it was nothing compared to what we heard when the glacier's shifting led to a rifle crack report. It was followed by a kind of ricochet sound that seemed as if reverberations were passing through the ice back and forth several times through a myriad of cracks and fissures.

The trip to Switzerland was an extravagant but characteristic gift from my mother, who loved traveling and always promoted cultural experiences. It was also a kind of "let's pretend" trip, and I remember holding my breath on a number of occasions that the boys wouldn't cause some kind of trouble. Aside from wanting to drink every time wine was served, they were wonderful. Back at home, the avalanche of problems resumed.

During sixth grade, we met with Casey's teachers, the school counselor, or the principal a number of times. One of their concerns was Casey's acting like a bully. A vivid memory has me sitting at a table lined with school officials and a woman I'd never met from the system.

She opened the meeting: "So, what's up with Casey!?" I distrusted her false cheer, starting the meeting with phony concern for Casey, but I was defensive and probably hyper-sensitive; now I'm not sure how she might have opened the meeting that would have put me at ease. But I hated that I cried.

In a response to a letter Adrian had written while he was at Sively House (one of four residencies during this period), Casey wrote, "Dear Adrian, I can't help 2 worry. I quit because the [football] coaches are 2 damn hard! I can't stand a couple of kids! They will tell on everything I do. I feel like kicking there @ss but I know they will tell, and I will get in trouble. I am not sure if worried

is the word, but it sucks without you. I will probably come and visit if you want. I am not going to become a [couch] potato because I start Going to the Preston Center. (I don't know y going is capitalized it did it automatically.) If you don't want me 2 worry I won't. I will still miss you. Sincerely, Casey Olmsted P.S. Hit me back!"

By the end of 2000, Adrian's residencies had come to an end. We probably spent Christmas with family in Florida. In January and then in March 2001, Casey went to the CCSU for the second and third times, for three days and then eight days. The reports are similar to his first stay: "agitated, out of control, hostile, withdrawn, flat effect, wants to hurt himself" modulating to "appropriate interactions, wants to go home, compliant." These three stays offered blessedly calm times at home when we got a glimpse of what life might be like without the blazing rages, slamming doors, objects flying through the air, voices raised and strained. We worried over what we could do differently, and at night, I wracked my brain for miracle solutions.

By this time, Ken and I had been struggling for over ten years with our sons' individual yet interrelated and escalating problems, but there would be no easing for another ten. What was the cumulative effect of such struggles—on the children, on us—as we careened from one coping mechanism to another, often with love and hope the only things to carry us forward?

The summer of 2001, Casey began attending the Middle School Learning Center. The director, the wonderful Clay Smalley, met Casey and me in his office. Casey sat with a scowl on his face and his arms crossed.

Mr. Smalley said, "Why you got that chip on your shoulder? Do you have a place to sleep, a roof over your head, food to eat? Stop acting like the world owes you something." Casey had begun gaining weight, a sign of his growing depression. One night, he, Galen, and I went to the mall. Casey was dragging his feet, not coming when I called him to keep up. Finally, Galen grasped him

by the back of the neck and propelled him toward the exit doors. He was near tears, and when we got into the van, he sat in the back, scowling. Galen and I talked, though according to him, "You and Galen laughed like I wasn't even there."

Was it around this time that he made the necklace made of red yarn and a message spelled out in beads: "forgot about me"? It hangs now over the edge of one of our framed photos, where it tugs at my heart—was he paraphrasing Jesus? Or making a statement, telling his parents, "You forgot about me."

Casey was asked to leave Sunday School. The teachers had tried to work with him, but his disruptive behavior became too difficult. Much later, when he was in high school, he was able to participate again and enjoyed church. In September, Casey transitioned to the mainstream Moss Middle School, after 60 days at Middle School Learning Center.

On October 25, Casey skipped school and served a day in detention.

On November 19, my mom died. About two weeks later, we held a beautiful memorial for her in which we played, as she had asked in a letter to me, Brahms' *Requiem.* Ken and I had anticipated that the boys would have trouble sitting through the hour-long classical piece, especially Casey, but they all sat respectfully through the service and afterwards during the reception. It must have been a sad time for Casey, because he and Grandma Betty had been so close, going back to the years in Minnesota. For me it was an incredibly stressful time. It was the semester that the artist Judy Chicago came with her husband, Donald Woodman, and worked with twenty students and local artists to create a revisioning of Chicago's 1972 Womanhouse project, a project we called "At Home in Kentucky." Dealing with this demanding artist involved putting out one fire after another, and yet I'm proud of that project, which resulted in a six-month exhibit of a house the university let us use, each room exploring a different aspect of domestic life. Galen was a freshman and created the sibling rivalry room. Other rooms

explored married life, old age, childhood abuse, eating disorders, and prejudice, and in the garage, pornography and rape.

On December 12, for failure to complete homework, Casey spent another day in in-school suspension. On December 17, he was charged with possession of marijuana at school and suspended for five days. We confronted Casey, and he said he'd gotten it from a neighborhood boy. Maybe we went to the house, but there's no doubt an angry mother said it was Casey not her son and that he was to stay away from them. I wanted badly to believe Casey.

I wrote him a letter on December 1: "Dear Casey. As you head into your first year as a teenager, I hope you will work hard on developing your mind and your generous, loving spirit, and letting go of your anger and jealousy and insecurity, because doing those two things is the way to success. You have so much going for you— intelligence, humor, charm, generosity, and these make you so easy to love and to be with—not only for friends, but family, too."

On January 17, 2002, Moss Middle School expelled Casey for possession. He transitioned back to the Middle School Learning Center. By this time, Adrian had met Latoya and she and Casey became instant friends, an abiding solidarity that survived break-ups and every other trouble. About that visit, Latoya says:

> He was full of questions. Oh my goodness, I didn't think anyone could be filled with so many questions. And stupid questions is what I thought at the time. He did that on purpose, like, I know I'm annoying this girl, but I'm going to keep doing it. It was probably about why did you come to Kentucky? What's it like in Daytona? I know he asked about my family. Probably why is the sky blue? I think Adrian told him to stop messing with me, but he didn't listen.
>
> I do remember this, that Casey ruined the word safety, even though I'm a safety manager. Because every time he farted, he'd be like "Safety." I'd think, *Oh my goodness.*

So, he introduced me to the word, "safety," just in a different way. I remember what he looked like at 13. He'd wear this red shirt, khaki shorts, and high tops that he'd never tie. Just threw them on. He was at his overweight stage at that time, with those red cheeks and that smile. A pinch his cheeks type of smile.

In the fall, when he was to enter seventh grade, we decided to send Casey to a private school, and University Heights Academy admitted him conditionally. He would go to Hopkinsville with his dad and stay at the apartment there, coming home during the week once or twice, and then again for the weekend. He decided to go by "Lee," part of his fresh start. But it was tough. Ken remembers one incident when Casey spat in his face. Ken spat back, but due to a low level of saliva, he spat twice. This seemed unfair to Casey, so he spat again. This continued a while, but finally they realized that some kind of equity had been achieved so they stopped. Later they laughed about it and noted that it's very unpleasant to be spat on.

Ken would sometimes call on his friend and colleague, Brett Ralph, who Casey thought was cool. Brett told us about the connection he and Casey had:

At first, I was into lifting weights, and Casey was interested in that, and that was a point of connection. We might have worked out here at the college once or twice, but it was just something that I understood and could talk to him about.

The first time, we went out to see the remake of *Dawn of the Dead,* which was super violent and over the top. We'd decided to go see a movie the next time we hung out, and Casey didn't really want to see any of them, and I didn't, and we just thought that's what we should do.

Then the second time we went out, we knew we didn't want to go to a movie, so I said, "Do you want to just go

get some dinner?" And he said, "Where do you want to go?" So I said, "There's nothing good here, let's go to Clarksville." And he said, "Do they have a mall there?" and that's when he asked me if we could go shopping. It was December and he wanted to go Christmas shopping together. Cuz I like to shop and I'm good at it and he seemed a little uptight about picking gifts out for you all and his brothers. And I helped him, and he really got into it and was happy, and then that became our tradition. Two or three times we went Christmas shopping together.

I don't know if you remember but he wrote me this really sweet, apologetic letter from juvie one year apologizing for not being able to go Christmas shopping, and you know, canceling our annual tradition because he was locked up. But he wrote me just telling me how much he enjoyed doing that. It's the only letter I received from him. . . .

Brett's memories helped confirm what we felt—that Casey was not just a surly, unhappy teen-ager, that his inner light and affection for others had not died. A writing assignment from then gives a glimpse of his sense of humor and adolescent preoccupations. He titled it "Club Hop Town," a teens-only restaurant. "Parents, if you're worried about your kids coming in here—don't worry. The menu is healthy. For example, we have salads, soups, and pasta." Furthermore, the theme was "getting away from adults. Four TVs are there. One TV has football games, one has basketball, there's one with music videos and one shows a movie." There was no dress-code, and the best part was probably the "dances on Friday and Saturday night from 7-12. You can bring your music. The cost is four dollars at the door. We have an open mic competition with judges—the winner gets a free meal."

Another "eyewitness" writing assignment relates an experience he liked to recount, when his knee popped out during boxing practice:

"Last week a very strange thing happened. While I was hitting the big bag, my kneecap popped out of its socket. It hurt like crazy, and I fell down. Jeff didn't know what to do, so he called my mom on her cell phone, but she had left it in the car while she went walking. After about ten minutes, my kneecap popped back. We went to the emergency room, but the wait was going to be two or three hours, so we decided to go home and ice it, which is what they would have done. No one could believe it happened. It's very rare for a kneecap to pop out just because you hit the bag. . . .

"I'm glad I signed up for boxing. It was really fun (except for the knee incident). I can't wait until I start competing."

If the record is largely silent about the bulk of 2003, including the conclusion of eighth grade, there is no reason to believe that Casey's troubles were over. During this time, he became obsessed with music—a common enough thing for a teenager. I hated the rappers, Bone Thugs & Harmony, pot-smoking music that spoke to his growing obsession with marijuana. One day we went to Barnes & Noble, and while he wandered off, I sat down to browse a magazine. A few minutes later, he appeared behind me with a book about mj—"weed" was his word for it. One of the photos showed a plant with purple buds. "Look at that, isn't it beautiful?!" His favorite doodle was a five-leafed marijuana plant.

9th and 10th Grades, 2004-2005

After the private school experience, Casey returned to the Middle School Learning Center in Bowling Green. He also attended Day Treatment, a program for high schoolers who'd been kicked out of school, usually due to drugs or violence. In his Relapse Prevention Plan, Casey noted that he was in Day Treatment for eight months and 45 days at Care Academy. On my birthday, he was

found in possession of marijuana at the high school, and on the 25th of February, he was arrested. On April 7, the Warren County District Court ordered that: 1) Casey be placed on probation with DJJ and he fully cooperate; 2) Casey be assessed by Warren County Day Treatment and follow all recommendations; 3) Casey to comply with reasonable rules of the home; 4) An automatic pick-up order be issued to be activated by the court for any violation; and 5) 30 days in detention with him to serve ten days. Review 5/12. Total Yard. "Total yard" refers to the restrictive curfew requirement that he could only be at school or home.

Two letters on April 9-10 from the Warren County Regional Jail show his preoccupations and his "cool" colloquialisms:

Dear Mama, What's up. This is your baby boy. Nothing going on here. I only have 20 minutes to write this letter. I just talked to you about 10-15 minutes ago. I done a lot of reading since I been down here. I wish I could get a more interesting book. It ain't all that bad here, but it's 10x worse than at home. Tell Galen to tell Chelsea that I love her and I'm going to call her when I get back. . . .

[All caps and 1" tall] I'm dying to listen to music. . . .

ne wayz, Peace I'm out (on Friday...hopefully) Love, Mr. Olmsted HA HA HA

Dear Papa, Word hommie. I bet that when I get out of this mofo I won't be coming back! It's getting on my nerves to have to ask permission for everything. At least the food is alright. And I probably keep getting in better shape. I'm listening to music. Anyways I guess I'll have to keep living with Mom, but F it I deal with it. Write me back. I'm reading the book *Holes* right now. Just started, somebody took the book I was almost finished with. How's life on the outside world? Try to find out if the new D1Z [?] CD is out. I got six mo days; I think. I hope. I get out

143

early on Friday. Questions: 1) How Adrian and Latoya doing? 2) How are the dogs doing. [draws out] Peace Love, Mr. Olmsted Write Back [big letters]

Latoya later recalled that "what Casey and I shared was his love of music and his poems. He loved to rap. I wish I could get hold of his recordings. He would go to the studio and record music. Music was really big. We listened to music together a lot. He sounded like Flip the way his voice flowed. I told him that and it made him really happy."

In May, he was suspended for seven days for profanity toward the principal and staff and out of control behavior in the office area. The consequence was to "attend day treatment daily with no problems." A letter from Adrian, then in Daytona Beach, shows how concerned he was:

Casey, I am writing this in a very shaky truck so bear with me. It was wrong for us to smoke weed at Mom and Dad's house. First off, because this is our parents' house, and I had no right to come up there and shake things up.

Next is the question of maturing. You are really mature around me for the most part. It's just when you get around Mom and Dad that you act a fool Casey, every day of my life I think about how badly I mistreated Mom, Dad, and Galen. It was really awful. You remind me of me.

I have found that the main reason I got into trouble was . . . so people could look my way, attention, being cool, however twisted that is. A bad ass, Slim Shady, I just don't give a ---------. There are other ways to enjoy yourself. Try other things. Get some girls. The guitar is cool and is fun! I like gardening, but to each his own; whatever you do, get into something. Being sent away for nine months was crappy, depressing. What kept me out the last time is I wanted to have a life. I wanted a woman, a job, $$$.

Casey, I'm not saying don't smoke weed. It's too late for you to quit completely. But definitely chill on it. Get your head clear. R U responsible? Dude, when I was your age, I was not smoking anywhere close to the amount of weed you smoke. You got to find an outlet.

Bowling Green is the most boring city, so what do ya do. Smokey Mountains! That's why I think you would do good living with me for a while. But when you r older. 16? If you have shaded up. Well. I love you, Dogg, Adrian.

Brett Ralph, Casey's Christmas shopping friend, spoke similarly about the ethos of hip hop and Casey's struggle to grow into manhood in his own way:

I remember that I was into music and Ken was kind of horrified by Eminem's music, and I was not. I thought, *Well, he's just the Johnny Rotten of hip hop.* You know, there's always going to be the angriest man alive in every generation, and we need that guy. That guy's a proxy for us to express unexpressed rage or violent aggression.

I saw Casey as someone trying to figure out how to be macho and manly, and maybe I tapped into some traditional ways of doing that. I was into football and weight-lifting and violent music, and we could connect on those things.

Having been a punk rocker and into stuff my parents and everyone else disapproved of, I got that. I'm sure it's hard for parents not to worry about everything their kids are into, and I was relieved of that worry, so maybe he could share those things more readily. It never seemed to me that Casey couldn't communicate with you all or be honest or that he needed another outlet. We didn't talk in depth about stuff, and I didn't want to be a surrogate parent.

I just wanted to be his friend and hang out with him. I just really enjoyed his company and was interested in him.

I remember listening to music with him and talking about Eminem in particular. I wasn't a huge hip hop fan, but I got it and always liked a handful of hip-hop artists. [In addition to "Lose Yourself,"] there's an earlier song, I think it's called "Stan," about a guy who kills his wife, puts her in the trunk, and throws her off the bridge, in the mind of a serial killer. It's pretty disturbing, and I remember that one.

One insight I have about Casey, and it goes back to what I was saying about being a role and being quasi macho or whatever. I remember seeing Joseph Campbell's *Power of Myth* growing up on PBS and him talking about how every culture has violent rites of passage for young men. . . . Many men go to war, and that's how they become men, or they play football, or punk rock was violent. But men, right or wrong, need these physically challenging rituals to draw a line in the sand. Because it's nebulous when a boy becomes a man in American society. . . .

I kind of felt in Casey that he was trying to figure out how to become a man. And even drugs to some extent, you know, they go both ways. You're breaking the law, your part of this criminal sub-culture, and that seems manly and like you're growing up. But abusing drugs prevents the kind of self-reflection that would allow one to mature in healthy ways. So, it's kind of a trap. It seems like it's a way to grow up, but emotionally and psychologically, it has the opposite effect. I definitely saw in his struggle with drugs—his addiction issues being antithetical to his very real desire to become a more well-rounded, self-aware, self-accepting person.

Because he was very reflective, very sensitive and introspective. And he was kind of a tough kid too. And

that's verboten—and certainly I, as a person, felt this in punk rock . . . So maybe the closeness I felt with Casey was that I really understood that struggle of being a sweet, sensitive man who also still wanted to be manly and tough and take care of the people you care about, and that's fucking hard to figure out, real hard."

Documents from Lifeskills show ongoing counseling, reporting, and tracking as school and court workers attempted to slow Casey down.

June 1: Mental health: substance use, ADD, problems w/ depression; was taking Zyprexa at the time. Tasks: I will not use or possess drugs or alcohol. I will submit to random drug screens. I will talk openly with my counselor about my use, learn my triggers, and develop a plan to abstain.

Tasks: I will abide by my DJJ probation contract. I will not take my anger out on others. I will follow the rules at my home and be respectful toward my family. I will have no further violations of the law. I will not have contact with any known offenders or place self in situations where others are violating the law.

In July, the three of us traveled to visit my Uncle Bob and my cousin, Bette, in eastern Montana and then to Wisconsin for a family reunion, where we met a number of Olmsteds for the first time and reunited with my brother, Gordon, and my sister, Emily. One afternoon, Casey got into the punch and drank until he was loquacious and stumbling. He was very charming . . . until he got sick. We apologized for his behavior, and everyone was understanding. Later we were telling Glenda about it, laughing a little, and she reminded Casey to be wary of "good times" stories, as they can serve as a trigger.

But that was a wonderful trip. In Makoshika Park in Glendive, the state park that my uncle helped found, we went exploring. Uncle Bob was a veteran dinosaur bone hunter and helped Casey find some bones. Afterwards he said about his great uncle, "He's cool." One afternoon, as we grilled steaks on the top of a bluff, Casey walked and slid down to the bottom of the vast valley, until he was a tiny figure standing arms flung wide on a hoodoo against a big, blue Montana sky. I have a series of photos of him leaving and returning, near and far, that show him as free and friendly. He was a handsome, slender 15-year-old, reaching over six feet.

Like our earlier trip to Switzerland, this visit remains a vision of what our lives might have been. Maybe if we'd sold everything and gone on the road for 20 years . . . ?

In August, the Court ordered him "to be placed in detention and then an alternative to detention program for 45 days and subsequently to enter inpatient treatment. Continue in Day Treatment and follow all previous orders of this Court."

That fall, we let Casey go by himself to visit my cousin, Bette, for a skiing trip. She nicknamed him "Brad Man," after Brad Pitt. After the visit, Bette wrote this letter:

Brad Man—You have the world at your fingertips— you are drop-dead gorgeous; you have talents, skills and abilities!! Don't fuck it up. You have everything going your way, young man. Your CB Auntie loves you very much and I have faith and confidence you will succeed. Your Gramma Betty loved you with all her heart and soul, and she's up there in Heaven praying you will make good, solid choices. You have a mom and dad who treasure you and just want you to be happy. I just want you to be happy, Case. That's what life is all about, like that wonderful magnet you gave me which will always remind me of you and your million-dollar rich smile!

You and I are like 2 peas in a pod, Case. We have addictive personalities. We like the quick fix to ease our pain. But coming from someone who knows and has survived many kinds of bad addictions, I finally learned that there are no quick fixes for pain. You call me at --- if you need to talk and are having a crap day. I'm here for you and we'll plan lots of fun things. . . . You are a hoot to be around and such a great dude. . . . Talk with Niki about pot smoking and experimenting with bad shit. She learned and she'll share with you too. She also likes you because you're cool. You are your own person.

Instead of taking out your pain on Jane and Ken—connect with your shrink, dump on them, get rid of the crud which makes you soooo sad and angry. That's why shrinks get paid so well, it's to listen to our pain, dump in their office, do what they say to develop new life skills to cope with some of the huge bumps in life, ok? You have to do it; I know I've had to do it many times and it's hard!

Paint a picture in your mind of your loftiest dreams. You can be anything you want to be, like a musician, a counselor, a math teacher, but you have to put your "nose to the grindstone" as we old folks say and focus on where you want to be in 5 years, 10 years, 15 years, ok? Dream big and go for the gusto. You are very bright, intelligent and creative. Life is good, Case, it really is. Do your life work, my man. Make Ken and Jane, Gramma Betty, Cousin Niki and me proud, ok? I love you, CB

We talked for a while about sending Casey to live with Bette. He so wanted to get away; though in the end we felt it would be better to stay together (Bob's drinking was a concern). Casey, Ken, and I sat down, and I made a list of the pros and cons of moving to Montana.

Are there any problems?

149

K: I feel ignored sometimes, unless Casey needs something from me.

C: Is that because what you're saying is stupid?

K: Yes (laughs).

What are the pros of moving to Montana for five months?

K: Casey would be happy with Bette. It would boost Casey's self-confidence.

J: Casey would be happy moving away. Casey would gain independence

C: I'd see if I really don't like BG and might be glad to come back. I would be able to climb mountains. There'd be a smaller house.

What are the cons of moving to Montana for five months?

K: Second-hand smoke. Expensive. Big stress on Bette, who's caring for her father.

J: Staying with someone who drinks heavily, Casey might drink and smoke. Fewer safeguards (family, DJJ, court, Day Treatment, regular drug tests). We'd miss teaching Casey how to drive. Might be stressful for Uncle Bob.

C: I'd be leaving friends, family, and animals. Might be more stressful for me.

Do the pros outweigh the cons? K: No . . . J: Not sure. . . C: Yes

In September, Casey was at Care Academy in Willisburg for the first of two residencies, the first only about six weeks. Ken wrote this letter:

Dear Casey, I haven't written a letter to you since you've been in Care Academy, but it's not because I haven't been thinking of you. I think about you every day

and wonder how you are doing. From our last visit, I'm not sure if you even want to hear from me. My uncertainty about that has also kept me quiet on the letter. Your mom and I both miss you and we want you to be happy. We hope that part of being happy means being happy with us and coming back to Bowling Green and being happy together.

The scripture last Sunday from Hebrews read—"remember those in prison as though you were in prison with them." It made me think about you. I don't know exactly what it's like there but when I think of you being where you would rather not be a feeling of sadness comes over me as I feel sure that you struggle with that sadness too.

Our family has been through a lot of suffering. I had hoped to spare you. I'd like to see you have a happy time in high school and grow up to be a happy man. To me it seems like your depression stands in the way of that and pot is just deepening.

I know that you have some issues that you want to talk to me about. It may be hard to talk about them—but I hope you will. I love you and want you to feel that you can be honest with me and Jane. I look forward to seeing you Sunday. Love, Dad

That Christmas, Galen got nice outfits for all three of the boys. All three of them strutted around. Adrian especially wanted a photo of them all, one of the few of the three boys together, and the only one in which they stand arm in arm, hands clasped in solidarity.

Casey's Relapse Prevention Plan from Day Treatment:

My name is Casey Olmsted, and I am 15 years old. The reason I'm in Day Treatment is because of two possessions of marijuana at school and arguing with my

father. I've been going there for approximately eight months. I am on graduation phase. I have had a lot of help from Stephanie my drug counselor, Mr. Young my Day Treatment counselor, Spring my DJJ worker, and all the treatment teams at Care Academy. Care Academy is an alternative to detention where I spent 45 days for a positive drug test.

There are high-risk situations, and things I do that make drugs harder to turn down. Like negative feelings such as boredom, feeling mad or angry and like I'm going to explode, or feeling empty, like nothing is important or worth working for; when I have these feelings, I am at a higher risk to use drugs. Negative thoughts I would have are dwelling on past drug experiences and thinking I'm missing out on all the fun. Self-defeating behaviors (that will lead to trouble) are skipping school, violating probation, or lying, conning, and stealing from others. I would also have problems with other people, not being able to trust anyone. One of the main things is difficulty dealing with stress.

Ways of coping with those high-risk situations would be to get help in counseling if I am worried about the cravings. Or I could redirect my activity by chewing gum, getting involved in activities like playing pool and going to a movie, or working out in some physical manner. Mainly I need to avoid threatening situations, such as places that increase my desire for drugs. Stay away from people who may influence me to get high and cut ties with my dealers. Next make sure I have no paraphernalia. Don't have a stash of drugs, and get rid of drug related poster, magazines.

There are ways I can handle anger more appropriately. My triggers are getting blamed for something I didn't do, someone trying to start stuff, or people talking behind my back. My thinking errors include blaming others for my

mistakes, wanting to fight, and trying to bully. One sign that I am getting mad is breathing hard, and negative behavior when I am mad is yelling or cussing. My anger affects other people by causing them stress, causing them to miss work, and disappointing my parents. Ways I can cope with anger are to walk away, listen to music, and ignore people who are making me mad.

A short-term goal I have is to get a job. I will take the following steps to accomplish this goal. Stay clean, do well in school, and fill out applications. A medium-term goal I have is to get off probation. Steps to achieve this goal are to stay clean, make my appointments, keep curfew, and get good grades. My long-term goal is to live a drug free lifestyle. The steps I need to take are to stay clean, hang out with positive peers, think about the future, and stay busy at work.

From this experience I have learned that living life high isn't the only way, and you can have fun without being high. An example of me having fun without drugs is the last time I went to Florida. I feel I have matured a lot and my mind is clearer. In my opinion Day Treatment is good for some people to straighten out their life.

He had learned the discourse on relapse prevention, though he had good intentions and probably meant what he said. A poem written when he was a little older puts some of the same premises into his own words:

"Change"
by Casey Olmsted

When I think of what I did and who I used to be
There is so much change I don't know the real me
It has been so long since I've had a clear head

No more stumbling, binging, my eyes are no longer red
There was a time where I had complete oblivion
I tried and I tried to get it back again
The more times I tried the more times I failed
I knew if I kept on I'd end up in jail
That didn't stop me and I kept on trying
I told myself I was close to oblivion but I knew I was lying
I had to get someone to get it through my thick head
If I kept doing what I was doing I would end up dead
There is no telling what would happen to me
If I kept being what I used to be

In September 2004, Adrian's daughter, Omni, Casey's niece was born. They met for the first time in 2005, and with her a new— or the real—Casey emerged: gentle and loving, happy that he was no longer the youngest in the family, and happy when he made her laugh. As Latoya said, "How he treated Omni, I was like why couldn't you be her dad? Everything I wanted Adrian to be. Make her laugh, play with her, be gentle. Casey would constantly ask, 'Can I play with her? Do you need a babysitter?'" In June, we gave him a Father's Day card: We're very proud of what a good uncle you are. Keep it up, Uncle Casey! Love, Mom and Dad.

In September 2005, he was arrested for violating a probation requirement—possession of marijuana. We have two letters that he wrote to us, September 18 and 22. Here is the first mention of Diana, the mother of his daughter, Leah.

Dear Mom, I have been thinking about the placement that I will be going to. I think that with the attitude that I have going in there that I will be able to progress and complete the program in the least amount of time required. I know I have a lot of things to work out, so when I get there, I will do everything I'm told the first time.

154

Anyway, things aren't going too bad here. But I REALLY miss my music and friends. I forgot and found out again that you don't know what you got until you lose it.

I wish there was a way that I could talk to Diana. I had a feeling that I was going to be sent off soon and was going to tell her that I might be sent off.

Dad was telling me about how Ralin [Galen's friend's son] was pretending to use a toy as a phone and pretend to talk to me. That was something that helped brighten my day. Write back and tell me stories about Ralin and Omni. Love, Casey

On September 29, Casey was admitted to Rivendell Behavioral Hospital in Bowling Green. We have extensive records of his time there. He was released on November 10, ahead of the scheduled time, in order to be transferred to Care Academy for a second, longer stay. Rivendell's discharge report shows that he did well there and was, by the end, a "model" patient.

Reason for Admission: Casey was a 16-year-old adolescent male admitted to our chemical dependency use because "I failed my drug test." He was referred to our facility by his DJJ worker after repeatedly failing urine drug screens.

Patient stated that his drug of choice and the drug that he used the most was marijuana. The first drug he ever tried in his life was alcohol at the age of 11 or 12. He began regular use at the age of 14. He stated he would drink two to three times a week, primarily liquor. He said that there were times he drank with the intent to get drunk, but other times he would just take a couple of shots. His last use of any alcohol was September 13, 2006. He began to smoke marijuana at the age of 13 with regular use at the age of 14.

He reported smoking two to three blunts a day every day with his last use being three weeks prior to admission to Rivendell. He started using prescription pills at the age of 14. He denied ever using them on a regular basis. He used them "a couple of times." He stated he took Xanax and Oxycodone orally. His last use of any pills was on 9/27/05. He used one mushroom on one occasion. He started using cocaine at the age of 15 or 16. He denied using it on a regular basis, but said he snorted a gram once or twice a week. His last use of cocaine was around the 1st of September 2005. He denied any IV drug use, use of heroin, LSD, ecstasy, or any other designer drugs.

Patient admitted to using drugs while alone, using more than one drug at a time, but denied using more than he intended. He stated that he did have an eye-opening experience when he was getting into legal trouble. He admitted he was dependent on drugs and had built up a tolerance to "all of them." He denied experiencing any withdrawal symptoms. He admitted to going to school high but denied getting high while at school. He stated that he did black out on one occasion approximately three weeks prior to admission to Rivendell when he used cocaine and marijuana together. He said he was able to support his habits by working at a fast-food restaurant and using approximately 20% of his earnings to buy drugs. He also admitted to trafficking, stealing and pawning, or trading his personal property for drugs. He denied ever having sex for drugs. Casey said that he had been in detention on three occasions where his longest length of stay was for 16 days. His history of legal charges include probation violation and possession of marijuana. He said his longest period of abstinence was around four months when "I was trying to stay clean." He said that this did occur the beginning of 2005 . . . He denied any past homicidal or suicidal ideations

or psychotic symptomatology. He denied a history of abuse.

Although he was quiet initially on the unit, he began to participate more in therapeutic groups, psycho-educational groups, and AA/NA meetings in the first few weeks after admission. Casey did very well, completing his assigned treatment work . . . He was able to complete NA workbooks from steps one through four as well as relapse prevention plan. Behaviorally, he did well overall. There was one instant where he became physically aggressive with another peer and required restrictions. Casey was able to successfully complete the TRUST program with high honors at the gold coin level. He was required to be released several days earlier than planned due to his placement at Care Academy being ready. He was discharged to the care of a DJJ transporter on 11/1005. At the time of discharge, patient denied any homicidal/suicidal ideations or hallucinations.

Prognosis: Fair at best. Signed: Edmund Cavazos III, M.D. 11/22/05

Sometime in October, Ken wrote this letter:

Dear Casey, I enjoyed seeing you on my last visit, but I have to say that you hurt me pretty bad, and I felt bad pretty much all that weekend. Perhaps I hurt you too by something I said. I hope we learn better, so that we don't hurt each other. I think there is enough pain in life without each of us adding to it.

The first step in stopping the hurt is understanding each other. I want to explain what you said and how it hurt and why as a first step toward understanding. If you want to write me a letter explaining yourself that might be good too.

Anyway, what you said that hurt me was that we wouldn't have to see each other much and we could pretty much stay out of each other's way. It seemed to me that you despised me and had so much contempt for me that you couldn't bear to be in the same house with me. Why I think that hurts so much is that I have such sweet memories of how well we have gotten along together in the past. I remember how once when you were recording sounds for the computer, you recorded, "I love my dad." I can still hear your sweet, high, innocent voice and how pure your love was for me. You could make my heart melt—you still can. I also remember bike-riding places with you. You sat on the back of the bicycle, and we talked and sang and had a good time. After you got older and were riding your bike, we would bike to your school together with Pup running alongside.

I know I touched a nerve with you when I said I found your story of your relapse into coke hard to believe. You insisted that I was calling you a liar. I couldn't get you to see that was not my intent, and you went off on that like a bulldog saying again and again that I was calling you a liar.

I know visitation time is a time for fun; but I also feel that given the fact that we don't see you much lately we can't just play cards and not try to work things out as well. That's not being real and not facing up to the problems that we have. We shouldn't be hurting each other like this. It's no good. Can we turn things around? Love, Dad

P.S. A Sunday school teacher asked the children just before she dismissed them to go to church, "And why is it necessary to be quiet in church?" Annie replied, "Because people are sleeping.

Although there was no date, I found this among Casey's writing about this time:

I have heard that word a lot at Rivendell, and said the serenity prayer, but I never really knew what serenity was. Until I heard a member of NA say something that really made me think. Serenity can help save my life. I could relate because he was saying he was very compulsive and needs to learn how to use times what he considered boring as relaxing times. If I did that then I wouldn't be so worried about everything or wondering what's going to happen to me next. Serenity is going to be especially important since I've relapsed countless times due to boredom. I don't always have to be doing something fun or not always something exciting going to be happening. But every day there will be times that I'm bored and have nothing to do. And instead of trying to make something out of nothing, I can take nothing and just relax . . . Plus not having serenity is feeding into the addict in me, because if I'm always expecting something exciting to happen then I cannot be satisfied . . . So, when I ask for God to grant me the serenity to accept the things I cannot change, all I'm asking is to basically accept how things are and not to worry about everything that could happen. Which reminds me of my favorite Bible verse, Philippians 4:6 which simply says, "Don't worry about anything, but pray for everything."

Additional paperwork shows the self-reported responses to a series of questions. His main concern in life was "being able to stay clean." This, he said, would be managed by "accepting tx and being honest." How would he manage anger? "Laugh about it." What makes him nervous or tense? "Taking clothes off to have search in detention." Family environment: "Cl. reports his older brother broke his arm because he was mad at him in third grade. C. reports both siblings have a history of substance abuse and he's used with both."

Some of this was later confirmed anecdotally. Latoya remembers:

I didn't care that he smoked. I didn't know about the harder drugs, but I could see it in photos, like that one with Ken, and I thought that's not weed. I've been around weed my whole life and I know the side effects, but when I saw that photo, that showed something completely different. Dark around the eyes, pale face. *Is he popping pills?* I wondered. That wasn't a side effect of weed. He was doing other stuff.

But the story of Casey's dark and troubled side, so relentless in the clinical notes, is only part of the story. People who knew him best, saw more. Latoya, for instance, saw him a lot during his high school years. She says:

Casey was my little brother. When I connect with someone like you all, you became my family. I could have taken Casey anywhere and would have said, "No, this is my brother." I think he tried to get me to smoke, but I would say no. It wasn't my thing.

Casey was hilarious. He could make me laugh, even being annoying. I could never be mad at him because he was just so funny. I didn't like the struggles he went through, in and out of the system, but he tried to stay positive. I've seen him mad, but it wasn't toward me. We didn't get mad at each other, because with addiction, the last thing you need is for someone to judge you. I didn't judge him for it. I would try to find reasons in it. He enjoyed laughing, and he would crack a joke or two to lighten up the mood. The time we went to the restaurant, or maybe it was at a facility, but we were all there for him, he was really quiet, and he had his awkward laughs. I figured he was thinking people were looking at him in a certain way, and I wished he didn't feel that way because it makes you feel alone inside. I really wanted him to be okay, to be

alright. I wanted him to get through whatever he was going through and be done with it.

While Casey attended Care Academy for much of 2006, he read a biography of Muhammed Ali, but was more profoundly affected by Malcom X's autobiography, and when he returned, he converted to Islam, attending the mosque near home.

Though he is not exactly sure of the exact time, Ken remembers an incident about the time that Casey was at Care Academy, perhaps during a home visit. Casey was starting to read a lot, especially about Islam, Muhammad Ali, and Malcolm X. The two of them went to Barnes & Noble and browsed together, and Casey ended up selecting four or five books. When Ken proceeded to the register with them, Casey expressed surprise, "You would do this for me?" Ken's thought, though he did not express it at the time, was *well of course, as your father and a teacher, this is one thing I am practically dying to do.* We were both happy that he was reading on his own and using the reading to help with his recovery.

We went to visit Casey on weekends in Willisburg, and on one occasion when he had a day pass, we went up with Diana, and the four of us hung out together, visiting Abraham Lincoln's home place in Hodgenville. When he graduated, he was given a brown sock monkey, which he wore around his neck for a day or two.

Our public image was very different from reality, as evidenced in my 2005 Christmas letter. Several times, in a rage, Casey pushed me. Once, he threw and broke his cell phone. One awful time I was sitting in the recliner with Casey leaning over me, screaming "I hate you! I hate you!" in my face. This and other times like it, I would go downstairs and cry in the darkness and relative privacy of our bedroom. My neck would get so tight that I couldn't move without piercing pain running down the side of my neck and into my shoulders. I remember thinking, *My neck is going to snap.*

Part III:
The Mirror at the End of the Road (2012)

I—EVOLVING

It's spring, more than three years after.

Recently we had two bird casualties, according to emerging legend. Buddy was found carrying around a dead blackbird. Did the bird hit our window, then stunned, provide easy pickings for the waiting canine? That seemed to make the most sense, until the next day, Galen watched as Ginger snapped one out of the air! She wasn't even on the picnic table, which sits outside our kitchen picture window, Ginger's favorite spot to keep an eye on us inside or to see what dogs might cross the no trespassing line. This was a finch, and though Galen rushed to rescue it, the tail feathers had been removed. He put the poor fellow in a box with some seeds and called the Humane Society, who referred him to a bird rescue place, who made it out the next day, the bird significantly weakened, and took it away.

So, now we talk about raising our bird feeders to about eight feet, removing the picnic table, or stopping feeding them all together. We watch from the picture window and hold our breaths.

I have been putting off writing about this, until I finally made myself take a picture of the dogwood tree that we planted on campus in front of my office at the Women's Studies Center. This is the dogwood that our friend, Mary Ellen, bought and arranged with WKU to plant in Casey's honor. We have just this week learned that the conviction of Manslaughter 2 has been appealed on the grounds that the judge's "Instructions to the Jury" may have been faulty due to his decision not to include instruction for self-defense.

A number of confusions seem to come bubbling up from that paragraph: what do I mean by "instructions," why is it quoted and why did Judge Wilson decide that it was appropriate to leave out the possible defense of self-defense in his directions to the jury? Instructions, we have learned, are directions to the jury prior to their deliberations. Why did Burns get "Man-2" rather than Wanton Murder? What is his life like, the man who shot the gun, and what is it like for him in prison? Why did I have to "make myself" take the picture? When I pass the tree and the plaque, which I do every day, I either notice or don't notice them. When I do, I say, "Hello, darling, I love you lots," and sometimes I make the sound of a kiss . . . When I don't notice, I suppose my head is down; at any rate, my thoughts far away. For this I am sorry, and I say this too when I realize that I haven't acknowledged him or sent him a conscious thought. That's when I say, "I love you even when I don't notice that you're gone."

June— "Oh, Canada, with your face sketched on it twice."

Ken and I drove all the way to Ontario this week, so he could attend an Edith Stein conference and I could explore on my own. This afternoon, I watched a live performance of *Fiddler on the Roof* in Stratford. Unlike everyone in the universe, I had never seen it. I sat in my chair and cried and laughed, a smile or a stunned look of recognition on my face. It was beautiful. As one reviewer put it in his closing paragraph, "Forget every *Fiddler on the Roof* you have

seen. This is something special, a show that makes you laugh and cry. You'll leave the theatre marveling at the entertainment quality of the Stratford Festival at its best, yet pondering the essence of the human condition the show reveals underneath" (Ouzounian).

So, somewhere along the way, I met myself from forty years ago, met myself in the moment and lost myself, too, transported somewhere else and returning only when the applause brought me back. The song that undid me was "Sunrise, Sunset." I thought of my boys, now men, the two still alive, and my one gone and so missed.

> Sunrise, sunset
> Swiftly fly the years
> One season following another
> Laden with happiness and tears
> What words of wisdom can I give them?
> How can I help to ease their way?

I know many ways to ease others' ways, and I know as well, that in the end they must face their own blue season as best they can. I hope they have the good sense to open themselves to experiences that due to other commitments or obsessions, they might think beneath them.

In a meeting last week with the Commonwealth's attorney, we talked about whether or not the man who killed our son would ever offer up some sort of apology or acknowledgement of wrongdoing. I wish I'd recorded his exact words, but they were pretty close to this: "In my line of work, I've learned that there's a subset of people who live in another world, a world of their own making. They rationalize everything but rarely do they look in the mirror and say, 'I was wrong.' I don't think you're going to get what you're looking for."

I hadn't realized how much I had assumed about the inner life of Leland Burns, not that I imagined exact thoughts, but

sometimes I saw him sitting in a cell regretting, sometimes his head in his hands, not blaming the police . . . or Casey . . . anymore. I imagined that the "I'm going to hell," which he cried out when the police officer was questioning him that night—words recorded and played in Court, uttered in a moan of doom—had stretched and deepened . . . had become more than "I've been caught and now I'm going to be punished in hell."

As we walked out of the Justice Center, I felt a wave of new loss. Could it really be that he isn't truly sorry? Not for himself but for Casey? That after almost four years, the most he can feel is regret that the system he'd been arming himself against had beaten him? I realized the apology I'd wanted half-consciously was for Casey more than myself. I could imagine Casey listening to the apology, and now I see him only waiting for it.

Since Cohron's comment, I've been thinking about the possibility that some people are incapable of remorse, and I just can't grasp it. Yes, I understand the existence of sociopaths, people with no empathy, or of people whose egos are so grand that they have pushed away all concerned awareness of others, constricting the capacity of their hearts and reducing others to cardboard figures that are of two sorts: helpful to the self or not helpful, beneath notice or in the way. But surely even the most corrupted person has some place within, some small, bruised spot that feels the pain of others. Doesn't everyone possess the ability to rise from the defiled self? I mean, this is a father!

I don't know whether the Commonwealth Attorney is right on this or not. He's not a spiritual leader, he's a legal authority. He said once when I asked what most of the cases he prosecutes entail, "Drugs, drugs, drugs. Child rapists and murderers." Years of experience have shown him a reality that I only glimpse from the distance of fiction, televised, leave-able. I wonder what the Dalai Lama would say about people who have lost the capacity that makes them human—if remorse is "human"—if compassion is in our DNA. If so, then perhaps there's a man in a cell, his head in his

hands, wishing that he could look Casey in the eye and say, "I'm sorry."

This Soul

This morning, my four-year-old granddaughter was sitting half in my lap and half on the arm of the chair, and we were examining hands. She asked what the big bump was, and I said it's my wrist bone. We then looked for her wrist bone, which is much smaller and nestled in flesh. But by bending and twisting her hand, we were able to see that we do both have wrist bones.

We then considered a black spot about two inches NE from my wrist bone. Why is that there? "It's just hanging out," I said, "wondering why that little girl keeps asking why it's there." We began an examination of her body, for I was sure I'd seen a little mole, but up, down, and around, at first, we couldn't find any spots, just smooth, very light, brown skin. Finally, I spotted a little dot. "Why is that there?" To make your skin more interesting.

From spots we moved on to lines—first, those on the backs of my hands, which she can push this way and that, and sometimes they stay where they're pushed. Those, I answered her, are wrinkles. We pushed her flesh every which way, but no lines appeared, and it always came right back to where it started. But on our palms, we had more success. We found that she has three clear lines on one hand and four on the other. I too have three, maybe four, on each palm.

Why are you wearing that ring? Why don't you put it on your pinkie? "What are those?" she asked, rubbing a blue and slightly puffy vein that runs over across to the northwest corner of my hand and up to the index finger. "Veins," I said, pointing to the inside of her elbow. Where did you get that? (Referring to my Tibetan string.) From India, blessed by the Dalai Lama. It shows solidarity for the Tibetans in prison and exile.

What does that mean, so-li-dar-i-ty? It means that you care about what happens to someone else. What's in there? (Referring to the yellow birdfeeder filled with thistle seeds.) Stistle seeds? Yes, those are the seeds that little birds like. "This-soul?" Yes, like that.

July—backyard volunteerism

We have an upstart sunflower with one little head growing beneath one of our bird feeders, the one that holds black sunflower seeds. A second, about half the size, has started growing beneath a second feeder, the one that holds an assortment of fatty seeds. Similarly, we have a peach tree growing beside our propane tank, which is now, though slightly pushed southward, full of one- to two-inch peaches. By our front door, squeezing out in front of one of our overgrown bushes, is a weed of some sort. It's going to blossom soon, and I look forward to seeing what kind of flowers emerge. Among our more annoying volunteers are the grasses—crab and Jamaica—that sprawl along the undergrowth like gnarled fingers. In humans, we think volunteering is what builds character. We encourage it in our students.

Last night, Omni and I watched *Chimpanzees*, a movie-fied true story about a chimp whose mother dies while he is still just a baby. The other mothers reject him (rather nastily), and the other babies seem to pull away. The last one that little Oscar turns to is the leader of the tribe, Freddy, a tough old loner who has no time for the antics of lesser beings. But Oscar follows him and Freddy changes. He becomes Oscar's volunteer mother, carrying him on his back, teaching him how to survive, grooming him. No one anticipated that Freddy had such nurturing in him. It seemed more likely that Oscar would waste away, ignored, losing weight, no one to pick the ticks and lice from his little body.

This week, I'm a volunteer child sitter, something I raise my hand for whenever I can. Yesterday was pretty boring for my good eight-year-old, and I appreciate her patience. She goes to work with

me in the morning, where I occasionally have to remind her to turn down the YouTube volume, and sometime around lunch we head home. Today she hopes to see her cousin and get in some swim time. I may agree to that. I mean, what would Freddy do?

II—CREATIVE EXPLORATIONS

I just finished my two-hour session with Jenny Horner, who runs Creative Explorations, here in Yellow Springs. My cousin, Bette, and I have driven up here together, my treat, a kind of quid pro quo for all her kindnesses to me, and because I know she is hurting. This afternoon, Jenny did the joint session with us, in which we drew with our non-dominant hands while our eyes were closed, letting the weak hand guide the crayon. Then we wrote what we saw and shared. Bette's included birds, perhaps a dove like the one her mother gave her and which she wears all the time on a necklace, and an elephant; disconnected lines and connected ones. Mine looked like a many-layered sheet of ice or water; my animals were a gorilla, looking meditative in the center, and a dolphin, an otter, water creatures. Then we shifted the page in the other directions and considered what emerged, and each view showed something different.

Jenny read about animal symbolism, Bette's elephant, my gorilla. Both animals share certain attributes—feeling creatures who heal or care for others in their communities. Coincidence? Or did drawing with our eyes closed and using our non-dominant hand tap

into the symbolic? Some people would say this was the corniest thing ever. If I'd drawn a fly or a cockroach, would I have been so fond of mine? There's probably something powerful even with loathed creatures—something about endurance or survival or adaptation.

Tonight, we talked a lot about Casey, and in particular my recent decision to go back on the vegan diet and to stop drinking alcohol, and that this has been difficult to stick to. Last night, I had a margarita, and then we went out to dinner, and we had two bottles of wine, Galen, Bette, and me. I told her how I'd gotten so invested in cocktail hours and my very stiff martini, that I would lose whole parts of the evening, beginning at four or five p.m. Drink, then dinner, then solitaire, then TV (long series), then tired and bed. Drinking served a purpose—getting through the evening so I could wake up and go to work, the only part of the day with enough distractions to endure.

Jenny suggested two activities. Imagine myself at seventy-five, as a wise woman who has found her center, who knows who she is and how to relate in the world in honest ways. I should write to that woman and have a conversation with her. She also suggested that I write to Casey and have him answer me, and so I will try that as well. She emphasized the importance of making this about communication, not a crafted poem. She surprised me, saying I am comfortable thinking my way through things but may be less comfortable with more direct emotion. That doesn't sound like me (cry-cry, feel-feel). She suggested placing my hands over my heart and just feel its beat, to love and accept that. Then she got another idea and suggested that I find something, like a sweater, that I can wrap around myself and let it hold me safely. I told her about the shawl I'd knitted but never used. Something a 75-year-old woman might wear. Again, easy to mock, but I'm not letting myself do that.

I love this space, its openness, the light, the art and messages that speak of peace and gentleness and beauty. There's a Zen room

for meditating. Perhaps I could make my "office" into a reflecting, quiet place, where my shawl can be available?

When I returned home, I got to work on my serenity room, as I've named it. It has its own history; breathing in the air of that history is part of the paying attention and part of the serenity, both. When we first moved here in 1996, it was Casey's bedroom. As the older brothers began moving out, he took the back room, and I turned the middle room into my office. There I wrote and did schoolwork for many years. My mom's and uncle's letters, part of the family project, are stored in my mom's old dresser, with more in bins in Galen's old room. After Casey died, it's the room where I went to close off the world and lose myself in Brahms *Requiem.* Now it's where I sit, breathing in that history, and when I open my eyes at the end of a session, I see the poster on the wall in front of me with the picture and passage from Margaret Wise Brown's *The Runaway Bunny*: "'If you become a bird and fly away from me,' said his mother, 'I will be the tree you come home to.'"

Upon the advice of Alice Walker (I wish it were in person), I ordered one of Sandra Salzberg's books, *Lovingkindness,* and began trying some of the metta (lovingkindness) exercises. They begin with a focus on oneself and then move outward to include all beings. There are typically four phrases (easier to remember), and you can adjust them, so they are right for you. The four go something like this*: May I live free from danger. May I be happy. May I be healthy. May I live with ease.* You can adjust them— "May I make friends with my body" instead of "May I be healthy." For some of us this has enormous consequences. I like the repeated phrases because you can do them *anywhere.* In the car, alone, or surrounded.

A couple of weeks ago, I was driving to work, approaching the light at Veterans, when a woman in a van cut in front of me. I saw her looking at me in her rearview mirror, so I made a gesture— raised my hands in a wtf way or like I was throttling someone's neck. She returned the gesture to me, and I said, "May you live free from danger. May you be happy. May you be healthy. May you live

with ease." It was automatic, and I found myself saying it out loud and then, as I drove on, thinking, so what was that all about (meaning me throttling her nonverbally in the mirror), and then laughing a little, because before I started metta, the last word would have been the gesture. As symbols go, not a good way to begin the day.

Since then, I've continued to try to meditate—I won't say I'm bad at it, as that's not the point. Instead, as Salzberg says, the magic of meditation is the coming back. Everyone's mind will wander, it's impossible for it not to. But whether we get lost in it or pull our attention back (to breathing, even repeatedly) makes the difference between mindfulness and monkey mind. They say that the coming back is how we build compassion, even resilience.

July 21, 2013—Trayvon Martin and my son

Yesterday I attended the march and service to recognize with others in my town the tragedy of Trayvon Martin's death. I found the march and service very moving.

I had read several commentaries about Trayvon's death and particularly about the racist elements that lace through everything—the stalking, the fight, the shooting, trial, media frenzy, and also the hard thinking and desire to act that have emerged and so often do emerge after such an awful loss. I have gone to several of the MLK ceremonies and am always better for it, and I knew in my heart that white people had to show up, to join in the grieving and look for insights into ways to make sure this doesn't happen again.

I feel a pull to Trayvon, the teenager in the hoodie, shot by a vigilante. Like my son, a wearer of hoodies, shot by a white vigilante/survivalist. I find the photo of him poignant—you can't miss the look of sadness around the eyes, along with a certain determination and questioning tilt of the chin.

Here is a picture of Casey in one of his hoodies, a backwards cap. I look at these two young men—17 and 20—and something in

their eyes expresses the same sort of emotion. What is it they are saying? What would they say now? Would Casey be friends with Trayvon, in the same way he was best friends with another African American boy in our neighborhood? I remember Decarlo calling to ask if it was true, that Casey had been shot. When I answered yes, he said, "Ah, no, no," holding the phone away, coming back, his voice broken and thick, "I have to hang up here." Later, he and his brother and mother came to our second-year memorial service, and she said, "Sometimes I see someone driving by and see him smile and think it's Casey."

As I look at these two pictures, I recognize Casey was trying to look mean. Manly. I think he took this picture himself, perhaps for a Facebook or My Space profile picture. But I know that those eyes would tell us a lot more about meanness and what is to be a man, if they could.

On the back of the program is a photoshopped picture of Trayvon with his arm around Emmett Till. There's no mistaking the similarities in the circumstances of their deaths—at least in the way their innocence—mere presence—was criminally re-constituted as danger. I know that my son's death was not racially motivated, that there's a big difference in context. But as the pastor said at the service, "This could have been anyone's son." As long as we can shoot with impunity, any paranoid with an urge to act out can point, shoot, kill.

Tomorrow we go back to the Court House where Leland Burns will have his sentence commuted to seven years. We have requested a meeting with him. Can I face him? Every time I even think of it, tears fill my eyes and Casey enters the room with me. Will he apologize to us? Will Zimmerman ever atone (will America?)? Will it matter? I think it does.

Courtroom Sightings

I am interested in the cross-section of humanity who end up here in the Warren County Justice Center. Some of them, like me, are family victims. Others are family or friends here to support. And others are here to clear their names of something they did or didn't do. I suppose there's a small minority of people who are here for entertainment.

This week, the docket was full (as usual), so we had some time to wait. In Court, the same scene as always. In front of us lawyers talking. They lean across the table or pace back and forth. One is talking about an unreliable witness who keeps changing her story, something about blood tests in Cincinnati. Another is joking behind a cupped hand. Their constant motion makes it difficult to hear the judge—the charges, the responses, the consequences. Sometimes the lawyers all stop, seemingly of one accord, and then I know that something interesting is going down. Galen, who has come with us (he still feels bad for not wanting to come to the trial), leans over and whispers, "They all look like douche bags." I stifle a laugh.

Most of the people stepping up to the podium (with or without an attorney) are white. One grandmotherly woman pleads guilty to taking over $10,000 from her church. She was the treasurer, and it was apparently too much temptation. Most others are white men—except when the orange suits are brought in. One is a white woman, one or two white men, but five or six are black men. One of them saunters and leers, and I'm surprised Judge Wilson does not call him out, as I've seen him do many times. One day he must have been unusually cranky, because he yelled at a dozen people whose pants were around their knees, tube tops falling off.

The Warren County Commonwealth's Attorney tells us that there are two kinds of people, those who give to the community and those who take, and he deals with the latter. Such a job must necessarily skew one's view of humanity. I guess all our views are

skewed. Most people are stupid, I hear. Most people are good at heart. Most people only care about Number 1. Add a modifier here and there and all kinds of trouble begins. Most people in Court are —. Most people arrested are —. Most men who sag . . . most women who dress like —s are . . .

I try not to judge these people I don't know. Meeting that old white woman on the street, I'd never think, "There goes a thief." Would I if it were one of those Black men in orange? Any number of times when I've been alone with unknown men, I've felt the flash of fear and talked it down. I refuse to be unduly fearful, especially due to racism.

And yet, we hear Judge Wilson say over and over, "The right to a jury is the highest principle we hold." He says to each person who pleads guilty—a lot today—the same thing: "What is your level of education? Are you under the influence of drugs or alcohol? Do you have a mental condition that would prevent you from understanding? You have a right to a trial. You do not have to plead against yourself. And if a jury finds you guilty, you have a right to an appeal." Then, after reading off the agreement: "Is this what Atty — has said to you? Are you satisfied with the counsel you have received? As anyone offered you money or promised you anything for this plea? Are you certain that this is in your best interests?"

All of them, including the grandmother, respond, "High school [or tenth grade or third grade]. No, no. Yes, yes, no, yes."

There is more, but this is Courtroom B, Warren County, July 22, 2013.

III—SPIRIT ANIMALS

A little thing, a poem, a cross

It's a little thing, this cross on a chain that I have worn now for almost four years. A friend of mine said once that of all the people to wear a cross on a chain, I was the last one she would expect to do so. She said this, I think, because she knows I'm not a Christian and am suspicious of easy symbols that aren't grounded in authentic reality. It's not that I don't respect the importance of symbols hanging from rearview mirrors—mine sports a butterfly—or that cheap, store-bought trinkets can't be beautiful in the context of someone's life—I honor anyone's private use of symbols. I also recognize the beauty and spirituality of public symbols in holy and sacred spaces. A Guadalupe candle, a little Buddha, a rose.

My cousin, Bette, wears a white dove on a silver chain. She's worn it since her mother died of cancer many years ago, in her loyal care. She says she hasn't taken it off since. I only take mine off when I'm preparing for a massage, or the doctor says so. For my cousin, the dove is a spiritual symbol, a sign for the possibility of

communication between this physical world and the world beyond. Her mother's presence always there, against her breastbone.

My cross is more of a medium, since it belonged to my son, who wore it for its more expected reasons. He was a spiritually searching person, who was baptized in the Russian Orthodox Church, became a Muslim, and then returned to Christianity. At eighteen, he was reading Edith Stein's *Science of the Cross*, underlining passages in the Bible, writing poem-prayers.

Some few days or weeks after Casey was shot, we found his cross on the sunroom floor, where it had come off during the night. I placed it on a red string that had been blessed by the Dalai Lama and put it around my neck. At the time, the surreal led to my imagining the impossible. I wrote "Blessed by the Dalai Lama," and the last stanza says: "Such a great spiritual leader—surely / his blessed string could have entered you, / could have retraced the path of anger . . . / and closed the unnecessary hole / could have pulled the metallic smell of absence out.

From the vantage point of nearly four years, that retracing to heal, the closing of the wound, the pulling out some lingering "smell" is still what I think the Dalai Lama or someone like him could do, if only . . . Or maybe all this threading is what we're doing ourselves on this long road towards . . . recovery and recovering our beloved.

Meditation and the Great Blue Heron

I am spending the weekend with my friend, Barbara, who is nearing the end of radiation treatment. She lives with her husband on a small farm on a two-mile gravel drive, which they share with a handful of neighbors, each at least a half mile away. This morning, I awoke early, unable to sleep, due to repetitive worry over things that I can do nothing about. But now I think I was called from sleep to don my sneakers and slip out the door for a morning walk.

It rained last night and all the blades of grass, leaves, petals, edges of bark, spiderwebs, and globes of fruit dangle with droplets of water reflecting and magnifying the lushness around.

Since I arrived at Barbara's I have wanted to see a deer, and before I headed off on my walk, I had sat with my cup of coffee in silence on the deck waiting for one to show up. Now, crunching down the road, my footsteps declaring, "Stay away," I give up dreams of fauna coming to say good morning. The sky is soft gray, and along with birdsong is an intermittent but regular sound of raindrops falling. The colors are muted, and I try to breathe them in down to my toes.

Yesterday, Barbara asked if I'd been to the pond and I hadn't, so I head up the hill thinking that if my shoes get wet, I can always take them off. It is misty and quiet, when a bench and small deck with a ladder descending materialize from the gray. Further to my left is another sitting area that Barbara's neighbors have carefully established for a place to reflect or to watch the kids swim—I deduce this because there's a water gun tucked into a bit of siding where I lower myself. Will I get wet sitting on the wet bench? Brush that aside, too.

I sit for a few minutes then decide to try my meditation, thinking what better place to let go of the clutter that keeps me awake. I close my eyes, feel the air, begin to focus on the bird sounds in the facing woods. I move to metta, first myself then my dear friend, "May you live free from danger. May you be happy. May you be healthy. May you live with ease."

To my right, the softest sound of something walking pulls my attention. I half open my eyes, cutting them to the right, just in time to see a Great Blue Heron pass at my side, a mere four feet away. With barely a change in my posture, I reach for my camera and press the lens into an opening in the lattice behind me, just in time to capture the great bird walking away.

I turn around and tears fill my eyes. I can't breathe. I don't know what has happened. Is it a sign from God? A gift from the

animal world? An answer to the metta prayer? My cousin would say, "It's Casey; he came to say he loves you." I don't know what it means when grace wraps us up, only that everything stutters to a stop and for a moment we are left gasping.

Unexpected gifts: my boy

Today, I went and got a massage (deep tissue) from the Jacque. She pried until it hurt, but in an okay way. She is wonderful, gentle, and kind in her touch. As I lay on my stomach, my face pressed into the face-hole, snot gathering in my sinuses, I was overcome, had to press the sheet to my face to keep from sobbing. I don't know if she knew.

Then I hurried home for a pre-semester "judgment free" party at my house for about 17 women. We sliced and roasted and ate together. I made my new hibiscus lemon drop especial, and we sat in or by the pool with our food and laughed and shared. Everyone seemed comfortable. The affection that I saw circle among them made me feel extraordinarily at peace.

I really don't know why some days are so blessed. The whole day was an unexpected gift, and this is where I tell you about the special thing that happened. It's the kind of gift you're hungry for but don't know until someone places it in your hand. It happened at an awards ceremony last night, where I sat next to Jill B, a colleague. As we were about to leave, she handed me something, saying, "I found this picture of Casey and wanted you to have it." She then told me about how he had helped her on International Day. It was in 2008. I asked her if she would email me the memory, and she did:

Casey was in my World Regional Geography class in the fall of 2008. The students in the class were required to do an engagement project related to course content. One of the options was to work at the BG International Festival. Casey signed up for the first shift, 6:30-10:30 a.m., for set

184

up. I remember asking him if he would be able to get there that early on a Saturday morning. He said, "Yes, I have a baby. I will be up earlier than that." When I arrived, he was already there waiting for me to unload the car.

And now you know why that massage, someone gently getting to me at the muscular and tissue level—while I lay vulnerable and trusting—brought forth in a rush the mingled grief and joy and gratitude at the unexpected gift. My boy handed to me . . . in a picture in a folded piece of paper, an act of kindness in a setting that could have been just another university function; something she had planned, knowing that she might see me this day, almost four years later.

Sometime later, Leah drew a beard and mustache on the photo of Casey from that morning at the International Festival, with a sharpie. A lesson in attachment? Fortunately, I'd already scanned it and have a perfect digital copy.

Discovery

This morning as I was waiting for my coffee to brew, I took to looking at various photos and artwork that we have tacked up around—on the refrigerator and cabinet doors. Most of what's up has been there for years. There's the "It's a girl" we put up when Leah was born five years ago, one of Omni with her dad on a field trip to Chaney's Dairy, one of Ken and me taken back in 1998. And there's the drawing Omni made for me. I have loved this drawing and looked at it many times, but today was the first time I noticed the word "find" over on the left side.

It's a welcome back sign my granddaughter made for me. Where had I gone? How long was I absent? The answer is shopping and about an hour. This morning I discovered the word "find" and now see a new dimension of this work of art. It's not just a pretty

design with flowers and bright colors. It's also a puzzle. Who will be the first to find the two "I love you"s? And now I see there are actually three "I love you"s—one vertically down the center of a red ziggly-jiggly, one above the G of "Grandma," and one along the bottom, with "find."

Our friend, Tsering, would say that this is a most auspicious way to begin the morning. It would do no good to say, "Today we are to discover something we have not noticed before," because once it's a rule and we go off with our magnifying glass, then it's not really a discovery. For it to be a true discovery, we have to stop looking for it. And the more receptive we are, the more likely discovery will happen. Part of the joy of discovery is the story that snaps to.

In this case, the story has many chapters and scenes—but our story goes back to 2004 when Ken and I saw her together for the first time, when Latoya, who we knew a whole lot less well than we do now, let us take her out for a couple of hours. We went to a park, and she examined the bolts on the picnic table. Even as a little tyke, she exuded her trademark intelligence, curiosity, trust, and beauty.

I think we might be a better people if we did more drawings for people we care about, cards with "find 'I love you' two times."

Meditation 101.1

Developing a habit of meditation is called a practice, even when you have been doing it a long time and can carry a state of mind through turmoil. I like that. I have a practice. One of the most important points I've learned is that I don't need to apologize for being a rotten meditator—in fact, what I thought was "bad me" is really much more the way of the human mind. Its nature is to wander. The beauty is not that you lock on to a particular state, but that you return to this moment, from whatever fantasies, plans, rehearsals, and recriminations the mind has jutted off to.

As our meditation leader on Wednesday nights says, "Your mind is well trained but undisciplined." Because I'm a neophyte, I like guided meditations and have been experimenting with various YouTube meditations. Sharon Salzberg is tops. I like her voice, which is matter of fact, smart, and calming. In one session, she speaks of those flitting thoughts, saying (paraphrasing) that when that happens, notice the thought, and instead of focusing on the object or the content of the fantasy or image, consider whether it is positive, negative, or neutral. Doing this allows you to shift from obsessive content to the feeling the image carries. Rather than reacting to every good/bad thing that hits us, we can recognize it as negative (aversion), positive (clinging), or neutral. Point to it, name it, and let it go. Like a song that gets stuck in our heads, same refrain beyond endurance, the repeated scenarios infiltrate our consciousness and leave us very little space, from which we might recognize the beauty of breath, our presence in life.

Recently I have been feeling bad about a thoughtless act— and during meditation have found myself rehearsing mini-speeches that I would offer should this or that event transpire. If I got called into the principal's office. Since this is not a pleasant feeling, I'm not sure why I'm "clinging" to it. I should feel aversion to it. But perhaps, my fantasy speeches are agreeable because I come away looking good in them, thus relieving myself of the feeling I don't like.

A friend of mine says, "The only thing that gets me to change is shame or humiliation," joking, but there's an element of truth. Why do we cling like slugs to mistakes, rehearsing what went down, trying out for roles that fix it, speaking in the tongues of oppressors, scolding parents, overseers? When we spend our internal life elsewhere—practicing, rehearsing, rebutting, planning—we are dead to the moment at hand. The only freedom is in being fully present, noticing the feelings of the body, the sounds around us, the breath. All else slips away, the good feelings of success, the negative ones of. They are like waves. What is stable is awareness.

Another technique was in a YouTube by Lori Granger. You are to imagine the fantasy or thought as a balloon that enters your mind. You see it rise, you let it float away as you return to the field of now. I'm not sure how well this worked for me, because I enjoyed (a little too much) the image of this individual or that in a balloon. If I blow gently, that person, hands pressed against the convex surface of the inside of the balloon, watches me, "Nooooo, noooo, don't send me away." Another sits in the bottom of the balloon, hands crossed over his chest. He doesn't see the pin that suddenly appears in my hand.

My mind has cleverly appropriated the exercise to exact revenge. I turn off the balloon machine and return to the breath.

IV—MYSTICNARY

11th-12th—2006

A Care Academy review in January notes that "Casey's family appears to be supportive of the program as they have attended family visitations regularly and continue to stay in contact with myself [Mr. Wright] through phone calls." Much like the goal-setting that he'd learned at Rivendell and every other facility, Casey wrote the following Behavioral Objectives:

BO1: I will be honest and discuss my feelings regarding my family; methods: I will be open about feelings concerning family; discuss relationships and how they could be improved upon.

BO2: I will be open and honest with my family about my problems.

BO3: I will accept responsibility for my behaviors: I will not make excuses to my parents or others for things I have done.

On one of Casey's home visits from Care Academy, he and Ken were driving by the mosque in Bowling Green, and Casey said he'd like to go there sometime. Ken said, "Why not now?" and did a U-turn. Ken said that he surprised himself in doing it; Casey was also surprised. When they walked in, a group of about six men stood in a group in a relaxed way, their arms folded, a prayer service just concluded. It was a decidedly masculine group, but welcoming. Casey told them of his interest in Islam. The president of the mosque, physician Abny Morsi, was there and talked to him about services and available classes. Seeing Casey's father and learning that Ken is a Christian, he said that Islam teaches respect for parents and that Casey should not come to Islam without talking it through with his parents. Ken spoke up and said that he had given his blessing to Casey, that perhaps God was leading him here for help.

For a time, Casey was very devout about his prayers (five times a day) and going to the mosque. The Imam, Bilal M, is Bosnian and was part of the large group of Bosnians who had sought and found refuge in Bowling Green after escaping the Serbian ethnic cleansing. He is a cosmopolitan European with an excellent education in Arabic and Islam. He had attended a venerable Islamic seminary in Cairo, Egypt. He taught both Ken and Casey a lot and was a patient teacher and counselor. He was also an energetic person, making sure Casey stayed busy and active, and in turn, Casey responded well. Eventually under Bilal's guidance, Casey recited the Shahadah: "There is no God but God and Muhammad is his prophet."

Casey's Episcopal priest, Jim Q, felt that given Casey's depression, his youth, and the vulnerability of his mental state, he should have deferred the decision. The church's practice was to allow time for discernment. Ken thinks that Fr. Jim was right to some degree—there was a kind of desperation in the decision to convert, but at the time, Casey's urgency for discipline and prayer resonated strongly with this new choice, and Islam helped to move his recovery forward.

In March 2006, Casey returned from Care Academy and was admitted to Park Place, where he stayed through May. Like all the other placements, they worked on goals and plans. On the last day, Ken, Casey, Diana, and I sat in the center of a circle of residents to share ten regrets, ten requests, and ten "I appreciates." Casey regretted the lies he'd told us, stealing from us, being violent. Ken appreciated "your kind nature and your willingness to help, your love and the faithfulness you show to Jane and me, that push comes to shove I feel confident in you." Diana appreciated "that you are the father of Leah, all the things you do to make me happy, you're honest, your voice, your blue eyes, your beautiful smile, that you love your family, and that you're getting help." I told him I appreciated "your sense of humor, your intelligence, your sense of right and wrong, your bravery in facing a dark side, your change of heart about reading books—they can transform your world, your gentleness with children, your capacity for joy which is still there waiting for you to release it, your capacity to make something wonderful out of your life, your ability to work hard, your vulnerability and willingness to show it now and then." I wept through my entire reading. I could see peripherally that he kept his head down.

Around this time, Casey started working at Pizza Hut. Gwyn Kinkead (Galen's friend and co-worker) talked about her memories of Casey—mostly when they worked together:

Casey wasn't a lazy worker. He'd come in and actually made everyone laugh. A lot. And the girls blush, and I'm not just saying that. He was very charming. He'd make funny jokes, or if there was music in the background, he'd do a couple of little dances. Because he was just very handsome, everyone would giggle.

I knew there were problems. I remember conversations about him getting in trouble. One time, when I was at your house and needed to go to work, I said I could

drop him off at the public pool. I was at the red light to turn, and he said, "Well I'm going to a friend's and I'm getting out here." I'm like, no you're not, and he said, "I totally am." So, he got out and went, and I called you to let you know he wasn't where he said he'd be.

Other than that, he was very, very, very polite, but he had a short fuse. But the only time I saw that was here, interacting with you or Ken. I didn't see that when he was with friends or at my house. I don't remember the triggers for why, but I remember him getting upset with you and Ken and raising his voice and throw out cuss words. I remember you guys staying very calm.

Latoya remembers the fighting this way:

They were stupid fights, and Adrian has this thing about "don't disrespect me," and if Casey said anything that Adrian didn't like, it would turn into a huge argument. I don't think I allowed fights around me because it's going to turn physical. I didn't want anyone hurt. But Casey punched a lot of walls. He was angry with you and Ken. And he was angry with his brother. Sometimes he didn't get his way, and I'd say, well, you shouldn't be getting your way all the time. There's a reason why. He probably caught on to the fact that I was telling you. I can't think of an example right now. But he was angry.

Antagonism among the three boys characterizes their relationships. On January 4, 2006, Adrian wrote this explanation for the problems between himself and Galen:

I have such a problem with Galen because he is tactless and disrespectful and talks smack too much. Over the years starting from Berea KY where our relationship was straight

but there was lots of problems in Berea and from there on out. In addition, I was really hyper. MN is where the problems had begun, but in Berea precipitated all the relationships in the family. Very shortly after the move we came [to Minnesota] and did not fit in, country ass boys in a city area and a different culture. The problems as I recall was that we fought all the time. We were able to hang out with some of the same crowd. This all combined with problems at home my crazy ass. Along with the fact that I was angry about the fact that I had problems with kids being ugly to me and not having or knowing how to… all of this mixed together help nurture an environment of turmoil.

In August 2006, Casey was sitting on the back of another student's car, in Rose's parking lot, next to Warren Central High School. When the driver pulled out suddenly, Casey fell off and broke his arm, though we didn't know it for some time. We took him to the doctor, but the break was not identified until a week or more had passed, and Casey continued to protect the arm. We took him back. Finally, the local doctor re-x-rayed but did not want to attempt the specialized surgery, which would require removing a blood vessel from his hip and attaching it to the wrist, to "feed" the healing. We took him to Louisville, where he saw Dr. Gupta, who operated on his wrist, which eventually healed beautifully.

That night in the hospital after his surgery, between the pain in his hand and the pain in his hip, where they'd removed a small chunk of bone to retrieve the blood vessel, Casey got little sleep. His dad spent the night with him, sleeping on a cot right next to him. Every half hour, it seemed, Casey would need something: water, ice, or a trip to the bathroom. It was a tender time for both of them. Ken loved the Gerard Manley Hopkins' poem "Felix Randal." One of the lines, "This seeing the sick endears them to us, us too it endears," resonated with the convalescence.

September, another Relapse Prevention Plan shows the following:

- Problem list (What/who is causing me grief): myself, work, past, brother, probation, drugs, rehab
- Triggers: certain songs (mainly Bone Thugs), when I get stressed, boredom, when other people are in a bad mood, thinking about past "Good times," Ray, Sean
- High risk situations: I'm bored, already set up plans to get high earlier, just got off work, at work and take a break, stressed out, friends acting shady
- Positive People: Bilal, Mom, Dad, Grandma, Grandpa, Jean, God [underlined]

In December, on a trip to St. Augustine, the second of two fights with Galen occurred. We talked about that fight and also about the first one, when we had gone up to their cousin, Casey Ayres', wedding and our Casey refused to go. There was an argument over hair in a razor; finally, Ken let them go outside to fight. When Galen "won," they came inside, still fuming. In revenge, Casey spilled the beans and told us that Galen had been taking him out to smoke pot. Galen reflected:

> I remember feeling that he had humiliated you guys somehow and that he needed to be humiliated, and that was the fight outside. He did something really nasty, I don't remember specifically, so that was my stupid righteous indignation. The drugs, that was the truth. It was the only time that we would spend time together talking. I never smoked anything other than marijuana, though we drank sometimes.

He wasn't completely grown, not as strong as he was when we had our second major fight, in St. Augustine. He stole a big bag of weed from me when he was 16 or 17. I remember I pitched a fit and admitted to you guys I had a bag. He confessed to me much, much later he didn't know what to do with it, so he threw it away. We didn't drink often, mostly smoking, 'stinky blunts,' we called them. We would go around the circle and talk. I remember feeling like this was the only way I could get either Adrian or Casey to talk. This was the only time we bonded, was over a blunt. After it was smoked, we'd split up, so it was only ten to 20 minutes at a time. We were doing this almost every day.

We'd talk about stupid nothing stuff, girls, drugs. Casey and I had a couple of conversations about Adrian, and he was always reluctant to say things about people behind their back. That was one of his biggest principles. I just remember incredible relief whenever Casey and I or Adrian and I had a feeling of solidarity, and that's why I smoked pot with him. And whenever those times happened, I was really happy about it.

The second big fight was in St. Augustine. Galen said, "That was a very bizarre fight. Casey must have been thinking about something that he was angry with me about from the past, and to this day I have no idea what it was. But he was really angry. He came inside. I was obviously watching my own movie on the computer. He didn't say anything but turned on the TV and turned up the volume. I was like, 'Casey, can you turn that down?' and he was like, 'Fuck you,' and so we started arguing. He stood up and I stood up and we went after each other. It was at night. He had taken a walk along the beach and was stewing about something."

The fight spun through the living room and ended up in the kitchen with the two boys up against the corner. It was only when

Ken tried to intervene and cried out, "For the love of God," that they stopped. Galen remembers:

> I think I hadn't realized the fight was over when Casey went limp and I kind of sucker-punched him, and I think I gave him the shiner. I remember hitting him in the eye twice. I slammed his head against the wall, but not hard because I didn't have good leverage. He had control of the fight for most of the time. He managed to get me into corners, I remember.
>
> Afterwards, when you two were sad and upset that we were hating each other, we went out, did another smoke walk, and talked. I remember realizing that we didn't, none of us, ever really share our deepest dreams and hopes with each other. We had other people for that. I remember feeling that at that time.

Galen thinks he was selling around that time. "I helped him a little. I made one drop. I caught on to the sting operation that they had. I tried to tell him, 'Dude, they're going to get you,' because he was having that car pull right up to the driveway. He was handing it off in broad daylight. The guy pulled up and he tried to hand me the money out in the open, and the second he did that, I looked up to see if anyone was looking. I think they used the [neighbors'] house because when I looked up at their window, the blinds were swinging. I went and told Casey you cannot do that anymore."

Galen also talked about the period when Casey had gained a lot of weight:

> Body shaming is my biggest source of guilt. I know that had an enormous effect on him. I was bullied and I know it has an enormous effect on me. It changes how people feel about themselves, and I have to fight that all the time. Self-hatred about what you look like. It's extremely

hurtful, much more than I could have imagined. It was not a good relationship, never healthy. Towards the end of his life, we were maybe the furthest away from each other. I knew he was religious, had converted to Islam and then back, but I felt that Casey distanced himself from me. I remember making an effort but feeling he'd never make any effort. The biggest thing that was stolen from us as a family and from me as his brother was that Casey was turning around. It could have been a much better relationship later in life.

We also talked with Adrian, who said:

I never viewed Casey as an addict. We hung out and smoked weed, or we would go out and walk and smoke weed. It was a part of our interaction routine. At one point you left us $100, and we spent it on really good weed and smoked it all weekend. I was in my 20s and Casey was 18 or 19. Maybe he was 16 or 17. That was a central part of our existence. For me as a person, weed has been a social crutch for a long time for social anxiety. It had a beneficial impact in that regard.

He, too, remembered Casey stealing from him:

I think I lost a half ounce of weed in the yard and found out years later that Casey had taken it. He was 13 or 14. He was the last person I suspected. He told me he'd taken it.

But our best times were hanging out together, talking about our plans. I have tremendous guilt, and to this day think I had something to do with his death, that he was trying to prove himself when he went over there . . . I had a lot of plans for his 21st birthday. I was making good money then, wanted to have Casey move up to Louisville

and room together and possibly starting a business together some day.

Casey and I were like two peas in a pod. Galen and Casey got along a little better than he and I did. As a group, smoking helped us have a relaxed environment to interact, and I have good memories of that. Casey was the balancing factor. I remember him being leaps and bounds beyond his age in spirituality, integrity, being truthful. In his writings he had a way of describing selflessness and good will towards other. He was a selfless person, put his friends before himself. He was a very trusting person. I always viewed him as a better person than myself.

I remember a time when the four of us were arguing. Casey was upstairs and said like three sentences and we all just defused. I was a terrible role model because I was always in trouble. I think he wanted to prove himself. He asked to do cocaine with me once. I never entertained that idea and told him he needed to leave that shit alone. We only drank beer and smoked pot.

Our relationship kicked into gear when he was 15 or 16. One of our favorite things to do was wear each other's clothes and shoes. He really enjoyed doing that. He laughed about it and we bonded. We both had similar style was one way we linked up. We listened to Bone Thugs & Harmony and smoked pot all the time. One violent song we listened to was 'Body Rot,' a very angry song, talking about cops and their bodies rotting. This was when he was between 17 and 19. He had picked up the Thugs mentality.

One thing that is so salty in my mouth is how hard he worked, and you two really struggled, and him at the point of turning, it's such a shitty shitty shitty shitty situation. Twenty years old, about to turn to manhood, so much going for him, for him not to reap the benefits of his effort is horrific.

Bless Us Not Me (by Casey)

What a selfish person I was before I met and finally understood Christ. I still don't fully understand, probably never will. I'm not completely selfless either. So many things I could do better. Lord, I know or think I know that I am getting back on the right track and getting on your merciful side . . . I am in love with a beautiful woman. She means everything to me, after you. She had faith in me when I was down in the dumps. In rehab, and when I got out, I left her . . . I loved her but was not ready for a relationship. Lord, I think that with your help I am ready for the ultimate commitment. Marriage. Although my mother and father were married, growing up I never recall talking about marriage with them.

Now Lord, I want to talk to you about one of your great creations, Diana. I want to receive your blessing on us. I pray that you can see us as one trying to praise you. Before I can receive the honor of this blessing, I need to let her father know some things.

I want to let you know that I love and respect you for raising your daughter. I know you are great Catholics. I also have a lot of respect for the Catholic Church. When I read *St. John of the Cross,* he brought me to Jesus after I converted. If you didn't know this, I practiced Islam awhile in Care Academy. It was a way I was seeking God (that's a whole different story). But coming to know Christ was through a saint. Also in Romans. What I'm trying to get at is, before your daughter and I get married, we must all come to an agreement on which church. . . .

But I say love your enemies! Pray for those who persecute you! In that way, you will be acting as true children of your Father in heaven. For he gives his sunlight

to both the evil and the good, and he sends rain on the just and the unjust alike.

In this paper, which I don't think he ever sent to Diana's father, he mentions his reading of *St. John of the Cross*. Ken remembers, "Everyone he would meet, if religious topics came up, he'd ask if they knew of Edith Stein and would talk about her life, her conversion to Catholicism. He didn't have any idea of how obscure it is. I think he read it while he was in jail." Regarding Casey's religious readings, he went on to say:

In *Romans*, Chapter 5, Paul says basically, 'I do the very thing I hate. And no matter what, I keep coming back and doing it.' So, it's talking about a divided will or a divided self who can't really change himself. And in the *Book of Romans*, Paul's solution is that he's loved the way that he is, and though he hopes to change, he's saved by grace, and not by anything that he does, but the fact that God loves him. And that spoke a lot to Casey. And you could say that chapter in Paul is a kind of a woe-is-me because I'm doing what I don't like and I kind of hate myself. He also read the Apostles and loved the Prodigal Son story (which we asked the Priest to use at his memorial service).

For Casey's birthday in February, Ken gave him the *Collected Works of St. John of the Cross,* inscribed with, "Casey, May God give you light to illuminate, Love Dad." Although he did not underline any passages, he did bracket this, from *The Dark Night of the Soul*:

Thus, although persons suffer this purgation, knowing that they love God and that they would give a thousand lives for him (they would indeed, for souls undergoing

these trials love God very earnestly), they find no relief. This knowledge instead causes them deeper affliction, . . . They grieve to see within themselves reasons for meriting rejection by him whom they so love and long for. (*Book 8*, Chapter 7, 409)

This passage speaks strongly of Casey's internal strife. Ken said, "It ties in with what he was going through in *Romans*, because of the self-torture. He just didn't see anything that he had done was worthwhile . . . We had an ongoing debate about that, though I didn't try to argue with him, and my views may have changed some. He would tell me that everything happens for a reason, and I told him I just couldn't believe that...some things either random or absurd. He found strength in that belief, that there was some kind of plan, or that things would make sense, not that he could ever tell you what the plan or reason was, but he believed in a strong providence.

For his high school portfolio, he wrote about a profound experience he'd had at the church's Bible School in Leitchfield, Kentucky, called All Saints:

One day Robert asked if I would walk to the lake with him, and I did. While we were walking, he was talking like an auctioneer, and I took in maybe half of what he said. There was this big rock that we climbed on to throw rocks into the river. He threw everything he could as fast as he could. I don't know where he got the energy. I threw one and my sunglasses fell, and a lens fell in the rocks below. We were looking from the rocks we were sitting on and couldn't see it. A couple minutes later, I decided to go down and look, and still couldn't find the lens. I felt a presence tell me to pick up this certain rock. I was skeptical of whether it was from God or just a hunch. I went ahead

and picked up the rock anyway and found that lens. Then I thought to myself, no it was probably just a coincidence that I picked up the right rock. Then I yelled to Robert that I found the lens and he said, "Praise the Lord!" I was stunned and replied, "Praise the Lord."

That is probably the most valuable lesson I learned at camp, and I learned a lot from it. I learned three valuable things. One, that to praise someone else is a great reward, if not for yourself, then for the person receiving praise. Also, that when I think I feel a message God is sending me, I always question whether that was Him or not. This isn't completely bad because we do sense things that may seem like Him or try to make us believe it's Him and it isn't. But then again, why question all the time? The last learning I received was when Robert said, "Praise the Lord." Whether it was Him or not isn't the point. The point is to give praise. We cannot see Him, and that makes up faith.

The Camp only lasted two days and ironically . . . Not only did I not want to leave, but I want to get a job there this summer. I would like to end with this, give anyone a chance and they can help you more than you realize.

Casey interviewed to be a counselor at All Saints Camp but had spoken frankly about having done cocaine and was turned down. He was crushed, as he had hoped doing something positive would help him. At the time I was coordinating our Women & Kids Learning together Summer Camp, and I was able to give him a week-long counselor position, which helped mitigate against the disappointment with the church camp. In May, he wrote:

I am sitting in my room doing nothing. Wanting the world to come to me. Not ready to embrace the world. There is too much out there I don't want to be around, but even more that I would love to see. I'm not sure where I

am with God, having been clean only a few days I am just now gaining back consciousness. Thank God it's coming back as good as it is. Help me to embrace the world instead of living, O Lord. Because isolation from the world is the familiar, and choking sobriety, even without drugs, living nothing just makes life seem boring. Something is coming up for me to do helping my mom work at a camp for low-income mothers. What a privilege. Please God be with me more than ever when I am there. Be with me and everybody else. I'm not sure what to expect, but I have a feeling that I am going to be the one getting the most out of this trip. This will be a big help to my sobriety which the Lord has led me so very graciously to. Enlightenment is the key to darkness, while sloth is wearing me down. How many chances do I get? I lost count, and only God knows. How many do I deserve? Way less than what He has given me. Should I look at those chances, shamefully? No, but I have, get up and run with those blessings and pray for more so I can give more to others. I need to love instead of hate, do good instead of think about what good to do. With that may the Lord be with you, and may you accept him. I pray I will.

As co-leader, TJ, said later: "I was looking through the camp memories book 2007. There are wonderful pictures of Casey throughout. All the kids were drawn to Casey like a magnet. In almost every picture he had a different child sitting on his shoulders. Just as he carried my son Chance…and just as I remember him throughout the camp. What a gift he had!"

After High School—2008-2009

The year 2008 marked an intense legal period, beginning in February with his felony arrest for selling marijuana within 1,000 yards from Bellwood Presbyterian Home for Children. The charge

was eventually reduced to a misdemeanor when we proved that the school (a group home about a mile away) was beyond the felony distance.

I came home that day, and as I stepped through the front door, I sensed right away that someone had been there. Casey's room was in disarray. I called him to ask what had happened. I was mad and scared, offended that someone had come into the house looking for evidence while we were away. Casey went to the police and turned himself in. He told his dad he felt bad for bringing trouble into the house—that was why he turned himself in, to handle it himself. He was released five days later to our custody on a $10,000 bond. Just as Galen had warned him, one of his customers turned on him, and they caught him exchanging money in our driveway.

Three months later, on July 8, Leah was born. When the obstetrician determined that Diana needed a C-section, Casey donned a sterile suit and sat by her side. Leah's other grandparents and I arrived as soon as we were allowed, and Casey walked toward us down the long hall, face down as he cradled his new baby in his arms. Ken arrived later, after a trip to Florida, but they talked by phone, as Casey urged him: "Come and see my beautiful daughter!"

We were proud of him, but summer 2008 was a rough time for Casey. He was indicted on the trafficking charge, and we hired an attorney. Naively floored by the $3,000 retainer fee, I gradually came to see that he was happy to let us do all the work, which included determining the actual distance between our house and the school. Ken drove it, walked it, and measured it over and over and finally went to an architect who had maps that could confirm the exact distance. In the end, the Court confirmed that it was further than 1,000 yards and therefore a misdemeanor. We felt consumed with worries, but in October, the worst seemed over, with one year in the custody of the Department of Corrections, probated to two years under statutory conditions, a fine of $2,275, a requirement of evaluation for substance abuse, and 250 hours of community service.

As Casey was released from custody, he got pulled over for failure to signal and was found in possession of marijuana and paraphernalia. On November 6, he entered a plea of guilty, and on November 7 was pulled over again, with this citation: 1) Rear license not illuminated; 2) Drug paraphernalia; and 3) Possession of marijuana. Casey gave permission for the vehicle to be searched, and the officer found marijuana in a blunt cigarette, which had been partially smoked. Bail $200.

On November 8, his conditional discharge was revoked after a drug screen on the sixth showed positive for marijuana and cocaine, which Casey admitted to using. On the 29th, Casey's cousin, Christina, got married in Louisville. Luminous with pride, he proudly showed his daughter to his extended family. All three boys were together, no one fought. It was a great day.

On December 11, after testing positive again on December 4, Casey was ordered to complete Drug Court: "A shining example of Kentucky's success in specialty courts. Instead of spending time in jail, eligible participants complete a substance abuse program supervised by a judge" (website). The description indicates that now in its second decade, "there is irrefutable evidence that Drug Court is achieving what it set out to do—substantially reduce drug use and criminal behavior in drug-addicted offenders."

Casey hated it, saying, "I do what I want, because I don't like people telling me what to do. Drug Court tries to control me, so I try to find out ways to do what I want," but at the end of that year, at the time of his death, he had finally succeeded in his long effort to stay clean. A series of citations and court appearances interspersed with AA and NA meetings, arrests for failure to comply, and personal problems with Diana characterized the rest of 2008 and 2009.

He wanted to do well and felt overwhelming despair at his inability to stay clean. His writing shows he struggled with his addiction. He also wanted to do well by Leah and had high hopes that she would help him change his life. Latoya remembers, "When

Leah came along, he took her with her everywhere, to the NA meetings. If I had to picture a strong father, that would be it. Here's someone who's trying, who keeps his angel at his side. She was his everything. Maybe not the answer to take away all the bad stuff, but he did change. She's missing out on an awesome person." Due in part to Leah's as yet unidentified lactose intolerance, we found living with Casey and Diana and their baby difficult. Leah screamed when her stomach hurt, arching her back and locking her legs. Ken and Casey put her in the snuggli and walked with her, the only thing that pacified her.

One night I woke up hearing a weak cry from Leah. I found Casey asleep on the sofa in the TV room. Leah had rolled from his chest and lodged in the space between the seat and the back, her face pressed into the crack, her arms and legs icy. I scolded Casey who mumbled something from a deep sleep, and then took her downstairs to sleep next to me. I was scared.

One weekend during this time, Ken took a retreat with Casey to Gethsemani Abbey, a favorite retreat location for Ken and a place Casey liked as well—he and Diana had spent a weekend there sometime before Leah was born. On this occasion, Ken wrote, "Today so much has happened that is wonderful. I have vowed to write a paragraph a day during lent. I met with James Conner, a monk at Geth. for direction, had a good walk with Casey (what I tried to say so carefully Casey told me was bull-crap), sat by Merton's grave; left a wreath; talked w/ Merton—who wanted a sip of my coffee. One day Casey borrowed the car to travel to Care Academy in Willisburg to see Mr. Wright, the counselor who had worked with him. He had worked hard to try to track him down by phone and eventually found that he had become a pastor. Casey set out early in the morning and stayed late. Due to poor directions, he got lost and came back frustrated. I see that journey as emblematic— good intentions, bad results, frustration, and anger."

Casey got his second tattoo, located on his other arm, of Leah, her chin resting on her hands, and surrounded by a wreath of

roses. The first two months of 2009 brought a seven-day stay in jail, followed by three weekend incarcerations. In March, another seven-day incarceration for positive drug screen, and in May, 14 days. From February through mid-May, he wrote in his journal, a paragraph for each day—these are examples:

The meeting was about why we must stay away from our old using friends. When we stop using, that's not all we do. We get a new lifestyle and must be willing to do anything to achieve it. Hanging around the same people too much who use can be devastating to our sobriety. It's hard for me to accept that I'm not to be trusted, but I can understand why. Because I used to lie all the time, but I must move on.

I heard a lot about people's understanding of their higher power and how they struggle with it. I can relate because I am constantly questioning God's will, which I believe can be good, because if I accept the first thing that comes to my mind, then I may have settled for less.

What a day! Today was really hectic. One of my friends came over the day before and then this morning my mom's iPhone was missing. I really don't think that my friend would have took it. My family keeps going off on me saying that he was the only one that could of took it. I went to a meeting which made me feel a lot better. Plus, I got a sponsor.

Again, with the drama. We're still trying to find out where the phone is, and I'm starting to think it could be him. Then my brother [Adrian] called and left a voice message which set me off. I don't ever remember in my life yelling for that long. But I talked to my sponsor, and I felt 100 times better. I am really starting to believe in the AA & NA unity, and I now am building back my personality.

Today was a little better. I am still sick and tired of my brother calling me and just won't leave me alone. I feel very stressed, but I just wish that I could have some peace. The only peace I can get is at meetings, and usually after the meeting peace only lasts a couple of minutes. I can't wait to get to a more peaceful time.

Today was a pretty good day. I am moving on and getting out of the relationship with my baby's mom. I still want to help raise her, but I don't see myself being with Diana. I feel kind of down and depressed, and I want to get high, but I managed not to.

Spent some time with my niece and her mom, which was fun. Also, I may be getting a job at Firehouse Pizza on the by-pass. If I get the job, I think I'll do a good job because I used to work at Pizza Hut. I also can have an interview at Red Lobster. I would like to get the job at Red Lobster because I think I'd make more money.

Today was an uneventful day and I was really bored. I watched Leah and was at the house by myself. I'm ready to get a job so I can be more occupied. I think that a lot of my drug use comes from boredom. I feel better about myself when I work and stay busy.

I had fun today because I had a good day at the Humane Society. Also, I talked to the girl that I want to talk to. She doesn't live in Bowling Green, but she comes down a lot. I think that's good because I'm not ready for a relationship with living with someone. I also need someone not so high strung because I am easily aggravated.

Today was a good day. I did some community service at the Humane Society. I really want a job so I can earn some money and can quit bumming money for gas and other things. I would like also to get to phase 2 so I can have a little bit more freedom. Also, I would like to go to

the studio so I can get these rhymes off my mind and some of this energy off my chest.

April 1. Today was horrible. April fools. Nah, but today was a good day and I got a couple people with April fools' jokes. I told my mom I'd be going to jail, she believed me 2. I'm glad that was an April fool's joke because I don't like going to jail because I can't see the people I love. I'm glad that I'm doing better in Drug Court.

Starting new today and I might try to work things out with Diana. But it might be best if we take a break from each other. I haven't been spending much time with Leah because I'm scared to get attached to her because they're moving out. But I really shouldn't let it bother me as much, and no matter what happens between us, Leah will always be my daughter, and I will always love her and try to spend time with her.

Today was a very difficult day because when I talked to Kathy and Tyler, they were close to terminating me from Drug Court. I feel depressed and wish I had more serenity. I want to change the things I can't and can't get rid of the thoughts. I don't get a lot of things and I just wonder what's the point of going on, but I don't want to give up.

Today was a good and relaxing day. I'm glad I did my community service last week. I still haven't started on in it yet, but I will have to start working on my community service hours more early. Sometimes I like myself but sometimes I feel depressed. It comes and goes, and it will go away. When it comes back it comes back tenfold.

I really enjoyed spending time with my daughter today. She is starting to grow more and more each day. She still hasn't started to crawl yet, but she can scoot around on her butt. It's really cute, and she looks a lot like me. Sometimes it's still overwhelming being a father. There's nothing I can do to change it, and if I could I wouldn't.

Again, I got to spend time with my daughter, and she was laughing a lot. I really like to see her laugh; it brings me joy. There are a lot of responsibilities in having a daughter. We might have jumped into having a kid but can't change the past and just want to look forward. Taking things a day at a time was IMPOSSIBLE for me.

Today was a little bit better, and I'm nervous about what will happen to me Tuesday. I almost feel like I've lost everything, spiritually and worldly. I'm so used to going downhill, it's like once anything happens, I will go plummeting down really fast and can't see a point to go back.

Every day is just another day. I've already come down so far I don't see anything coming positive. The only positive thing is my daughter, and I can't even see myself being a good father until I get to a more stable point in my life. I haven't been doing many things positive and I don't see things positively. I don't see things like other people. I just don't see.

Writing seems to help, but I don't really share it. Not really shy, but I just don't want to offend anyone. When I write I say what's on my mind and don't realize how I feel until I see it on paper. Once I get writing, I can write a lot and get most of it out, but I'm not sure what "it" is.

I don't always feel as low as I have been, but I never feel good. I'm tired of feelings and I try not to bother with them. Still not sure how to deal with my problems and am starting to realize they don't just go away.

Today was all right, and as long as I can get back up and wipe myself off, I might be able to do it. I try to say I might because I don't want to be cocky about it. Last time I had 30 days sober I got cocky and just kind of gave up about it.

Today was a pretty good day. I felt relieved and confident when [Judge] Grise talked to me and said that I can do this. I needed to hear that, and I did not expect to hear that. I'm really grateful that I have Grise because he has faith in me. For some reason, I have no idea why, but he does.

I can already feel my medicine start to work. It might just be a little bit right now, but even just a little bit I feel a lot better. Starting to think more positively and not get upset as easily. I'm ready to start school and want to go full time in the fall and also have a part-time job. Hopefully they will hire me at McDonald's because I really want a job.

Casey was in jail for Leah's first birthday, and the day after, July 9, he was court-ordered to participate in inpatient treatment at Park Place Recovery Center. Documents from Park Place give some insight into his feelings, for instance, this hand-out on guilt and shame:

1. Define: Guilt-done somthin bad. Shame-feel like a bad person.
2. 10 things you feel most guilty about: done drugs, stealing, lying, not being there for my kid, cheating, being mean, fighting not praying, not listening to others.
3. How have these feelings affected your disease and behavior: It has caused me to use and not think I can change.
4. How have these feelings affected your relationship with:
 a. Yourself? Low self-esteem
 b. Others? They don't trust me.
 c. Higher Power? I have lost connection.
5. How can letting go of these feelings affect your recovery? By believing and making amends

6. Write a letter to the person most harmed: Dear Mom, I'm
 sorry I stole and lied to you. Please forgive me and give
 me another chance. Love, Casey
7. The person we hurt most is usually ourselves. Write a
 letter where you express your anger towards yourself,
 regrets, forgiveness.

Dear Me, (self-proclaimed asshole)

I know I've messed up a lot. It is not too late but could
never be soon enough. So, I need to stop feeling sorry for
myself and continue to work the steps. Too bad I realized
that when my hands were in cuffs.

Additional records from July suggest that Casey was taking
responsibility for the first time, perhaps in a decade of trouble. He
remained critical of himself, but honest about his challenges and
hopes. Latoya remembered: "Oh my gosh, the last few months, I
was so proud of him. He was really trying. But the people he was
hanging around with, they didn't make things good. When you're
hanging around negative, that's what you take out of it." He began
attending daily NA meetings, focusing on recovery, and this
intensity of purpose seemed finally to be paying off. After he came
home from Park Place, he began journaling again:

Tuesday [n.d. perhaps August 11]. Today was a good
day and the judge is glad that I'll be going to college. I can't
wait to go. I am ready to start learning, and this will help
me stay busy. Glad to be clean and sober.

Wednesday. I had a good day and got to spend most of
it with my daughter. She is growing up fast and walking
very well. I am also spending more time with Diana and
our relationship is getting better. My mom will be gone for
a couple weeks, and I miss her. [I left for a solo camping

trip in Colorado then visited my cousin in Montana, 8/24-9/19]

Thursday. Today was a boring day, but I got a chance to work a lot on my math homework. Diana and I got into an argument, but we worked it out. It was nothing too serious, and sometimes we end up arguing about real trivial stuff.

Saturday. The meeting I went to tonight was a speaker meeting. The speaker was my sponsor's girlfriend. I sat by my sponsor (Adrian), and we got to talk. His phone has been broken and mine has too. But I found one of the old phones that used to be my dad's and am using that now. I plan to keep this sponsor and call him regularly.

Sunday. Today was a great day. My daughter, niece, and dad all went to church with me. It felt good to go back to my church because it has been so long since I have been there. I was glad to see everyone, and the priest there has a son only a couple weeks older than Leah. It was a lot of fun to see them play together.

In mid-October, Ken wrote this letter to Casey, in jail:

Dear Casey,

I am proud of what you have been doing lately. I may not say it enough. You are working hard with a lot of stuff working against you. I hope you are proud, too, of yourself—you've come a long way working on your recovery. Slip ups happen, tests get missed, but the important thing is to get back up and not get down on yourself.

I went through some hard times quitting pot myself. I always thought that if I had kids of my own, I'd be able to relate and help—that hasn't proved to be so. At least not yet. As a father it's complicated; however, I would like to

be both your father and a friend. Friendship takes two—I just want to let you know I am open to it. I also understand if you need someone besides me for support. Just know that I am there for you.

I'll be banging on that door for you too. I've got a new prayer life lately. I am trying to pray four times a day and doing a bit of reading in the psalms. This morning I thought of you when I read the Lord sets the prisoners free. I hate jails, I know you do too. Maybe this time will be the last; with your progress you are getting closer to be able to stay out of it. That's my prayer. Lots of love, Dad

Christmas letter 2009

Dear Friends,

It is Christmas time and the season of glad tidings. However, this year at Christmas we have bad news to bear. On Oct 26 our beloved son Casey was shot and killed. On Friday Oct. 30th we had a memorial service and liturgy for him that was beautiful. (He is pictured last year with his daughter Leah and niece Omni.)

There is an ongoing murder investigation; one person is now under arrest and indicted for murder, tampering, and weapons violations—details are sketchy. The police are competent and Ken's sister who is a lawyer is helping us by going to hearings and meetings and tracking events. What I can say is this: Casey drove over to a boy's house, got in an argument with him and the boy's father came out on the porch and shot Casey as he was driving away. Why would someone do such a thing? We may never know. He probably died within minutes. His car went off the road about 100 yards past the house. He was later found by a good Samaritan; an ambulance was called, and police later arrived on the scene. Police have the man, age 55, of

Rockfield, in jail. He has pleaded not guilty to the charges. Although these details are unusual for a Christmas letter, we understand the need to know a little about what is going on.

We are stunned, horrified, and grief-stricken. Despite all the sorrow, we feel blessed to have known him; sorting through his writings we find that there were depths to him that were not always apparent. It was and is a great privilege for us to be his mother and father. His surviving daughter, Leah, now 18 months is a joy, and we were fortunate to take her for a week to Florida, where we spent time in St. Augustine and Gainesville. We spend a lot of our time now sorting pictures, journal and poetry writing. This seems to help. We (Jane mostly) have worked hard on getting a memorial website running . . . We would be happy to hear from you.

Galen and Adrian are struggling with the loss of their little brother, though they are otherwise well. Adrian is a mortgage banker in Louisville, and Galen is in his first year of an MFA program in ceramics at the U of FL (go Gators). The support of family and friends has been a tremendous help to the four of us as well as to Casey's aunts, uncle, cousins, and grandparents; remarkably, it appears we will make it through this great loss, though we expect to have an erratic emotional life as we learn what life means without our beloved Casey.

One guiding principle has been that if something was valuable before his death, it will continue to be valuable after. We do not want his death to diminish anything good and so we will celebrate Christmas with our family. Our tree is up and shining. It will be our first Christmas without him—but he is as dear to us now as he ever was, and in this season of love, we will remember him with tender hearts and also wish for you a Merry Christmas.

Ken and Jane

For a while I kept a memorial blog for Casey, and these are some of the memories posted there, for which we are so grateful:

Christina (cousin)

I remember how our families spent every Christmas together, and how Casey, being the youngest, always wanted to measure himself with us. He probably passed me up when he was 14, but he was really happy when he started passing up the other boys. And even at my wedding last year he had me stand back-to-back with him to see how much taller he was . . . I also remember how we used to lie down on the sofa feet to feet and that he never had any expectations, we would just lie together in stillness. He was someone you could be still with.

Crystal K

As TJ said, he was indeed, great with the kids at camp. In fact, when the other counselors were reaching the end of their nerves, he was almost always the one to volunteer to watch their kid while they went to take a break. He had such unending patience and enthusiasm with the kids, that it was a great motivation for me when I was feeling overwhelmed. He will be remembered fondly.

Kelly R

My favorite memory of Casey is when we had dinner at the Ethiopian restaurant w/ Leigh and Catherine. He was so happy and peaceful and eager to learn and was asking Catherine all about her religion major at WKU.

Linda L

I remember being struck several years ago by how teenaged Casey was so tender with his baby niece, Omni. I always thought he would make a good father. I also recall when he was seven and asked his mother what "popular" meant. Jane told him it's when a lot of people like someone. He said, "You're popular with Dad." Very sweet.

Kathryn A

When I first met Casey, he was the "other brother." He lived with Ken in Minnesota while Adrian (Sam's buddy) and Galen (his good buddy later) lived in Bowling Green with Jane. I came to know him slowly. My best memory of Casey happened when Jane attended an NWSA conference in Boston 2000 (I think). I drove into Boston from my summer home in So. Deerfield, Mass. I'd agreed to stay over and hang with Casey while she attended the conference and then bring him out to So. Deerfield for a couple of days. We went to the Museum of Fine Arts, where we were both, I should say, thoroughly bored. At some point, I said to him, "Let's take the subway back," to which he replied, "It's called the 'T.'" Even though he did not know it, he had spoken like a true Bostonian. Later, Jane came out to western Mass., and we had a cookout with friends in the backyard. We were hanging out, playing music. Casey brought out a CD and asked if he could play it. He seemed shy around these unknown people. We played the CD and things seemed to relax a bit, and then Rosie said, "Casey has fabulous taste in music." He seemed really happy. It was a really good day.

Casey A (cousin)

I remember when Casey Lee was a baby, and we would be in the car, and he would push his fingernail into my thumb nail. I used to think it hurt . . . but must have not been too bad! Also, how at Christmas time he would help with puzzles but only put like two pieces in, one at the start and one at the end, just to say he helped with the puzzle.

Farrah F

I love the memorial site. You all did a great job bringing out Casey's subtle humor. That's what I remember most about Casey. He was quiet, and when he talked, everyone listened, and he was funny. I always wondered what was running through his mind. I was over at your house fairly often and there was this one time when you were hosting Carol Mason over at your house for dinner. Casey had just come in from his part-time job—I want to say it was Hardees. He sat down and joined us for dinner and never said a word. We all talked about Carol's book and the anti-choice movement. We were all talking about one of the abortion clinic shootings and Casey piped in saying how hypocritical that was. I remember thinking to myself how mysterious Casey seemed and impressed that he listened and took in all of that information. There are not that many young men who care about the academic and political conversation at their mother's dinner party. Casey cared.

Paul B

Casey is enrolled as a student in my literature class this semester, and I have to tell you that he impressed me as

someone who truly wanted to be here. He would come to my office to get help with deciphering a short story when he was struggling—something none of his classmates made the effort to do. I respected him for that. He was always polite. He was always kind. He was a son of whom you have every right to be proud.

Mary Ellen M

I always thought Casey was the most gorgeous of your beautiful and brainy boys. I loved to just stare at his face—like some elegantly sculpted work of art. He could certainly have been a model. He could have been so many things with a little more time, but he was so much as it was: kind and loving. I remember when he brought his almost new baby and her little cousin down to visit Trish and me. He was so proud of both of them. There was such a quiet sweetness in him when he was not dealing with his troubles which fell on him so undeservedly. But a great deal of luck was built into his short life as well. Think of the parents he might have landed with but instead they got the two most loving and compassionate people on the planet. Anybody would envy him that. He loved his camp kids. I watched him with them and thought how much his loving nature mirrored the natures of the two of you. At this point I don't know the circumstances of his death, but I know he died young, loved, and beautiful.

Smart lad, to slip betimes away
From fields where glory does not stay,
And early though the laurel grows
It withers quicker than the rose.

There is something out there. I think Casey believed that as well. There is something warm and comforting and welcoming where he is now. Forever beautiful and young, your precious Casey. With so much love in my heart for all of you, but especially him.

Part IV:
What We Have to Give

I—NEARING FOUR YEARS AFTER

Tender Moments

In some cultural traditions, mothers-in-law are permitted to dominate their daughters-in-law, but nasty stereotypes seem to cross all nationalities. The folktale tradition has added its own take, evil stepmothers standing in, perhaps, for the domineering mother-in-law. Maybe all mothers except for the True Mother are suspect. We can never measure up.

But I have wonderful in-laws. Right now, they're in trouble, and that makes me want to do something. Brush aside the miles and wrap my arms around them. Call for the true spirit of "in-law" and give narrative space to the gift of a loving family. Put in writing why we need more ever-loving mothers and sisters and brothers, widening our family circles. And they don't have to be official. I call the mothers of my two granddaughters my daughters-in-law, though they never married my sons. They are mine and I am theirs. That's "law" enough for them to be "in."

Two of my sisters-in-law and one brother-in-law are right now at my mother-in-law's side as she struggles to breathe, to cough

out that fluid in the lungs. Four days ago, she had surgery to remove a sarcoma attached to her sternum and a spot on one of her lungs. The doctors successfully removed the tumor, but the "margin was marginal." Evelyn, under the trauma of surgery and medication, has had some delusions. She has been restrained. Her son is worried from afar, though the ticket is bought, and we will go in a couple of weeks to step in with the next stage of recovery. I think of my sisters-in-law, her daughters, at her side, day and night, comforting, appeasing, caring for her. They are tired and worried. My brother-in-law is helping them help her. My father-in-law—what must he be feeling right now, his wife of well over 50 years so unlike her usual strong self. I think of my letters project, those testimonials that father, son, and daughter wrote about the mother, Isabel. I think about the triangle that my Uncle Bob drew after the fourth leg of their quadrilateral had died and that their smaller family now embodied.

Tonight, she is sedated. Tomorrow they put in a pacemaker.

Who is this mother, my mother-in-law, Evelyn, whom we all adore? You hear about someone's being the "glue" who holds a family together. The "rock," perhaps. I don't think of Evelyn as glue or a rock, though she is a powerful force of adhering—to her principles, to her unmitigated love for her family. And she is as strong as any rock. But she is more like the spirit of love that infuses our family and teaches us how to be our very best selves. Casey said of her, "You know what I love best about Grandma? She doesn't judge people." When I think of unconditional love, it is Evelyn's face that comes to mind. Recently Galen wrote her this letter:

> Dear Grandma,
>
> I would like to take some time to tell you in writing how much I admire your bravery through this harsh treatment for your cancer. It has been a wonderful inspiration to watch you take this scary news head on, and it comes to no surprise. Dad has been keeping me informed

of many of the details, making a great effort to stay positive. You have been such a great source of support for your family, so I hope that this letter is seen as a cane for you to lean on.

It is important to remember why so many people love you, so I would also like to say why I love you. I find your curiosity to be one of your defining character traits. It is good to hold on to this, because it makes you forever youthful and hungry to learn. Although I do not hold loyalty to any God or religion, I find your commitment and faith propelling me to believe in my own set of principles. Your integrity is another thing I have never seen waver. It makes me aspire to the same level of honor and commitment to loved ones. We are here for you, Evelyn, my grandmother—your whole family supports you. I think of you every day and hope for a speedy recovery; I imagine you well and ready for new days; this is my version of a prayer for you, my lovely grandma. I love you so much. XO, Galen

So, bury your tired, woman-blaming tropes. Let the headstone read, "You lied." And to my mother, Evelyn, take that glue, that loving spirit and wrap it around your body; take that rock and stand on it. Say, "Not yet, not yet. My family is calling me, my daughters, my son, my husband, my daughters-in-law, my son-in-law, my grandchildren, my great grandchildren, they're calling me."

I am midway through the second week of helping out. My sister-in-law, Susan, hasn't been home for three weeks, and Evelyn's other children, husband, and in-law children have been here as best they can to help her and to spell Susan. This has been a harrowing time for the family, but also for those whom she has folded under her magnificent wing.

Two incidents happened several days ago, around the time Evelyn was having bouts of respiratory distress, as many as three

times a day, due to mucus plugs blocking her trach tube. One morning, my father-in-law and I were at her side when she became increasingly pale, breathing heavily. "I have never been so fatigued in my entire life," she said, and then a few moments later in a broken voice, "I am utterly miserable." She tapped her trach and mouthed "respiratory." I made the request, the CNA came in and she requested the RT (respiratory technician) as well, calling down the hall. Thirty minutes after the first call, the RT arrived, but during the wait, Bob and I stood at her side, each of us holding one hand and watching her belly rise and fall, her throat rasping, her skin pale, her eyes anguished. Once the RT suctioned her and cleared out the tube, she recovered. Bob and I had exchanged glances twice during this ordeal—nothing said, but our faces spoke.

Afterwards I said, "That was enough trauma for one day."

"Yes, it was," he responded. These moments of tender solidarity, unexpressed except in nonverbal ways, were unlike anything my father-in-law and I have shared. I'll never forget it.

That day—or the next—all these days run together—Evelyn gestured for me to come closer, reaching for my hand. We were alone. Sometimes she likes to hold hands, so I thought that was all she wanted. But she gestured for my other hand then pulled me close. She pressed her face against my stomach as I stood before her, patting her back and then just hugging her. This lasted a full minute, and I felt blessed. She seemed better, too, as she settled into her pillow to await sleep.

Here's the note she wrote this morning on her writing board, several days later and after much progress, after the best night's sleep she'd had in the past three weeks: "It was so deliciously wonderful to sleep last night."

II—BREATH IS LIFE

If you can pull yourself away from the demands of work, as I did when I went to help Evelyn after her surgery, or even for just a while each day and focus all that attention on the most basic part of your life—breath—you may find a different way of being, even in the midst of the most complicated situations. That's what I tell myself, in my trip upstairs to my serenity room with my laptop under my arm, as I click on the guided meditation about breath.

One of the ways that we are taught to feel the breath, at least in the guided meditation CD by Sharon Salzberg and Joseph Steinberg, is to note when the "in" begins, when it stops, when the "out" begins, when it stops. Sometimes there's a pause between the out and in, and it's there that you can settle your attention. Such moments of not breathing are a place of suspension, a place where you can glimpse the hugeness of the mind, what it can be. It's like standing on a very high hill where the land stretches out. Even with your eyes closed, you feel the space as something endless and you are small and at the same time an essential part of it.

The mind won't stay put, however, and the return from wherever it takes us back to the breath is the essence of meditation

practice, always returning, gently, patiently, without judgment. When Salzberg says, "One of my teachers once told me to imagine every breath as your first breath and your last breath," I feel the air fill my lungs—and think of Casey's last breath. I try not to linger there, but he's with me, though his last breath was not in his old bedroom, but on a county road 20 minutes away. The doctor who wrote the autopsy spoke of the shape of his lungs as if they were a beautiful cathedral.

If life is precious, dear—giving breath a few minutes of undivided attention—or a few seconds until the mind skitters away, so then a few more seconds, and on and on—might be the best way to say thank you.

Thanksgiving Tree

At first, I thought of it as a kind of Christmas tree, with ornaments on which we'd write down what we're thankful for. However, I knew if I gave the assignment of drawing the tree to Latoya, we'd have something better. First, she drew a November tree, strong and brown with the heartwood in plain sight. Then she and Omni began cutting out leaves for us to write on.

As our guests arrived, we pointed them to the "art room," where they could choose a leaf shape and markers and design their own leaf. Since our group was mixed—very young, family, new friends, old friends—it proved to be a good icebreaker as people leaned in and watched each other, then *ohhhh* and *ahhh*, as they saw the leaves emerge. I think it was Latoya who saw that the leaf shapes also doubled as frog shapes, so we ended with tree frogs as well.

This is a new activity, but every Thanksgiving we go around the table with whoever's here and share what we're thankful for. I volunteered to go first this time, and Ken said, "Don't make everyone cry," which made me laugh. But this year it seemed—with Leah writing for the first time and putting "mom" and "dad" on her

leaf—that he was recognized in a new and better way than my usual quivering voice.

I am very thankful for this girl. For her pronunciations— "Can I play on your I-padge?"— "Give us this day our layly bread"—and thrill of learning to read, "Th" "e"– "The"– "mmm" "aaaa" "nnnn"– "man"– "iiiii" "ssss"– "is"– "ffff" "aaaaa" "ttttt"– "fat." The other day, she asked if she could have a piece of jerky from a bag that was sitting on the coffee table. I said sure and went back to reading. A moment or two later, I looked up to see her trying to open a tiny square packet. "Wait," I said, "here's where knowing how to read is so important. Come here." She brought me the packet and I had her sound out the words: DDD—OOOO NNNNN— OOOO—TTTT EEEEE—AAAA—TTTT. "Do Not Eat," she said. Thankful for the way she flops in an armchair, sitting on her neck, her legs waving in the air.

"How do you do that?" I ask.

"You could do it, too, Grandma, just try." For her smile and the light she brings into the room.

It's not corny to say, "I'm thankful for family." I'm sorry that so many people don't have a family or that they're estranged or that Thanksgiving dinners are cause for more pain and disappointment. I'm sorry a celebration of thankfulness is historically rooted in conquest and massacre. It's not corny to be grateful for what you have, or to realize that if you lost it, how lonely you would be, how bleak the world. Does that keep us acting as if what we've got is precious? As if our closest friends and families could break?

The point of the breathing meditation, I think, is not to take it for granted. Since my mother-in-law is recovering from surgery and still struggling with respiratory distress, I know that she would agree that when we are denied air, we would give anything to have just one more breath. At that moment, all ephemera will drop away and who we are as beings in the world—fluid, re-forming, contrary, sneaky, courageous, contradictory—will come to a single point, of

rising, falling, and though I don't really know what that feels like, I suspect that in the moment when there is no more, some sense of self and who we were and are will rush in.

In that moment, we will want to feel gratitude—not regret.

Ruminations on Self-Doubt

Who doesn't have it now and then (or in some sad cases, perpetually)? And what makes it so oppressive? If you could turn it off with a switch, would you? It would be nice to think that once you reach a certain point on your path that you no longer have to deal with the darn thing. The trouble is that once you clear one high bar, someone raises it. Maybe you do. And maybe it's just the nature of the mind: to churn on about what is real, what is meant . . . the "yikes" question: Who am I? What's my purpose? That's probably why we surrender to laziness—it's just easier to shut down. Whatever.

Writers know it. Virginia Woolf describes it in her great *Room of One's Own,* when she says, "Think of Tennyson; think—but I need hardly multiply the instances of the undeniable, if very, unfortunate, fact that it is the nature of the artist to mind excessively what is said about him [her]. Literature is strewn with the wreckage of men who have minded beyond reason the opinion of others" (55-6). Since she also devotes an entire chapter to Shakespeare's sister, who died at the crossroads and is akin to other women known as Anon, we know also that there is plenty of wreckage of women. There's a quote attributed to Mark Twain who may (or may not) have said, "Keep away from people who try to belittle your ambitions. Small people always do that, but the really great make you feel that you too, can become great" (Maclaren). There's a lot to be said for building a network of friends who affirm your worth. And alongside that is this: You have to build coalition and community with people who either don't recognize the Wonders of

You or who don't know how to show it, some so wounded and closed off themselves that it's like bouncing off a sealed sphere.

University professors know it. When we collect our student evaluations and 98% of the comments are positive, those 2% nasty are what keep us up at night. My mother, not a university professor but teaching for a few years in her twenties at a high school, wrote, "This morning, of a sudden, I just knew I didn't want any more of small high schools and sassy kids. Next time I teach I hope it'll at least be a junior college and MUSIC." I'd like to have been there to say, "Mom, don't expect them to love music the way you do." But I don't want to betray all those students who love learning and appreciate their teachers. It's those harsh comments that are hard to take. Some students may find anonymity, a screen they can hide behind—passive aggressive, sucking up for the grade, then snarling on the evaluation. I guess the same thing happens when faculty evaluate administrators—all that anger surges out. As a dean friend said with a laugh, "Oh, you learn all kinds of things you didn't know about yourself!"

Self-doubt is as human as hunger, and most of us have our own Gollum crawling around our legs, looking up with longing and disapproval, tugging on our belt loops, uttering recriminations in terse phrases, *Shut up. Fake. Selfish. Worthless.* Whatever.

My mother knew it, writing home about her goal to overcome meekness.

Heroes know it. Martin Luther King, radiant light, also suffered from self-doubt, at least according to the King Papers Project, who note, "Rather than exhibiting unwavering confidence in his power and wisdom, King was a leader full of self-doubts, keenly aware of his own limitations and human weaknesses." Perhaps that's the key—to be aware of one's limitations and weaknesses, to struggle with doubt, but to refuse it mastery—to hold in front a keen purpose that can silence the slaughter or at least quiet it. Ken says that Edith Stein talks about the importance of self-doubt as a counter to self-delusion. She says we can't achieve perfect

understanding of ourselves alone, that we need the mirror of others' perspectives as well as our own. And Saint Augustine (paraphrasing) says that when we doubt, we know we do not know and should therefore not be too hasty in suggesting we do. As the armchair philosopher that I doubt I can claim to be, more like a rug scratching philosopher, I do affirm that doubtful though I am, I am sure that I am.

And the Dalai Lama says self-doubt is a form of laziness, muddling us in inaction. He also says—I usually find reason to say this in every class I teach— "If you want *others* to be happy, practice compassion. If *you* want to be happy, practice compassion." A little self-forgiveness can go a long way to get us over self-doubt. As Gloria Steinem said, "Measure yourself by the real, not the ideal."

Meditation 101—empty phenomena rolling on

I am preparing myself for another piece of writing, which I intend to offer on Casey's 24th birthday. It's a commentary I've known is coming since last July, when Ken and I sat down in that tiny room off the courtroom, to hear The Apology. This might be my practice session for what I've been avoiding for over six months, but which I must contend with, for Casey.

Joseph Goldstein (in his and Sharon Salzberg's Insight Meditation Correspondence Course) says that "the great awakening happens when we understand that all experience is empty phenomena rolling on." He says, "What we call self is a constellation of changing experience . . . of elements—elements of body, elements of mind, and each one of these elements is also momentary and insubstantial . . . We rely on a superficial perception of recognition." As I reflect on just how superficial my understanding might be, I'm struck with the similarities between these Buddhist principles and post-structuralist thought—ephemera rolling along, no essences. However, while one dismantles

232

materiality and leaves us with uncertainty and meaninglessness, the other frees us—at least that's what Goldstein says.

When I hear more disgusting news—another bombing, rape, attack, lies covering up abuses—I wonder, how did that person get from "just wanting to be happy" to such a horrendous act? I think about this when someone acts out in a rage and we look on, stunned. Hardly "empty phenomena rolling on." Maybe reckoning with bad things means in part recognizing that there's "no one behind the experience to whom the experience is happening," no fixity of person. If "everything is arising out of conditions," who are these conditions? And are we always just responding?

In that last moment, when in the next we are no more, what is it we are about to stop doing? Who are we about to stop being? Did we find happiness? Did we give it? Maybe then we are finally "empty" of self and "great" with awakening.

In the Moment

It's a cliché. Running from task to task, the little voice says, "Be here now," and I reply, "Just a minute." Remember Janis Joplin's "Tomorrow never happens, man. It's all the same fucking day"? And the Buddhists say the same thing. This world we've parsed out into segments called time, which we "manage," is an illusion. A sleight of hand. The sun rises and sets in a "day" and "night" begins, but only on this street. Globally, it's ephemera sweeping the land.

But on occasion, I realize that I've just been so in-the-moment that I've forgotten myself—the myriad responsibilities, my hopes and worries, my longings and regrets and rehearsals of times now gone. But wait, even there, in that sentence I've defined "myself" by my jobs and various big and little obsessions. Is that who we are? Heidegger philosophized the "dasein," which means basically "being there" in one of two modes, authentic or inauthentic. For Simone de Beauvoir, there were two selves, Subject

233

and Other, with the male always the former, and the female (woman is not born, she is made) always the Other, caught in a state of immanence and voicelessness, while "Subjects" speak, write the histories, declare the laws. So, I've mixed up Heidegger and Existentialism in one paragraph, having gotten to them through Janis Joplin. This thing we call "self" is much more than the sum of what fills our interior landscapes. I am not my worries. You are not your heartache.

Last Sunday, during a quick trip to Florida to help out my in-laws, I was sitting with Evelyn, my mother-in-law, just the two of us, in her temporary apartment in a wonderfully sunlit and comfortable assisted living facility. Her husband and son were gone for the morning. We were listening to a local church service on TV, led by a former Baptist now Presbyterian (that seemed relevant). He was talking about stillness, using some psalms and a passage from the *Old Testament* about Moses and the people he'd led into the desert. "How do you respond to a spiritual crisis?" the preacher asked. It was rhetorical, but his assumption was that most of us weep or yell or pace, but we don't go quiet. We don't let things spin around us, instead we spin. We are not the mountain that the winds pound but cannot hurt. We are not the sky that the clouds pass across but do not change.

Because I'm a knitter, I was knitting while listening, my eyes on the color purple, my fingers, the clicking needles. Evelyn was to my right. Suddenly everything outside of us seemed to slip away. I wasn't particularly focused on either of us—didn't wonder what she was thinking or feeling, wasn't my impatient self. It was a moment of peaceful listening. And then I noticed it and thought, *Wow, that was really pleasant.* It was as if we were there and not there at the same time, the her-ness and me-ness evaporated, and we slipped into a different sort of place. Maybe *dasein* had a moment of authenticity.

Occasionally there are moments of slippage and then an awareness of a different level of consciousness. Sometimes it's gender that disappears. Sometimes in the midst of conversation there

is such a connection to the person that I forget I'm talking to someone with a specific gender. Then a little voice goes, "Wait a minute, is this a man or a woman?"

It seems like a good thing to forget the self and then to notice that it disappeared for a moment. Even to welcome it back.

III—BROTHERS

As a child, I had all the attention an only child usually gets—nothing to share or divide among people whose gouging, grasping fingers would pinch me if I didn't keep my mouth shut or give up what I wanted to hang onto—but I also knew that people existed whom I could call "brother" and "sister" and that I had a place in a larger family, where I could recognize in their faces some of my own features. The best of two worlds.

And yet, as an "only child" with brothers and a sister raised in a different family two states away, I couldn't think about them without a creeping suspicion that they had it better than I did. My sister's straight hair (mine impossibly curly in the age of Dippety-do and Girl from U.N.C.U.R.L.), their proximity to each other (*they* didn't have to do everything alone), and later, their education at top-notch schools—these examples of their good fortune accentuated the absence of mine and resurfaced as reasons for regret when I looked through my stack of pictures of them, or sometimes just out of the blue, part of a peripheral world that caught me unawares, like the swipe of a paw when a creature normally dozing in the shadows arises to knock something out of the way. Whether it was green-

eyed or blind, it was the slyness of the beast that left me wistfully gazing out the window in the midst of washing dishes or answering the phone. "What are you thinking about?" my mother asked me several times a day. "Nothing." When I finally met them, one by one, I was variously terrified, mortified, and thrilled. One thing was certain: I would never do anything to disappoint. I would be polite yet amusing, pleasant yet independent, and even though this meant adopting a perpetually alert stance (no dozing allowed), given that we rarely saw each other, and when we did, the visits were brief, I succeeded in hiding my many faults, most of the time, though some of them showed, like a slip below the hemline, when my attention wandered.

I realize now that at least some of this performance-slash-wariness was modeled by my mother, whose watchfulness led in her later years to a hyper-sensitive attention to the meaning of subtle cues that might or might not have existed in reality. Being with her felt like walking a minefield sometimes, where one stepped cautiously and took care to respond to every request lest she explode in a fury of hurt feelings or withdraw into sulking silence. But this is the sad-and-wary mother, someone who appeared later, when I was in my twenties and thirties, not the one who raised her only child alone, independent and generous to a fault. That mother was someone to look up to, if sometimes an embarrassment (using big words, gurgling with delight over a sunset). At these times I was convinced she'd adopted me, and my real mother was vacationing in Japan. Why else would my very real brothers and sisters be separated from me? The divorce was just a trick to keep me in the dark. But now I can look back and see that, yes, she must always have been sensitive and wary, and I must always have been impatient (and wary), and I was always hers and she mine.

She is the person I learned intimacy from—how to share secrets, express anger, how to be utterly myself in private when social demands required someone very different. She was head music librarian at Oberlin College, and during the hours she worked,

I roamed freely—from one friend's house to another's, across town to an alley, where a family of hungry kittens mewed for the cat food we bought and fed them, to the Ben Franklin's store, to a friend's tree house, where we took a stash of nudist colony magazines we'd found in a trashcan and pored over them, laughing and screwing up our faces with disgust. We lived next to my elementary school. From my bedroom window I could look out at a strip of grass where a privacy fence hid our garbage cans, and then a vast expanse of gravel parking lot, where I sat and crushed stones into sand, and then the playground to the right, and the huge, three-story brick school building straight ahead. Pretending to be sick, I stood at the window and imagined my classmates adding and subtracting or bending their knuckles around their crabby cursive letters. I'd pick up my book and read myself into another place.

Being alone is an art. It can also feel like hell.

To avoid it, I cultivated friendships with girls from large families. My favorite family was the Dodsons, made up of an aunt and uncle, who let Mrs. Dodson and her six children live with them in exchange for housekeeping. All I remember of Uncle—who seemed always to wear a dark green uniform with his name stitched over a pocket—is the way he would try to look into women's cleavage when they appeared on television, peering into the bottom of the screen, as though he could see inside the metal frame to the fleshy bosoms the rest of us couldn't see. I giggled, along with the sisters, learning, with them, what breasts do to men. I remember the day I had to pee and one of the sisters locked us out. When I banged on the door, calling for her to open up, Auntie yanked the door open and spoke through lips in a rigid line, "This isn't your home, go bang on your own door." Now I can imagine what it must have felt like to live in a house over-run with loud, smelly children, but whether I ran home or just huddled in the corner of their sofa, silent and ashamed, that *feeling* of embarrassment is as redolent today as it was then. *How presumptuous you are, how full of yourself!*

The one member of the family I feared and disliked most was my best friend, Barbara's, older brother. All of us kids liked to jump on a big bed upstairs, and one time Ricky lay down on top of me and rubbed me with his nudist colony. Another time he got my friend Allison to suck on him behind the school. I backed away and looked into the black reflecting windows and over my shoulder and up into the sky, down at the pavement, and finally back again, in time to see something like green snot come out. Allison was giddy with excitement as we walked home and didn't notice that her splendid initiation had left me speechless.

If I'd had brothers to call on, wouldn't they have done something to protect us? Marching around the edge of the building in a little gang, they'd have beaten Ricky up or yelled at me for being in the corner of the schoolyard with a dirty boy and a nasty girl who didn't know better than to get on her knees for a greaser. One thing was certain: my brothers wouldn't be like Ricky. Maybe my biggest brother would drape his arm over my shoulder and walk me home. Maybe I'd get punched in the arm and could scream, "It wasn't my fault, I'm telling Mom!"

Telling on other kids, however, remained a neglected art, though I could tell Mom my own secrets, or even better, make up stories. She didn't question my sick days, which one year mounted to thirty. I used to hold a thermometer in the stove flames, then shake it down to a reasonably sick 101. While Mom was at work, I crafted a world entirely my own. One day I picked up *A Wrinkle in Time* by Madeline L'Engle. I could hardly stand the suspense, as my eyes sped to the exciting conclusion, heart racing, palms perspiring. I paced around the living room, then dove back under the cover that I'd thrown back. On one page was a simple line drawing of an ant walking along a string, unaware that he was crossing over a loop of string that hung below. This was the wrinkle. Someone could walk along the top while another person moved down the loop, each unaware of the other and even more mystically, unaware that

another dimension existed so closely without emitting a breath or a hint at all.

Wasn't I in a kind of loop below the line where my siblings walked? How would I ever find my way back to the surface? What if there was no opening where the loop and line met?

Soon after, I met the brother closest in age to me, Gordon. He and our stepbrother, Rolf; my father; and his third wife, Cynthia, were traveling through Ohio, so they suggested a brief visit. I waited for them to arrive, my heart in my throat. I was too timid to say much to my father, and Rolf wasn't *really* my brother, so it was Gordon who bowled me over. So good-looking with his dimples and wide-legged stance, I couldn't imagine why he showed interest in this curly-haired, geeky monster. Snap, snap, a few pictures for memory's sake. And then they were gone.

From the concrete fact of their visit, my longing for brothers grew. About this time, I received a box of hand-me-downs from a family friend. What a feast of textures and colors of blouses and skirts, dresses, and slacks. I tried on everything, then stocked my dresser drawers to overflowing. Still, I was not satisfied. What I wanted was a boy's sweater, a little too large, worn at the elbows and rolled up at the cuffs. At my friends' homes, I let my fingers drag over any boy's sweater left lying around, and if no one was looking, I snatched it up, scratchy like my own sweaters but tipped with smells that promised something. Much later, after I'd told my oldest brother, Hugh, about my desire for hand-me-downs, he sent a box of used sweaters, replete with rips and stains. That, as I understand it, is what you call a brotherly gesture.

I met David, the middle brother, when my father and Cynthia invited me to visit. Something about the vastness of my inferiority tells me I was in junior high. David, a teenager then, was a god— beautiful, remote, superior, and tolerant. I didn't know how to relate to my mathematician father, who could have been an angel and I still would have mumbled so that he'd have to lean toward me and say, "What's that?" On the second night, I sat at the dinner table

with a mouthful of food I couldn't swallow. I knew I'd throw up. Neither parent said anything and when they started clearing the table, I slipped away and went to the bathroom to spit it out. Many years later, Cynthia said, "I remember that visit. You were terrified."

I eventually learned that my brothers' and sister's growing pains were no less definitive than mine. In high school, David was probably already developing the psychosis that would send him to mental hospitals and on godly missions that ended with the police. When I was in graduate school, David came to see me. This time, his melting brown eyes burned, and the crooked smile was gone. He picked up the phone and spoke to the dial tone, "This is God speaking." He kept referring to my friend in the next apartment as Jezebel and to fire as redemptive. He stared at a spot in the middle of the room and spoke sternly, "Get thee behind me, Satan." I called someone—my father, Hugh, Gordon, I don't remember. It was my first glimpse of insanity. This brother eventually died at forty-nine, months after my father's passing, alone in a trailer in Arizona. This brother of four, utterly alone.

Now much of our personality is formed by what we know we don't have—or by what's ours and yet not ours? Was the centrality of longing in my psychic life unusual? Did you ever want an old sweater with holes and boy B.O.? If you'd had brothers, would you have given it up so easily to lean, hard-muscled boys in bars? What did David want—the first mother, who died suddenly? The second—who was my own? The third, who couldn't bear his craziness? Was it really God he sought in the reams of narrative poems he wrote, all in upper-case? I'm sorry I scoffed at those poems, couldn't read them, knew they were ridiculous. He called me "sister," and though he died young, Hugh still refers to him as "little Davy."

Maybe longing isn't so unusual. A couple of years ago I taught Caroline Kettlewell's *Skin Game* in a class on autobiography. She spent years cutting herself, not because something particularly traumatic had happened to her (no rape, no incest), but as a way of

coping with chaos and an overwhelming sense of despair. Is that what happened to David, alone in that trailer in the middle of the desert—despair? None of us misses the fact that he followed our father to the grave by months, followed the gentle father who'd loved him but couldn't protect him from, or take him to, the absent mother. For me, longing never crossed the line into despair. Someone called, or Mom came home, or a book snapped me out of it. What I recognize in Kettlewell's account (and David's) is the wrinkle in time and space, that secret life where we make meaning out of a world that jolts along on the string above us, while we craft realities that are often mistaken and misguided—realities that someone could help us change, if only we'd let them see.

I have tried to see the unseen and unspoken in my own children's lives.

When I became pregnant the first time, I was sure it would be a girl. It wasn't. As if there really was a god up there, doodling in the margins of the master plan, in my adult life I got the sons that as a child I had wanted as brothers. I love them the way my mother loved me, fiercely and loyally. So much went on that I didn't see or that I explained as being the result of something else. Hesitancy grips me.

He was a hyperactive boy. Even at the age of two he couldn't nap, while the other children in daycare drooled onto their mats. He twitched, bit, made noises when others managed to sit still. In kindergarten, he saw a counselor who used play therapy to draw him out. In elementary school, he couldn't enter a room without flipping the light switch on and off until someone in exasperation grabbed his hand away. He keyed my mom's car; positioned his favorite watch in front of the tire, so when I drove away it was crushed. I fed him peanuts on a plane trip because another passenger said it had a calming effect. He went to the hospital psych ward for the first time in fifth grade. To a treatment facility in eighth. Again, in high school. But it was at the facility in Tennessee, where we drove every

weekend to see him and do family therapy, that he told the counselor what was bothering him.

It was a secret he kept for seven years, but when he revealed it, a curtain lifted for us over the dark years, and suddenly the acts of sabotage and rage made sense. We understood why he had so relentlessly tormented his older brother, why in his longing to be like his older brother he might turn on him. How many times did I interrupt the boys at play to stop the gay bashing they used against each other? One night Galen came to me in tears, "Why did you give me this name? Didn't it even occur to you that this would happen?"

There they are, at the age when speaking one's pain seems impossible: A hyperactive boy filling drawing pads with images of forts and battles, huge robots torn apart by thousands of invaders, gouging the paper where the bullet holes hit. A sensitive brother burrowing beneath the covers of his bed in the middle of the day, refusing to come out, wanting the darkness. A third boy crying out in anguish, "Why do you hate me so much?" What big brother could I call on to watch over them when I didn't see and couldn't understand? Surely one of the greatest sorrows for parents wells up when we fail to protect our children. How was I to see into the loop when I could barely keep track of the line I was walking?

Once I realized I was going to have children, I assumed I'd be a mother of girls. I'd grown up surrounded by girls and women; I've had dozens of best girlfriends—I *talk* girl. Instead, my life has been defined by my love of boys—first my brothers, real and imagined, then my boyfriends (real and imagined), and finally my own sons and husband (all real). This is a scratchy territory, where physical strength and agility still melt my heart. It's a world of loud guffaws and low chuckles, a lot of swearing, name-calling, backslapping, and complicated handshaking. Sweaters stink or never get worn, remain wadded up in the back of a drawer. But it's not as different as I thought it would be. Boys *do* cry, they suffer overwhelming insecurities and sadness, they struggle with words, they want to be tucked in.

Mostly, they long for a world where cars are faster and shields melt bullets and they're not the youngest one in a family that pinches and hits and steals things from their room, a world where there's no doubt about love—a family where it's easier to see what's going on.

IV—APOLOGIES

The Killer Apologizes—a letter to my son

Dear Casey, Today is February 10, what would have been your 25th birthday. You were shot and killed four years and three months ago, on a dark Kentucky Road, by a 55-year-old man, father of three, a gun collector with a third-grade education, a poor man with disabilities, a beer-drinking redneck with a subscription to *Soldier of Fortune*. He was a little drunk that night when he grabbed the handgun out of his son's hand, stepped out on his porch, and began firing into the darkened car so whoever was out there wouldn't come back and try to "whup his boy" (or whatever was going on between an 18- and 20-year-old). Leland Burns fired four shots; three bullets hit a tree and one went lower, into the car, where you, still seat-belted, were heading for home. A terrible force entered your shoulder and traveled through your lungs, your pericardium. Did those seconds of time, mere speckles, stretch and burrow? Did you think of us, your daughter, your parents, home? Did the ephemera of the life you lost blast you into a new awareness?

About six months ago, your dad, Aunt Susan, Galen, and I, met with the attorneys to put an end to the civil suit. The man who killed you had already served some three and a half years and this settlement was a reconciliation of sorts, a recognition that he'll be out soon, no matter what we do or say, having served the typical 60 percent or so of his state sentence—the federal charges on gun violations are an additional sentence, and he'll serve something less than 18 more months. For this meeting, we requested an opportunity to talk to him. We'd spoken with your lawyer about our desire for an apology, and he spoke with Burns' lawyer, for this is how things unfold in the courts—lawyers talking to lawyers, formulating and delivering. He had said, "Do you think an apology will have value if it doesn't come voluntarily?"

I found myself thinking about the times we made you kids apologize to each other for some misdeed. Did it mean anything? Were we teaching the usefulness of the hollow "sorry about that"? Or is the habit of apologizing something that grows on you, gathering meaning as you learn how to shape the words? My answer was, "Yes, it will still matter." I thought that I could look at his face and know if he was sincere.

As we crowded into a tiny room behind the courtroom in the Warren County Justice Center, my heart leaping at my throat, I knew that an important reckoning was before us, but I didn't realize what a mashing of the superficial and profound it would be. We sat there staring at Burns, while the jaded old toad of an attorney interjected now and then and the Commonwealth Attorney stood by the door, respecting that this was important to us but unmoved by the regret expressed. They handed us this letter, typed on an ordinary piece of white paper.

July 22, 2013

To the parents of Casey Olmstead,

On October 26, 2009, I was at home with my family minding my own business. I had been drinking that night. I did not know and had never met your son Casey Olmstead.

The first time that I knew anything about any trouble was when my son, Patrick, started out the door with his gun. Natasha was screaming that some people had come out to fight Patrick. From what I was told by Patrick and Natasha, I thought there was a whole bunch of people outside. My wife, Faye, grabbed Patrick and held him back and I grabbed my gun and went outdoors. I had no intentions of hurting anyone unless I was attacked first.

When Casey backed out of the driveway onto the highway it occurred to me that Casey and whoever was in the car might be about to shoot into the house. I fired four warning shots to scare them off. One of the bullets hit Casey and killed him. I truly regret that your son lost his life that night.

Knowing what I know now, I understand that this was just an argument between kids that got out of control. I know Casey had his troubles in the past but that doesn't mean he didn't love you as his parents and I know you loved him. When he died Casey was young enough to turn his life around and I hope he would have done so.

I regret what happened every day of my life. I hope this letter will help you heal over the loss of your son and I ask that you would consider forgiving me. I had nothing against Casey as I didn't even know him. I so wish that night had never happened.

STEVIE BURNS
Steven Leland Burns

I think I tried to read it, but the words were meaningless—later, I read it twice more, but except as a token, it has no meaning for me. I could pick it apart, but I don't want to. The spoken words were more important, and so I want you to hear them now.

Your dad said something to Burns, some gesture of kindness and expression of regret that you had driven over to his house—nothing about the craziness that ensued, just a reaching out. I wanted something more—more than was possible in that room crowded with court representatives. I wanted to hear the workings of his mind.

"Why did you do it?" He answered that everything had happened so fast as to be nearly impossible to untangle.

"I wished I could go back and redo that night," he said.

"What has it been like for you, these past four years?"

249

"That's difficult to say," he said. "I got nothing. I lost everything—my wife, my home." He tapped his heart with his right hand, "I'm sorry, I really regret what I did. They was just kids being foolish." Tapped his heart again. "I'm sorry, I wish I could take it back."

And then, Casey, my voice broke. "I need to know you feel remorse because I couldn't bear it if the man who killed our son didn't care about what he did."

He tapped his heart. "I am sorry, I truly am."

Do you believe the apology? Do you think he suffers over the taking of your life? Is he a different person—surely, yes, but how? Do you enter his dreams, terrifying, like the creatures that used to enter mine? I hope you don't think his only regret is that he "lost everything." That he is that empty. Had I the wherewithal, would you have wanted me to say, "Nothing? You have nothing? You have your life, Mr. Burns, and the opportunity to live it however you want."

In *Letters to a Young Poet*, Rainer Maria Rilke wrote, "Perhaps everything terrible is in its deepest being something helpless that wants help from us. So, you must not be frightened, Dear Mr. Kappus, if a sadness rises up before you larger than any you have ever seen; if a restiveness, like light and cloud-shadows, passes over your hands and over all you do" (38). There's a beauty of expression that reminds me of you, my suffering brave warrior of a son.

The most terrible thing I've ever known is losing you. If I'm to listen to Rilke, what is the helplessness therein that could possibly get help from me? What if "everything terrible" (that would be Mr. Burns) is the "something helpless" who wants help from "us"? I want to believe that life has not forgotten you and that those of us still here, missing you, can do something more than sigh. From my poem, "Memento Mori": "I know the feel of your head in my hands, / your body tucked in the bowl my elbows made."

In "Architecture of Loss," I tell about a dream where you came to me, how we had only the briefest of moments to share before the dark knowledge of death clouded your face. I was in a cave-like structure in a deep woods:

> The doors slam shut on the night-time
> river of sliding images as the boy rises,
> brushing leaves and debris from his shoulders.
> He looks up, a grin spreads slowly across his face . . .
> but something gives him pause—is it in my reach
> for him or my shadow on the vaulted ceiling?—
> Oh, to stop that cellular movement of knowledge across
> the eyes, nose, mouth drawing down—
> *What am I doing in your dream?*
> *There, there, my darling, come and let me hold you,*
> *I'm sorry I'm sorry I'm sorry . . .*

Meditation 101.3— "release it"

In Sharon Salzberg's guided meditation on breathing, she begins with "take several deep breaths and release it." Now, she is not one to confuse "them" and "it," and yet it strikes me that after one takes several deep breaths, the logical thing is to release "them." But it's "it." So, what is this "it" that we need to release? I don't know whether to be relieved that I can release this thing today or stressed that I need to figure out what the one thing is. What if I'm releasing the thing that's easiest to let go and hanging on to what would set me free?

Is it the mind, imprisoned by habit and indulgence? Is it fear? Hatred? Guilt? Regret? In another Salzberg meditation that I shall return to, I'm sure, the instruction went something like this:

"Imagine a difficult time when you felt bad about yourself. How did your body feel? Now imagine that you are wrapping arms around that person who was you and surrounding her with

compassion. What happens to the body, the memory, when you do this? Can you feel the change? Now imagine that same process with someone else, someone who is difficult or easy to dislike. Perhaps the person was unknown to you, and you noted them only because they were yelling or shaking their fist. Can you see that person as something more than the angry action of the moment? What happens to them when they are wrapped in loving arms? What happens to the anger then?"

It is now clear how important it is to slow down and give attention to the things that I am accustomed to giving just a nodding glance before moving back to the obsessions of the moment—their towering insignificance.

Tonight, I was listening to the Christmas adagios CD, which always make me melancholy. They make me think of my mother, who loved such music, and my son, who always comes to mind when I hear the angels sing. I went in search of him then, again, going back through the files in a folder marked "Casey's writing," seeking something I'd missed or forgotten.

The phone records for that day, the letters and journals I transcribed afterwards, incidents I'd written up so we wouldn't forget. Two things catch my attention tonight. The first is an account of a really bad time, when it was so hard to wrap him in lovingkindness, and the second is a prayer he wrote when he was 18 and working to turn his life around, a prayer about forgiveness and healing from "death on Earth."

When you are the victim of abuse you don't always know it, and when the perpetrator is your child, you don't imagine until it's over and you look back, that those desperate nights when you hid in the darkness of your room in tears do not congeal into particularized massive failure—how you failed to protect or love enough or set the example so squarely before him that he'd have no need to seek escape in drugs. It's not until later that you come to understand that it wasn't you he was trying to escape. He wasn't cursing you, though his finger was jabbing at your face.

It's hard to acknowledge that he was as wounded as he was, or that I am so flawed. But he would have hated a fake picture. He would have wanted honesty. So, here we are. The year is 2005. He's 16. I had written up the incident:

> It seems to have started when Casey was sitting down in our good armchair at the computer eating ribs. I asked him to go into the kitchen to eat them. He didn't. A few minutes later I walked by and saw that he had finished the ribs and his hands were greasy and had bits of charred meat on them. He rubbed them on the arms of the chair and refused to go wash his hands, saying they were clean.
>
> This escalated into cussing and refusing to get up to wash. I asked his dad to come help me, since he was ignoring me. A lot of f-word and yelling, saying we were over-reacting. We were psycho for always taking away the video games as punishment.
>
> He knocked over a large cup of water on the desk, which sent water everywhere, including under the protective glass. His dad told him to go to his room. Casey slipped in the water and came up spewing more insults and cussing that if his dad thought Casey was "his bitch," he would take him on and kick his ass.
>
> We cleaned up the water, which involved removing everything off the desk in order to lift the piece of glass and dry underneath it.
>
> Casey came back and sat down at the TV to play a game. He didn't talk much anymore. His brother took him to work at 4:00.

The process of memory smooths the harsh edges, blends discreet incidents in time into one scene, shifts the burden of blame, fills in the blanks necessary to make the narrative coherent or tolerable. I read about that event and remember it as if for the first

time, until it rises from somewhere deep inside, shoulders hunching, moaning, and I think, *Yes, that's how it was, this time and so many times.* And that's how I managed all those years, burying the strain and sadness—but also, and here's the contradiction—forgetting as well all those other discrete moments that coalesce around kindness and forgiveness.

Two years later, Casey was well into recovery. It was a long, slow, terribly brave journey. Sometime—I'm not sure of the date—he began reading the *Bible* and certain mystics, really deep, probably over his head, St. John of the Cross, Edith Stein . . . But he knew what they were talking about, knew the "dark night of the soul," and he was returning to the self he'd lost to hatred, rage, despair—the self he'd used against us, one desperate plea after another.

From Casey's Journal, 2007

I am Casey Lee Olmsted, an 18-year-old male, and . . . I want to tell you that life in Christ, for me, is the only way to escape death on Earth. I would like to start out by explaining what it's like to be dead on Earth. By death, I don't mean it literally. I mean it by over-indulging in things of this world, for example, drugs, sex, sloth, and trying to avoid the truth . . .

Unfortunately, things don't happen right when we want. So, it's easy to choose life at first, then drift into death when we don't get immediate results. But by choosing delayed gratification, instead of ME NOW! ME! ME! ME! your wait will be worth it.

Keep a humble heart so you don't have to be humbled. Proverbs 29:23. "Pride ends in humiliation while humility brings honor." A lot of people have it backwards. Some think to admit your faults makes you weak. They couldn't be more wrong! Admitting our faults brings us up! . . .

What if the Prodigal Son stayed proud? He would have nothing. You can see from this story, a son drifted away from his father and drifted into himself. What did that get him in the end? It got him a little instant gratification. That is an example of death on Earth. Emptiness. How did he return to life? Humbling himself.

Forgiveness isn't something to rely on so we will have a "clean slate." It's God's gift to people so we can strive for perfection. If we were perfect, we wouldn't need forgiveness. We're human, far from perfect! It's okay to mess up, but it's messed up to keep making the same mistakes . . . Let's move on, learn from our mistakes, do our best not to make them again.

May God be with us in everything we do. May we accept his advice, grace, and prosperity, and share it with everyone, especially those in need. In the name of Jesus Christ. Amen.

That's my son, and the other is my son as well; growth and regression, contradictions running side by side. In searching those bins I'd searched so many times, I also found a picture, taken in 2008, when he was 19 and about to be a father. He's holding his niece, Omni. You see the mutual affection—in the way she leans into him and the way his arms surround her gently. We were at Fort Matanzas, the 350-year-old outpost for St. Augustine, and he'd said, "Take a picture of me and Omni, over here." Do this in memory of me.

WITH GRATITUDE

Thanks to National Alliance on Mental Health (NAMI) for the work it does supporting individuals with mental illnesses and their families. Ten percent of the royalties earned from sales of this book will be donated to NAMI.

Thank you, friends and family, for your enduring kindness. For sharing your perspectives about Casey, in interviews and letters—especially Galen, Adrian, Latoya, Gwyn, Bette, and Ken, for reading drafts and helping remember. For writing to us when it had just happened, sending cards and sharing memories on our Memorial page, then a year later, when you came to the one-year memorial and wrote such beautiful messages on the prayer flags— we still have those!

Thank you to the children who knew Casey and who miss him.

Thank you, to my sisters- and brother-in-law—Bob, Kathy, and Kathy, for long hours in waiting rooms and your perpetual good humor, and Susan, for driving back and forth from Atlanta in order to help us with the legalities and to meet with the Commonwealth's attorney in the months before and during the trial. Glenda, for loving

us and helping us through. Thank you, all who shared the writing of haiku during that period when we lit up Facebook with our poems—especially Linda, Kathryn, Kathy E, Tim, Mark, Molly, Trish, Ellen, Melanie, and Susan. I still have that little collection.

> my hands grasp at air
> every day the tear widens—
> will I split apart?

> No, you will not split
> even if we don't know how
> we'll hold together.

WORKS CITED

Brown, Margaret Wise. *The Runaway Bunny.* NY: HarperFestival. NY, 2017. Orig. 1942.

Coontz, Stephanie. *The Way We Never Were: American Families and the Nostalgia Trap.* 1992. NY: Basic Books, 2000.

Bodhipaksa. "The Dalai Lama: 'If you want others to be happy . . . '" *Wildmind Meditation.* https://www.wildmind.org/blogs/quote-of-the-month/dalai-lama-compassion-quote. 28 December 2020.

Didion, Joan. *The Year of Magical Thinking.* NY: Vintage Books, 2005.

Hesse, Herman. *Siddhartha.* 1922. NY: Modern Library, 2006.

Karr, Mary. *The Liar's Club.* 1995. NY: Penguin Classics, 2015.

King Papers Project. "Martin Luther King, Jr.: Charismatic Leadership in a Mass Struggle." *Stanford University Libraries.* https://swap.stanford.edu/20141218230000/http://mlk-kpp01.stanford.edu/kingweb/additional_resources/articles/charisma.htm. 28 December 2020.

MacLaren, Gay. *Morally We Roll Along.* Boston: Little, Brown & Co., 1938. See also *Quote Investigator.* https://quoteinvestigator.com/2013/03/23/belittle-ambitions/. 28 December 2020.

Patten, Lesley Ann (director). *My Perfect Teacher.* Festival Media, 2008.

Orr, David. *Hope Is an Imperative: The Essential David Orr.* Washington, DC: Island Press, 2010.

Ouzounian, Richard. "Stratford Festival's Fiddler on the Roof done to perfection: Review." *Toronto Star.* 29 May 2013.

Rilke, Rainer Maria. *Letters to a Young Poet.* 1929. Trans. M.D. Herter Norton. NY: W.W. Norton & Co., Revised Edition, 1993.

Salzburg, Sharon and Joseph Goldstein. "The Concept of the Separate Self." *Insight Meditation: An In-Depth Correspondence Course.* Audio, 05.1. Sounds True: Waking Up the World.

Schipper, Janine. "Awareness and the Mood of the Land." Rethinking the Land Ethic: Sustainability & the Humanities, National Endowment for the Humanities Summer Institute, 7 July 2011. Flagstaff, AZ. Lecture.

Steinem, Gloria. "Gloria Steinem's List of Top 10 Fearbusters." Pennsylvania Conference for Women, November 11, 2020. https://www.paconferenceforwomen.org/gloria-steinem%E2%80%99s-list-of-top-10-fearbusters/. 28 December 2020.

Warren, Julianne Lutz. "Music Beyond the Senses." Rethinking the Land Ethic: Sustainability & the Humanities, National Endowment for the Humanities Summer Institute, 21 June 2011. Flagstaff, AZ. Public Lecture.

Williams, Terry Tempest. *Refuge.* 1991. 2nd Edition. NY: Vintage, 1992.

Woolf, Virginia. *A Room of One's Own.* 1929. Mariner Books, First Ed. 2005.

ABOUT THE AUTHOR

 Jane Olmsted is a professor of English at Western Kentucky University. Her collection of poetry, *Seeking the Other Side*, was published in 2015 (Fleur de Lis Press) and a chapbook, *Tree Forms* (Finishing Line Press), was published in 2011. Her poems and stories have appeared in *Nimrod, Poetry Northwest, The Beloit Fiction Journal, Adirondack 2Review*, and *Briar Cliff Review*, among others. An essay about the loss of her son, "The Weight of a Human Heart," won the 2001 *Memoir Journal* grand prize for the guns issue.

Olmsted was born in Minneapolis and grew up in Ohio, with her mother, who was the music librarian at Oberlin College and who instilled in her a love of the arts and a political awareness of social injustice. Olmsted earned her BFA from Bowling Green State University in Ohio and her MA from the University of Louisville, both in English and creative writing; she also has a PhD in English and feminist studies from the University of Minnesota.

Olmsted and her husband, Ken Casey, raised three boys in Bowling Green, Kentucky. She teaches in the English Department, and he teaches philosophy and religion at a local community college. They are raising their youngest son's daughter; another granddaughter lives in Louisville. They live almost in the country with three dogs, two cats, and innumerable fish.

Made in the USA
Monee, IL
26 January 2022

89961613R00152